The Lithographs of Thomas Hart Benton

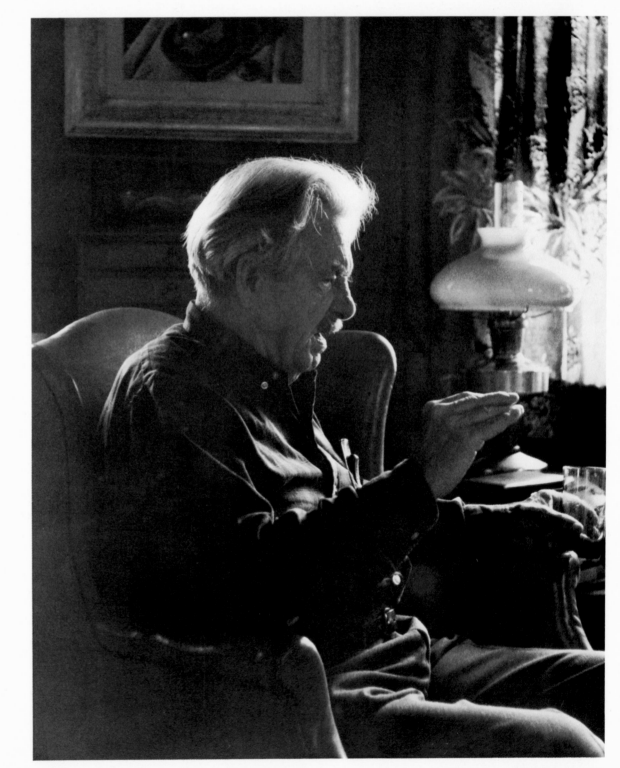

PHOTO BY ELIZABETH MEYER LORENTZ

THE LITHOGRAPHS OF Thomas Hart Benton

compiled and edited by Creekmore Fath

UNIVERSITY OF TEXAS PRESS, AUSTIN & LONDON

Standard Book Number 292-78407-4
Library of Congress Catalog Card No. 69-15946
Copyright © 1969 by Creekmore Fath
All Rights Reserved

Typesetting by Service Typographers, Inc., Indianapolis, Indiana
Printed by The Steck Company, Austin, Texas
Bound by Universal Bookbindery, Inc., San Antonio

To Adèle

CONTENTS

LIST OF LITHOGRAPHS

The Lithographs of Thomas Hart Benton

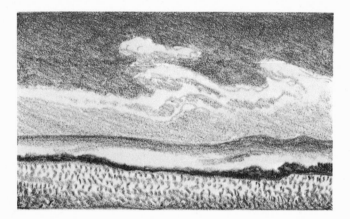

INTRODUCTION

To the making of books there seems to be no end. Yet to the making of every book there has to be a beginning. This book began a long time ago, back in 1935, when I read an advertisement of Associated American Artists in the Sunday edition of the New York *Times* offering "genuine" works of art—etchings and lithographs—by living American artists such as Thomas Hart Benton at five dollars each. I was a student at The University of Texas at the time, and I clipped the advertisement and stuck it away for future reference.

My first venture at an art purchase had been at the age of twelve, as the result of an advertisement in the Sunday St. Louis *Post Dispatch*. For the sum of one dollar I acquired genuine reproductions of three of Mr. Rembrandt's greatest etchings: *Dr. Faustus, The Three Trees,* and *The Mill.* I still have them. I liked black and white. If an artist couldn't say it in black and white, he couldn't say it so far as I was concerned.

Having decided at an early age to be a lawyer, there didn't seem to be any place in my academic curriculum for formal art education or appreciation. As a child I had been trotted in and out of museums —in places like St. Louis and Chicago—whenever my family happened to be in the vicinity of one. There were always books around the house illustrated with reproductions of the great masters, and I remember one magazine dedicated to the arts called *The Mentor.* All this had an effect on my awareness of art. By the time I reached The University of Texas in 1933, Mr. Roosevelt's New Deal was under way, and American art and artists were being publicized. The art programs of the New Deal, the art features of national magazines such as *Life* and *Time,* the publication and popularity of such books as Thomas Craven's *Modern Art* and *Men of Art,* all contributed to a general awareness that art existed and was accessible to everyone.

Looking back, I realize I am one of those persons at whom the

advertisement is aimed when it queries: "Are you one of many who admire the *Mona Lisa* for the wrong reasons?" I continue to wonder how come Francis I acquired the *Mona Lisa* without benefit of a course in how to understand and appreciate art.

So, without the benefit of any formal training about what is "good" in art, in time I discovered Dürer and Goya, Daumier and Whistler, Bellows and Sloan, Rivera and Orozco, Curry and Wood, and Thomas Hart Benton—all in black and white. I was satisfied that Gellett Burgess made good sense when he wrote: "I don't know anything about art, but I know what I like."

In 1939, having judiciously banked my first legal fee, I ventured my first order for a Benton lithograph from Associated American Artists. In due time *I Got a Gal on Sourwood Mountain* arrived, was framed, and hung in my law office. The decision to hang the lithograph in the office rather than at home was simple: I figured that I spent more waking hours there than at home, and I wanted it where I could see and enjoy it. That was the beginning.

During the next few years I acquired a dozen more Benton lithographs, and by the time I went into the Army I had twenty. Although I had not limited my acquisitions to Benton, his was the largest group by one artist.

In the years following World War II the collection grew. Whenever business or pleasure took me from Texas to New York, which it usually did two or three times a year, I browsed among the art galleries specializing in prints. Though I found other artists whose work I enjoyed and bought, I could not resist whenever I ran across a Benton I did not have.

In 1960 I went to Washington, D. C., on a short-term assignment as counsel to a U.S. Senate committee whose chairman was Senator Ralph W. Yarborough of Texas. The short term lasted over four years, and during this period I had many opportunities for weekend browsing in New York.

By September 1964 my Benton collection numbered some fifty-five lithographs. I wondered from time to time just how many lithographs Benton had made, but I made no attempt to find out until, on a visit to the Associated American Artists gallery, I chatted with Sylvan Cole, Jr., president of the gallery.

"Why," I asked Cole, "don't you put out a monograph cataloguing all the lithographs of Thomas Hart Benton?"

"Because," he answered, "even though I think we handled a majority of Benton's lithographs, we don't have all the information about all of them." Returning to the subject a few moments later he added: "Why don't you do it?"

My response was simple and direct: "I'm a lawyer and an amateur collector, not an art historian."

Cole shrugged. "I know you have a lot of Bentons and are interested in his work, and you want such a catalogue. I don't know how else you are going to get one."

"Well," I said rather lamely, "I might at that." But I didn't mean it seriously.

That visit was only my first stop that weekend; my wife and I were on the way to Armonk, New York, to spend the weekend visiting Pare and Elizabeth Lorentz. It was less than twenty-four hours later that Pare told me that the Lorentzes were spending the first weekend in October as guests of Sanford Low, director of the New Britain Museum of American Art in New Britain, Connecticut, to celebrate the opening of the Stanley Memorial Wing, which featured the mural work of Thomas Hart Benton!

Sanford Low was born in Hawaii and came to the mainland in 1921. Not long after his arrival he became completely devoted to Martha's Vineyard, where he spent the summers and met Thomas Hart Benton. Low was an artist of considerable ability and had become director of the New Britain Museum in 1938. In 1954 he arranged for the acquisition of the Benton murals "The Arts of Life in America" from the

Whitney Museum in New York City for which they had been done in 1932. The murals had been in storage for ten years before the museum was able to build a new wing to display them. Low also had acquired for the museum a collection of sixty-six lithographs by Benton which were going to be displayed at the same time.

I told Pare Lorentz that I was interested in finding a catalogue of the lithographs. Pare thought that the New Britain collection of lithographs was complete and that the museum might be able to provide me with the information I needed. So in October 1964 I wrote them, and they promptly sent a list of what they had. The list contained the titles of the sixty-six lithographs in their collection, some of which I did not own or even know about. What intrigued me was the fact that, unless there was a confusion of titles, I had several which they did not list!

My first thought was to try to complete my own collection of Benton lithographs. Since I knew that Pare Lorentz saw Benton occasionally during the summer when they were both on Martha's Vineyard, I appealed to him to write to Benton and see if, by chance, he had proofs of any of the lithographs which I did not own. Lorentz wrote Benton in December, and at the end of the year Benton responded very graciously that though the prints were getting rare and in most cases the editions had long since been exhausted, he did have extra prints of a few of the lithographs which he was willing to deliver to the "right people"—and this included any friend of Lorentz. So, as the friend of a friend, I had an introduction to correspond with Thomas Hart Benton.

In the beginning it was the acquisitive instinct that prodded me into correspondence with Benton. Why do people collect things? And why do collections have to be "complete" in order to satisfy the collector? I suppose the psychologists have simple answers to these questions, and where they fail someone like Thorstein Veblen fills in with "conspicuous consumption" or "display" and lets it go at that.

Whatever the motivation, collecting seems to satisfy some gnawing hunger that quiets down only with satiation.

My first letter to Benton in January 1965 was in furtherance of my desire to "complete" my collection of Benton lithographs. Using the New Britain Museum list of sixty-six lithographs, supplemented by my own knowledge of at least five others, I queried Benton about possible confusion of titles to try to compile a definitive list. The first letter from Benton on January 18, 1965, cleared up one question. The lithograph I had acquired under the title *Arkansas Evening* and the one entitled *Nebraska Evening* on the New Britain list were one and the same lithograph, *Nebraska Evening* being the correct title. After advising me of which of the lithographs he did happen to have extra proofs available, Benton added a postscript:

*P.S. I assume you are a Texan. It might interest you to know that I am half Texan myself. My mother came from Waxahachie and I knew the country thereabouts quite well as a boy. My grandfather had a cotton farm a few miles from town. The lithograph "Fire in the Barnyard" represents an incident which occurred on an adjoining farm when I was around ten or eleven years old.**

<div align="right">

T. H. B.

</div>

It was this "P.S." that first made me want to know not only the titles and other details about the lithographs, but something of the story behind each picture. I had owned *Fire in the Barnyard* for many years without having any idea that there was a story behind the picture. For example, I did not know the incident had happened in Texas. And I certainly did not know it was an event that took place when Benton was ten or eleven years old and that he remembered vividly enough to visualize many years later.

The next letter from Benton on February 5, 1965, though it stimu-

* A little more than a year later, in reply to my questions about *Fire in the Barnyard*, Benton said he was seven or eight when the fire occurred.

lated my curiosity about the number of lithographs he had made, advised me that not much could be expected from him insofar as completing my collection was concerned:

I did other lithos (all in all 77) but again they are just not to be had, either because the editions were very limited—a half dozen proofs— or because they, like "Plowing It Under," are exhausted.

I sure appreciate your interest but except for your #67 and #71 I can't help you further it. It is really amazing how difficult it is to get prints which had a large circulation when they were first released.

Sincerely yours
Thomas H. Benton

This was the first indication of the total number of lithographs: seventy-seven. (We discovered later that Benton had actually made seventy-eight lithographs by this time—and the two produced in 1967 brings the total to eighty.) But there was no indication of the titles of the eleven that were not included on the New Britain list.

On February 12, 1965, I wrote Benton to ask him if he would list the missing titles for me. I told him I realized my chances of finding them were remote but would like to know what I was looking for when I again had occasion to do the gallery circuit.

Over two months elapsed with no word from Benton. My short-term assignment in Washington, D.C., finally came to an end, and I returned to Austin, Texas, to resume the practice of law. Finally, the first week in May, came a letter forwarded from Washington, D.C. Benton had written on April 30, answering some of my questions on the margins of my own letter of February 12. His last comment stumped me:

I cannot, to save me, remember the titles, if any, of the others.

T. H. B.

But elsewhere in the letter Benton offered some hope: he and his wife were making an inventory of his lithographs, and he had sent me a consolation prize.

I have neglected to reply to the enclosed letter because I thought our inventory of the works we own might help answer your questions.

We have not yet, however, got to all of our lithographs.

Perhaps you have the "Station." I am sure we can supply that if you don't.

I think we will be through our inventory business in about two more weeks.

The print we are sending you is an offset and very poor but it has some historical value because of the use it was put to—that is raising money for the Kansas City flood victims of '51.

Sincerely yours
Thomas H. Benton

The offset print was *Homecoming—Kaw Valley 1951,* which Benton had made in a special edition for the members of the Congress of the United States and sent to them on October 13, 1951. It had appeared on the cover of *New Republic,* November 19, 1951, to illustrate Benton's article "Disaster on the Kaw."

I was too busy to answer my mail. The return to Texas after four years meant a reorganization of my own life that kept me very busy. So it was the middle of June before I got around to acknowledging the receipt of the offset print and reminding Benton that I was still hoping to receive the list of missing titles.

Still later in June came a letter from Benton from Martha's Vineyard:

We can send you the "Station," or "Edge of the Plains" as it has been called, and the "Letter from Overseas" when we get back to Kansas City in December.

We will be late returning there this year because I'm going to execute and cast (bronze) a piece of sculpture in Lucca, Italy. Be there Oct. & Nov.

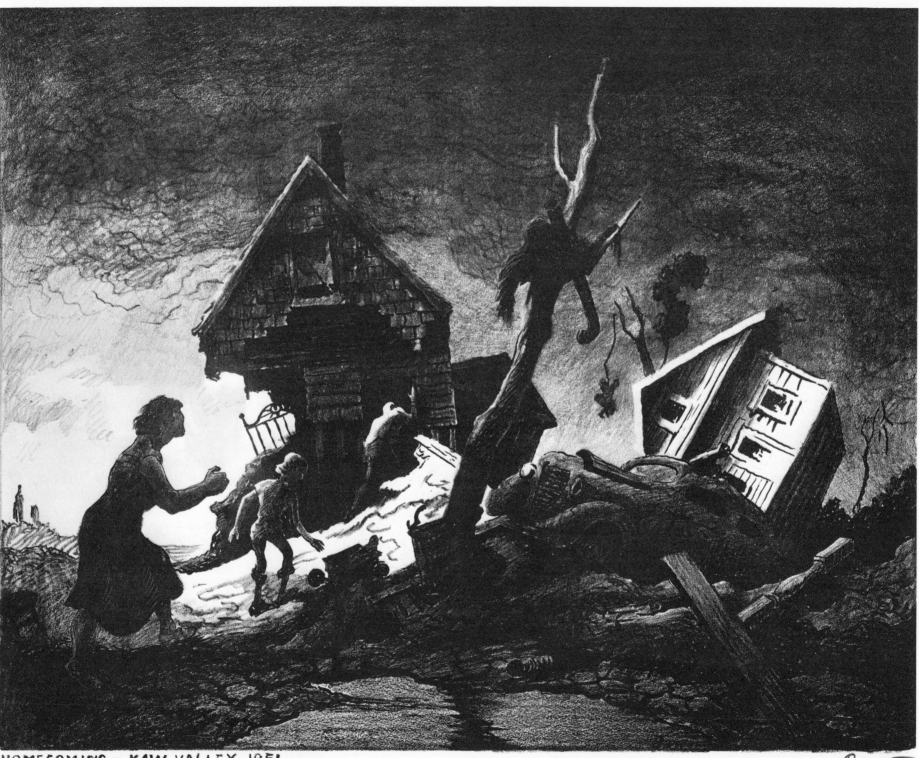

HOMECOMING — KAW VALLEY 1951 Benton

I don't know just when Pare is coming to these waters and don't know whether I'll get to see him or not.

I'll be away from 9th of July until about the 20th of August on a long trek from Omaha, Neb., to the head waters of the Missouri River—following the Lewis & Clark fur traders trails. Back here for all of September.

> *Sincerely yours*
> *Thomas H. Benton*

So I made a note on my calendar to tackle Benton again by letter in December about the lithographs that I now knew existed but about which I had no information. But though the note on the calendar reminded me every day to write Benton, when December rolled around, I was still too busy to do so.

In late January I read in the morning paper that Thomas Hart Benton had had a heart attack and was out of commission for an indefinite period of recovery. During the next couple of months I watched the papers for any report about Benton and saw only one item to the effect that he had returned home from the hospital and was more or less immobilized. I hesitated to bother him to satisfy my private curiosity, but the lithographs all around me kept reminding me of the catalogue I wanted. Furthermore, the footnote he had sent about *Fire in the Barnyard* piqued my curiosity. When, at some point, the conversation with Sylvan Cole, Jr., of the Associated American Artists came to mind, I decided that if I was going to have a complete catalogue of the Benton lithographs I was going to have to do it myself. So, on March 22, 1966, I wrote Mrs. Benton, reminding her that Benton had indicated that they were doing an inventory of the lithographs and would try to supply me with the missing titles. Then I plunged:

"Is there anywhere a project under way to do a definitive catalogue of the lithographs? If not, then this is something I would like to under-

take." I left it to Mrs. Benton to show the letter to Benton, or anwer it herself, or toss it in the wastebasket.

A few days later I had an answer from Benton:

I do not think there is a definitive catalogue of the lithographs. Try your hand at it if you wish—send me a draft for possible correction before you issue it.

. .

I am recovering quite rapidly from my attack but am under doctors' orders as to behaviour which may last a solid year.

I can read and write. Of the latter I have a good deal to do getting out a new chapter for "An Artist in America" to be reissued when I get it done.

Thank you for your continued interest.

> *Sincerely yours*
> *Thomas H. Benton*

Thus I decided to try my hand at it, and this book began.

Initially I prepared an information sheet for each lithograph and had the sheets mimeographed. Then I typed in what scanty information I had and mounted the kodak prints. It was in preparing these information sheets that I first discovered how difficult it is to reproduce lithographs adequately. I had to appeal to Russell Lee, the distinguished photographer, for advice on photographing them. Lee endeavored to tell me how to do it properly, but when he discovered that I really had not understood cameras since the "Brownie," he came to my office and photographed them himself. As an artist himself, Lee insisted that I had to have decent pictures of the lithographs on the work sheets, because it would be asking too much of Benton to have to look at a bad reproduction while filling in the blank spaces.

The information sheet on *Down the River* is typical. The handwriting, of course, is Thomas Hart Benton's.

Title:

"Down the River"

Size of plate:

10 x 12 1/2

Date:

Number of prints:

Commissioned by:

Done for myself. Dist. by A.A.A.

Story behind the picture: geographic location of the scene depicted; identification of the person, song, story, legend, etc. :

A scene on the White River in the Ozarks. Drawings for it were made in August 1939 while on a float trip down the river. The area presented is now under seventyfive feet of water, due to the construction of Bull Shoals dam. However, such scenes are still common on the clear water Ozark rivers which remain free flowing. Twice yearly, Spring and Autumn, I have floated these rivers for many years, fishing, camping out on the sand bars and gravel and just watching the river banks go by. The boy in the picture is my son T. P. Benton.

Also called "The Young Fisherman"

On April 28, 1966, the loose-leaf folder of information sheets was shipped to Benton. My covering letter was contrite: "I know I am presenting you with a real chore—I trust this will not prove to be too much of a burden." The seventy-odd pages of blanks to be filled in required a lot of work. However, I thought that if and when they were returned it would be a simple matter to get the catalogue in final form.

I soon learned better!

Instead of being the finishing touch to the catalogue project, as I had expected, the return of this group of information sheets with the accompanying letter and notes by Benton turned out to be only the beginning.

May 16 - 66

Dear Mr Fath —(Answer to your letter of April 28-'66)

Unfortunately I have kept no records showing the dates of execution of the lithographs. There are only two places to find these —

1. records of the Associated American Artists.

2. (possibly) Fogg Museum at Harvard where a record might have been kept of dates of purchase. I have been told that the Fogg people bought the lithos as they came out. If so that would give year of execution.

For the number of prints in each edition again reference will have to be made to records of A. A. A. Generally it was, as you remember 250 - to - 300 prints per edition — or that was what it was supposed to be.

As for the extra six lithos they were made but except for the flood scene were not widely circulated.

In the case of some only 1 or two proofs were pulled.

Mrs. Benton has been unable to find any of the six prints here. They are not with our collection. It is very

possible that they are in some portfolio of my drawings and will eventually show up when we carry on our inventories.

In any case except for "The Flood" you have all the lithos which had any circulation.

Others which were well known, like the illustrations for the Limited Editions Club were circulated in offset. A very successful use of my lithographic illustration was made for Oklahoma U. Press — Lynn Riggs' "Green grow the Lilacs". This is one of the handsomest of the books I illustrated with "offset" lithos.

You might have a note at the end of your catalogue, or maybe in your foreword, saying that Benton made a number of experimental lithographs which were not circulated and which are not obtainable or even in some cases recorded.

Your catalogue is the best that can be done. — or that has been done.

Sincerely yours

Thomas H. Benton

P.S. On the 31ˢᵗ May we leave here for Martha's Vineyard. Address there is CHILMARK, MASS. I'll be glad to answer any further questions you might have — answer them if I can, that is.

T. H. B

Notes —

Instead of using "commissioned by" I'd use "circulated by."

Most of the lithos were done just because I wanted to do them — they were not "commissioned" as we generally use the word.

Most of my lithos were done in pairs — one on each side of the stone. Often I've done one side and then waited, sometimes for a couple of months, or more, before I had an idea for the other side. Often, also, I've had an idea for a litho (a drawing) but did not execute it, on the stone, for years. So while I generally remember when I found the original idea I don't do so well about its lithographic execution.

The business of dealing in works of art is generally kept vague — precise records are hard to get at. — lithos, like paintings rise and fall in value — speculators buy blocks of prints and turn them loose only when prices are high. — Everywhere the tendency is to be a little secretive with works of art.

It may, thus, be necessary to re-organize your catalogue project. You may find it impossible to get exact information.

T. H. B.

12

you will notice that I remember the dates of the original drawings from which the lithos were made — but often years would elapse before these were put on the litho stone.

I used to have sales records of the H.A.A. but when I broke with the organization these were put in a box and have just "disappeared." Bad business methods, of course, but you just can't be an artist and a book-keeper at the same time.

Mrs. Benton now keeps very good records but these cover only the last few years.

T. H. B

I had not anticipated that Benton would not have all the information about his own work. I had simply failed to weigh the probabilities. In a lifetime of productive work an active artist may produce thousands of drawings, paintings, murals, lithographs, and pieces of sculpture. As Benton says, an artist is not a bookkeeper, to date every item or, as in the case of lithographs, to count carefully every proof, when he sometimes produces an experimental stone for his own pleasure or for that of a few friends.

By this time, however, I was able to identify by title seventy-six

lithographs, and I knew what seventy-one of them looked like. Benton provided me with leads to follow up, and this I did during the next few months. I spent a few days in the library of The University of Texas. I spent three in the Copyright Office and in the Print Division of the Library of Congress. Another day was spent in the Print Division of the New York Public Library. Associated American Artists in New York City made available to me what records they still had. I visited the Print Collection of the Fogg Museum in Boston, Massachusetts. I went to the New Britain Museum of American Art in New Britain, Connecticut, and saw their Benton collection. And when I could not visit, I wrote letters.

In digging out the basic facts about the lithographs I kept running into critical discussions of their value as works of art. I also came upon critiques of Benton's work as a painter and muralist and many views of his place in American art. Before I knew it, I realized that I was also trying to find out, for my own satisfaction, just why it was that I liked the Benton lithographs so much. I gradually began to understand that my contact with art had been casual, that what I had achieved was a sort of familiarity with art rather than a knowledge of it.

In the middle of my research I reread Benton's *An Artist in America*. It helped tremendously to put things into perspective. I also read some of the articles and interviews by Benton. Slowly the lithographs, as part of the picture that Benton has created of the American Scene, began to slip into focus.

Benton was born April 15, 1889, in Neosho, Missouri. He began drawing at an early age, but his first influential teacher was Frederick Oswald, under whom he studied at the Chicago Art Institute in 1907–1908. It was here that he studied both watercolor painting from life, and composition, by analyzing Japanese prints, from which he acquired a taste for linear rhythms.

From the autumn of 1908 until the latter part of 1911 he studied at the Académie Julien in Paris, where he was initially influenced by the visual realism of the Académie and of Courbet, Manet, and, at one time, Zuloaga. After a bout with impressionism, under the influence of Pissarro, Benton moved in 1910 into neoimpressionism, under Signac's influence. Through his friendship with the American painter John Carlock, Benton became acquainted with Cézanne. It was also thanks to Carlock that Benton made studies of the Classic and Renaissance art in the Louvre. During his Parisian sojourn Benton zigzagged continually between different styles of painting. He left France without achieving a permanent style.

Upon his return to the United States in 1912 Benton lived in New York City, where he came under the influence of the American painter Sam Halpert and painted for a while in a Cézannesque manner. But from 1912 to late 1915 Benton again wavered between different styles, from visual realism through various forms of "modernism." Beginning in the summer of 1915 until the spring of 1916 Benton adopted synchronism, a school of painting founded in Paris by the American painters McDonald Wright and Morgan Russell and based on the schematic division of the spectral band of the Canadian painter-scientist Tudor Hart.

In 1916 and 1917 Benton devoted his painting, largely in monochrome, to a study of Classic and Renaissance compositional form. In late 1917 and 1918 he painted a series of constructivist paintings, studies in abstract form made from actual constructions of wire, colored paper, wood, cloth, and so on. In this same period he also began experiments with sculpture.

During a sojourn in the U.S. Navy at Norfolk, Virginia, in 1918 and 1919 Benton made a series of environmentalist paintings, and when he returned to New York City he continued painting directly from environment in the New York area. Inspired by his study of the Renaissance painter Tintoretto, he began modeling compositions in clay before executing them in paint, to increase solidity of form. This be-

came a permanent compositional practice and the basis for his mural style during the twenties.

The influence of the American environment upon Benton continued to increase during the twenties. Thus it was natural for him to become allied in the early thirties with the Regionalist group of American painters, which included Grant Wood, John Steuart Curry, Reginald Marsh, and Charles Burchfield. Although Benton had no stylistic affinities with Burchfield, Edward Hopper, or Andrew Wyeth, he did have a similar attachment to the American environment.

After 1919 nearly all of Benton's work was based on the American scene and its folklore. He did murals, easel paintings, and drawings, working in oil, oil and tempera, tempera, distemper, watercolor, and, in late years, acrylic polymer emulsion.

In 1929 Benton made his first lithograph, *The Station,* for the Delphic Studios. He had met George Miller, the master lithographic printer, and this lithograph was the first collaboration between them. George Miller printed all of Benton's lithographs, and while Benton lived in New York City, up to the spring of 1935, most of his lithographs were made in George Miller's studio on East Fourteenth Street. Benton preferred lithography to other graphic media because of the range of tone possible, and liked working with George Miller because he knew exactly the kind of light and shade contrasts Benton wanted.

Benton's lithographs were done both *for* and *from* paintings, as preparations in some cases, as re-interpretations in others. Though he preferred stone to metal, a number of his larger lithographs were done on zinc plates specially prepared for him by George Miller. *Jesse James, Huck Finn, Frankie and Johnnie,* and all of the lithographs in the *Grapes of Wrath* series were done on zinc plates. Though Benton became a master of the lithographic medium, he made no technical innovations with it.

For well over a generation Thomas Hart Benton was one of the most famous and talked about painters in America, and it was during that period that he made most of the lithographs in this book. When the first color cover of *Time* magazine appeared on December 24, 1934, it was a self-portrait in color of Thomas Hart Benton. There was no question but that Benton was controversial. He was accused of having an aggressive personality, but it was conceded that he had absolute confidence in his own artistic convictions. Benton had declared his belief before the Federation of Arts in 1932: "No American art can come to those who do not live an American life, who do not have an American psychology, and who cannot find in America justification of their lives." Moreover, Benton was and is an example of the Eugene Manlove Rhodes maxim that when required by circumstance, no man worth his salt hesitates to charge hell with a bucket of water.

Peyton Boswell, Jr., editor of *Art Digest,* wrote: "Thomas Benton is a dramatist"[1] Laurence E. Schmeckebier, chairman of the Department of Fine Arts, University of Minnesota, said: "Actually [Benton] is more than an artist, for in him are combined an exciting reportorial style of painting with a literary skill"[2] However, I think Carl Zigrosser, now Curator Emeritus of Prints, Drawings and Rare Books at the Philadelphia Museum of Art, caught the full flavor of the man and his work when he wrote:

Colorful personality, knowledge of life, intelligence, showmanship, polemical eloquence, grasp of affairs—these he has in plenty. In his murals he has dramatized a panorama of American life more varied and pungent and grandiose than anyone has ever before attempted. It is as characteristically American a contribution as the movies. His travels all over the country, so engagingly described in *An Artist in America,* and the thousands of drawings

[1] Peyton Boswell, Jr., *Modern American Painting* (New York: Dodd, Mead & Company, 1940).
[2] Laurence E. Schmeckebier, *John Steuart Curry's Pageant of America* (New York: American Artists Group, 1943).

he has made, more spontaneous and direct on the whole than his painting, reveal his keen and never ending interest in every aspect of American life. The South, the Ozarks and Appalachians, river life, farming and industry, religion and sex, New York a world in itself, Hollywood, and his own native haunts, all add their color and flavor to the big and robustious parade. As his illustrious forebear was a great factor in the original opening of the West, so Benton plays his part today in revealing to America the untold possibilities of its subject matter.[3]

The lithographs of Thomas Hart Benton have been created out of the wealth of raw material available to the perceptive observer of the panorama of American life. Out of his experience and knowledge Benton has created a series of pictures of the essentially native, American way of life. The aspects of American life and lore portrayed in the lithographs are close to the soil and as American as black-eyed peas and sow belly, corn pone and six-shooter coffee. Benton's vision has reflected his consciousness of his American identity, and his idiom has been a perfect tool for projecting this indigenous series of pictures. Walt Whitman *heard* America singing and wrote it down in his poetry. Thomas Hart Benton *sees* America as it was and is; he draws and paints his vision in his murals and oil paintings, in his drawings and his lithographs.

Looking back over some of the critical comments of the past forty years on Benton's work gives one a bit of insight into the man and what he has tried to achieve with his art.

In reviewing a Benton Exhibition, C. J. Bulliet commented in the Chicago *Evening Post,* December 31, 1929: "Thomas H. Benton, who dives down into the hearts of the 'common people' and exhibits them in their humble activities, is the prize American of the Delphic Studios group." (Together with the Mexican, José Clemente Orozco, Benton was associated with the Delphic Studios in 1928–1929.)

Thomas Craven, whose two books *Modern Art* and *Men of Art* sold over a half-million copies in the early thirties and exerted a wide influence in educating the American public to an appreciation of an indigenous American art, called Benton the "foremost exponent of the multifarious operations of American life." In his book *Modern Art,* published in 1934, Craven said: "Benton is one of the few living artists, in any department, with a first-rate mind. He has not only the ability to live and to create but to think; and a painter with the ability to think is something criticism has not had to reckon with for many a day. No wonder his defiant forms and dramatic conceptions baffle the professors! He is, like Dreiser in the novel and O'Neill in the theatre, a pioneering force in American art"

Benton has probably traveled more widely in the United States than any other American artist. Up and down the Mississippi River, over the Alleghenies, through the Ozarks, all over the Great Plains and the Rockies, he has followed the Oregon Trail, penetrated the swamps and bayous of Louisiana, crossed the Southwest and the American desert. From southern California to New England, from Michigan to Florida, Benton has roamed the countryside of the United States. He was able to identify with mountain folk and farmers, cowboys and industrial workers, river rats and poets, and in so doing captured something of the American spirit. His region has been America, but it is the America of those who do the work.

You do not need a course in art appreciation in order to understand what Benton is driving at in his lithographs. Art appreciation is an individual matter. Although it may be hard to describe exactly what you experience when you see something you like, the satisfaction cannot be denied. That art is appreciated which satisfies the beholder.

Benton has said that his lithographs portray the American Scene. Here then in the lithographs are eighty facets of the American Scene of Thomas Hart Benton, native and realistic, imaginative and dramatic, but out of and part of the American tradition.

A book about the lithographs of Thomas Hart Benton would be

[3] Carl Zigrosser, *The Artist in America* (New York: Alfred A. Knopf, 1942).

incomplete if it did not include enough about George Miller to explain the unique contribution that he made, not only to Benton's lithographs but to American lithography in general.

Undoubtedly the services rendered to American lithography by George Miller will one day be told in greater detail than is possible here. Suffice it to say that from the time Miller set up his shop in New York in 1915 until his death early in 1966, he was the acknowledged master lithographic printer in the United States.

In 1915 Miller began producing prints for Albert Sterner. He soon had a second artist client, George Bellows. In the early 1920's, when the Whitney Studio Club was operating, Mrs. Juliana Force commissioned Miller to demonstrate how lithographs were made before a group of young artists. In 1923, when Miller was about to abandon his shop and return to commercial printing, Arthur B. Davies, Boardman Robinson, and Rockwell Kent, among others, brought in enough work to keep Miller at lithography.

The list of artists for whom Miller printed contains most of the famous names of the last half century: Joseph Pennell, Wayman Adams, Childe Hassam, Gifford Beal, Reginald Marsh, Grant Wood, Lionel Feininger, Stow Wegenroth, Lynd Ward, Richard Florsheim, Fritz Eichenberg, Diego Rivera, José Clemente Orozco, Raphael Soyer, Wanda Gag, Peggy Bacon, Adolph Dehn, William Gropper, *et al.* almost *ad infinitum.*

In the *American Artist* in September 1943 on "The Craft of Lithography," George Miller wrote:

It takes a fine artist and a skilful printer to make a good lithograph. The most brilliant drawing by a Daumier will not make a good lithograph unless its merits are fully exploited by an expert lithographer. On the other hand, no lithographer can produce a good lithograph from a weak and characterless drawing.

Lynd Ward, in his tribute to Miller in the *American Artist* of May 1966, said:

Because he had served a long apprenticeship in commercial lithography before establishing his own studio, George brought to his work with artists a body of experience that enabled him to deal with a host of technical problems, and to produce prints for artists with a bewildering variety of styles and technical requirements. When you worked with him you had the feeling that you were in contact with all the craft wisdom that was the heritage of a hundred years of printing from stone.

In the same issue of *American Artist* Stow Wegenroth wrote:

Any artist entering Miller's shop could feel absolutely sure that whatever his technique, or however many days or weeks had been spent in drawing the image on the stone, he need not worry that the printing would be any less seriously produced. George Miller had a combination of great technical skill, love of the craft, and infinite patience in his practice of it. Nowadays these are rare virtues, not to be taken lightly.

The name of George C. Miller is still on the door of the shop on West Twenty-second Street in New York City. George Miller trained his son, Burr Miller, to be as painstaking a craftsman in the art of lithography as he was himself.

Thus Benton's lithographs are the happy result of a great collaboration between artist and printer. George Miller printed the first seventy-eight lithographs in this book for Thomas Hart Benton; Burr Miller printed the last two in the spring of 1967. Thus a great American tradition continues.

The story would likewise be incomplete without reference to Reeves Lewenthal and Associated American Artists. It was in July 1934 that Lewenthal got together with Benton, John Steuart Curry, Grant Wood, and twenty or so other artists to propose a plan through which lithographs and etchings could be merchandised in department stores and by mail order through advertising in publications with national circulation.

Lewenthal proposed to call his operation "Associated American

Artists," though it was not an association of artists, since the artists had no hand in policy or management; it was essentially an art gallery operation belonging to Lewenthal and offering a program attractive enough to artists to get them to participate.

Prior to the advent of Reeves Lewenthal, lithographs and etchings were usually printed in small editions of from twenty to fifty copies and sold by art dealers and galleries at prices ranging from ten to fifty dollars. In the case of lithographs Lewenthal now proposed editions of 250, each lithograph to retail at five dollars. He also proposed that, instead of a dealer's commission, the artist be paid a flat fee of two hundred dollars per lithograph, with a bonus when the issues from ten stones or plates were sold out. We must remember that the date was 1934, and two hundred dollars to make a lithograph stone was a substantial increase over what the artists had been realizing.

The genius of Lewenthal's idea was to break down the concept of art as a luxury product, available only to those who wanted to consume conspicuously and could afford to patronize expensive galleries, and make it into a popular product available in the corner store or by mail.

There were one or two mishaps in the early days of Associated American Artists, with price cutting in some department stores, but these difficulties were overcome and it became one of the most successful art enterprises in the country.

All things considered, Benton's relationship with Associated American Artists was a mutually beneficial one. Associated American Artists circulated about fifty of Benton's eighty lithographs and sold about twelve thousand individual prints.

In 1966 Benton wrote in retrospect:

Reeves Lewenthal, whatever may be said about some of his methods, did a great service in popularizing lithographic techniques. I think some recognition of that should be inserted in the foreword to your book. I would not have made many lithos had it not been that Reeves built up the market for them.

Thus one is reminded that even an artist has to eat—and that though he must be able to produce without a market and without a prospective customer hovering in the wings, an artist with an outlet for his production may produce more and even better work. Lewenthal became the middleman through whom more people bought works of art by living American artists than they had ever done before, a not inconsiderable achievement.

The lithographs illustrating folk songs—"I've Got a Gal on Sourwood Mountain," "The Wreck of the Ol' 97," "Coming 'Round the Mountain," "Frankie and Johnnie," and "Jesse James"—are among my favorites. Back in the middle nineteen thirties, when I was an undergraduate at The University of Texas, a group of students would gather on a weekend evening, usually at the home of Dr. Robert H. Montgomery, the economist, or at that of Walter Prescott Webb, the historian, to sing folk songs, read stories, and indulge in good talk. "Swapping lies," was the way J. Frank Dobie, the great Texas writer and folklore expert, described the sessions at which he was a frequent visitor, as was Roy Bedichek, educator and naturalist, and like Dobie a natural delight to all who knew him.

Our guitar player for the folk song sessions might be Dr. Bob Montgomery or Dobie or Clay Cochran or Henry Daniels, and although our singing was not too good, it was lusty, and we enjoyed the sound of our own voices. At Walter Webb's insistence we wrote down many of the versions of the songs we sang. Webb and Dobie were intrigued by the variations of verses from the Great Plains over to deep East Texas and the embellishments provided by those who grew up on the Mexican border. The song versions I used to tell the story of the lithographs in this book are from my files of those sessions of the thirties.

The lithographs are presented in chronological sequence. As for

the variations in titles, the first title used is the one Thomas Hart Benton prefers. The alternate titles include all those that I have found used with reference to a particular lithograph, and all titles are cross-indexed in the alphabetical index of titles at the end of the book.

The dates were determined by research into all printed material that I was able to locate, from the existing records of Associated American Artists, and by Mr. Benton.

The dimensions of the lithographs specify width first and height second, to the closest sixteenth of an inch. Sizes may vary up to three sixteenths of an inch among examples of the same print, which simply reflects the contraction or expansion of the paper on which the lithograph is printed.

The number of prints in each edition of a lithograph has been determined by what records survive at Associated American Artists and by the recollection of Mr. Benton. When the prints were distributed by Associated American Artists it was the practice of George Miller to produce an edition of 250, with 25 prints reserved for Mr. Benton. In some cases, however, the stone did not produce as large a number of satisfactory prints—and *all* prints underwent Benton's perusal. In the case of *Flood* Benton approved only 196 prints; in the case of *Investigation,* only 193; and in the case of *Sunset,* only 204.

In the case of the six lithographs in *The Grapes of Wrath* series and also of the six lithographs in the *Swamp Water* series, no records exist as to exactly how many proofs were made of each individual lithograph. A small number of each lithograph were delivered to Twentieth-Century Fox Film Corporation, possibly a half dozen or so. In four cases, *Departure of the Joads, Swampland, Ben Ragan and Trouble,* and *Tom Keefer,* Benton sold a number of prints to Associated American Artists, possibly as many as seventy-five of each lithograph. The best estimate possible at this time is that the editions of these four numbered approximately one hundred prints. Of the other

eight lithographs in these two series—*Ma Joad, Pa Joad, Sharon Joad, Tom Joad, Casy, Thursday Ragan, Jessie Wick,* and *Julie Gordon*—Benton had only a few proofs besides those delivered to Twentieth-Century Fox. Therefore in these eight cases the best estimate possible is that the editions numbered approximately twenty-five prints.

The reproductions in this book were made from the original lithographs in the collection of the author, with the exception of four that were made from the original artist's proofs in the collection of Thomas Hart Benton.

The lithographs include all those that were done as individual works of art. Not reproduced are the two series of lithographs which he did for the Limited Editions Club to illustrate special editions of *The Grapes of Wrath* and *Green Grow the Lilacs.* The lithographs for these two series of book illustrations were produced in a half-dozen sets of artist's proofs of which only a few survive and none of which have ever been placed on the market.

For *The Grapes of Wrath* Benton used twenty-one lithographic zinc plates: on seven of the plates he drew two illustrations, on eight he drew three, on three he drew four, on two he drew five, and on one he drew seven. Thus on the twenty-one plates there were sixty-seven individual lithographs varying in size from 4⅞ by 1⁹⁄₁₆ to 5¹⁵⁄₁₆ by 7¹⁵⁄₁₆. These lithographs were designed to be printed in two colors and were made on lithographic zincs especially prepared for this purpose by George C. Miller.

For *Green Grow the Lilacs* Benton used seven lithographic zinc plates: on four he drew two illustrations and on the three remaining he drew three. Thus on seven plates there were seventeen individual lithographs, sixteen of which were accepted by the Limited Editions Club and used in the book. These varied in size from a 2⅜-inch-diameter oval to 6½ by 8⁷⁄₁₆. The one lithograph made by Benton but not used in *Green Grow the Lilacs* measures 3⁷⁄₁₆ by 2¹⁄₁₆ and will be found on page 3 of this volume.

In acknowledging the help that I have received, without which this volume would not have been possible, the first tribute must go to Thomas Hart Benton, and to his wife Rita, for being so patient and understanding and wonderfully cooperative. I suspect that when I first broached the subject of a catalogue, Benton expected me to do all the work. When I prepared the mimeographed work sheets and sent them off to Benton, I suppose I expected Benton to do it all. As it turned out, the compilation of the factual material, the documenting and confirming, required that we both do a great deal more work than either of us anticipated in the beginning. For me it has been a satisfying experience. Just getting to know the Bentons, and the many enjoyable hours spent with them discussing the lithographs in particular and art in general, has been one of the most rewarding experiences of my life. Benton's attitude in this respect, his willingness to help, he expressed in the following letter, which also explains some of the difficulties we encountered.

Oct 3—66

Dear Creekmore Fath—

I have answered the questions about the lithographs to the best of my ability.

When you have done as much work as I have it is hard to remember exact dates.

Up to a few years ago I did not date my paintings or drawings—sometimes did not even sign them—figuring the style was the signature.

I can remember a lot—but not everything. Keep your questions coming. I'll do my best.

Cordially
Thomas H. Benton

I am deeply indebted to many others who have contributed in various ways to the completion of this work: Pare and Elizabeth Lorentz, Mrs. Sanford B. D. Low, Sylvan Cole, Jr., Russell Lee, Burr Miller, William R. Throckmorton, and Sanford H. Low.

Acknowledgment must also be made to the following for the information they supplied or made available to me: Ruth Magurn, Print Collection, Fogg Museum, Boston, Massachusetts; Elizabeth Roth, Print Division, New York Public Library; Allan Fern, Print Division, Library of Congress, Washington, D. C.; Lois L. Ice, Assistant to the Director, The New Britain Museum of American Art, New Britain, Connecticut; Robert D. Mowry, Registrar, The University of Kansas Museum of Art, Lawrence, Kansas; John F. Helm, Director, Friends of Art, Kansas State University, Manhattan, Kansas; Louise S. Richards, Associate Curator, Department of Prints and Drawings, The Cleveland Museum of Art, Cleveland, Ohio, who supplied the text used to describe *Approaching Storm;* Mrs. Watson A. Tillman, Assistant to the President, Southern Methodist University, Dallas, Texas; Gary L. Carrico, Administrative Assistant to the Chancellor, University of Missouri at Kansas City, Kansas City, Missouri; Patricia C. F. Mandel, Research Curator, Whitney Museum of American Art, New York, New York; and to J. Emerson Titus and Stanley Gewirtz.

Special acknowledgment must be made to Associated American Artists, New York, New York, for permission to quote from several of their Catalogues and Patron's Supplements, and to reproduce certain works. Acknowledgment is also made for quotes from *The Grapes of Wrath.* (Copyright © 1939 by John Steinbeck. Copyright renewed. By permission of McIntosh and Otis, Inc.)

The Lithographs

THE STATION

also titled *Oklahoma, Edge of the Plains, Train in the Station*

6⅛ x 5⅞
1929
Edition of 50
Circulated by Delphic Studios, New York City.

Under the title *Oklahoma,* this lithograph was chosen by John Sloan to be in the "Fifty Prints of the Year Exhibit" at the Art Centre in New York City in March 1930. Reviewing the exhibit in The New York *Times* on March 2, 1930, Elizabeth Luther Cary wrote

Thomas H. Benton's plump "Oklahoma" has the look of extreme competency common to all his work whether on the scale of a mural measured in feet or a lithograph measured in inches. Lithography is a medium peculiarly appropriate to his highly individual style, and, whether he has shown us Oklahoma or not, it is certain that he has shown us Benton.

First lithograph. From a drawing made at Enid Oklahoma in 1926 when I made a trip in a model T Ford from Springfield, MO. To Taos, N. M. stopping on the way at the new oil towns of the Texas, panhandle

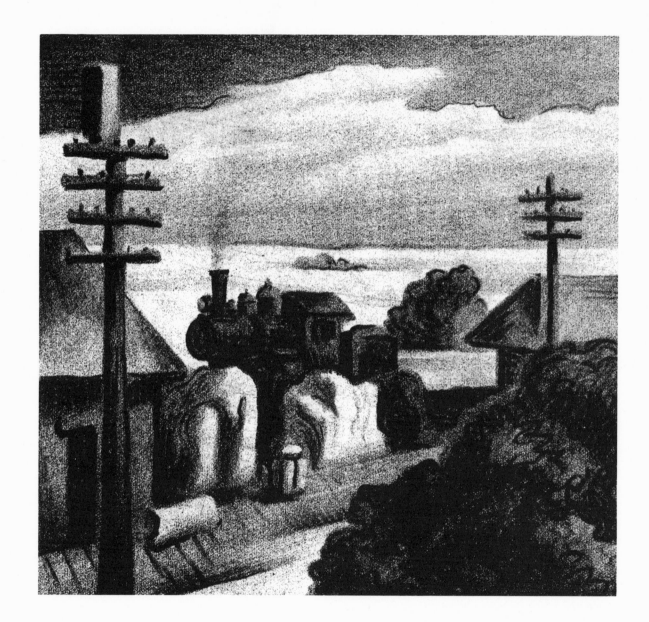

HISTORICAL COMPOSITION

11½ x 15¹³⁄₁₆
1929
Two artist's proofs

Part of project for doing Amer. History in lithos.
Never carried out. Only one proof pulled.

CONSTRUCTION

14 x 22⅛
1929
Two artist's proofs

Building operations in new York City

COMING 'ROUND THE MOUNTAIN

also titled *Missouri Musicians, Ozark Musicians, She'll Be Driving Six White Horses*

8⅜ x 11⅛
1931
Edition of 75

Circulated under the title *Missouri Musicians* by the Century of Progress International Exhibition and Sale of Prints at the Art Institute of Chicago, June–November 1934.

She'll Be Coming 'Round the Mountain

She'll be coming 'round the mountain, when she comes;
She'll be coming 'round the mountain, when she comes;
We all will know she's coming,
Cause we all will hear her humming,
She'll be coming 'round the mountain, when she comes.

She'll be coming 'round the mountain, when she comes;
She'll be coming 'round the mountain, when she comes;
She will get here just about eleven,
When she comes we'll be in heaven,
She'll be coming 'round the mountain, when she comes.

She'll be driving six white horses, when she comes;
She'll be driving six white horses, when she comes;
She'll be driving six white horses,
She'll be driving six white horses,
She'll be driving six white horses, when she comes.

We will all go out to meet her, when she comes;
We will all go out to meet her, when she comes;
We will all go out to meet her,
And we'll kiss her as we greet her,
We will all go out to meet her, when she comes.

*Made for myself
Distributed by myself*

Folk song - singers and song's action

28

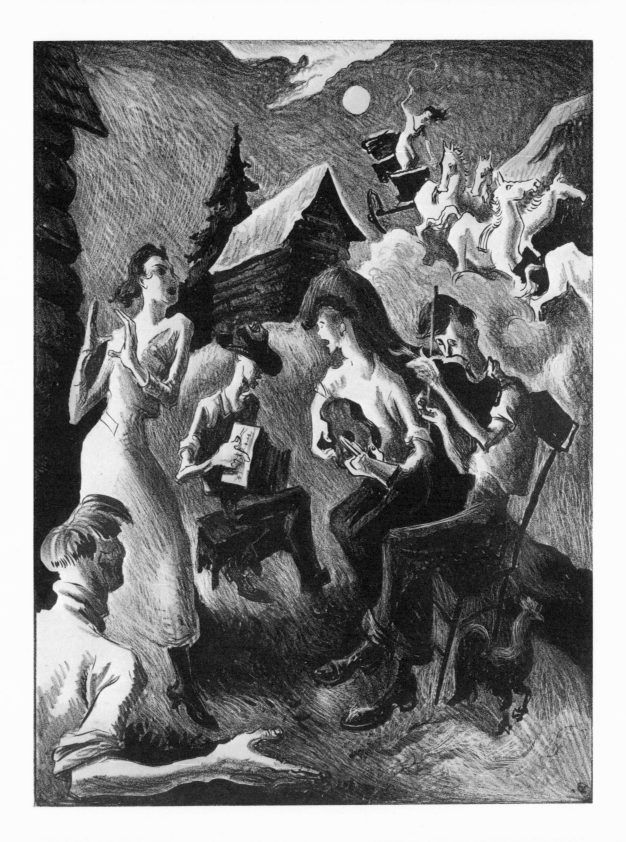

STRIKE

also titled *Mine Strike*

10¹³⁄₁₆ x 9¼
1933
Edition of 300
Circulated by Contemporary Print Group, New York City.

In October 1933 announcement was made of the formation of the "Contemporary Print Group," which, "actuated by opposition to the purist idea of 'art for art's sake,' is concerned with the belief that art can and should appeal to the general masses as well as to the cultivated few; that in striving to make his work more socially significant the artist naturally seeks to enlarge his public."

"Cooperative" in policy and in its profit-sharing, this new group was made up of the following: Reginald Marsh, Adolf Dehn, Charles Locke, Mabel Dwight, Jacob Burch, José Clemente Orozco, George Biddle, Thomas Hart Benton, George Grosz, and John Steuart Curry, with Leo Fischer acting as director.

It was also announced that the group would issue a series of portfolios of lithographs bearing the title "The American Scene," each portfolio to contain six lithographs.

"The American Scene," Series Two, issued by the Contemporary Print Group in 1934, contained six lithographs "by artists alive to contemporary social forces." The lithographs were: *Mine Strike* by Thomas Hart Benton, *Manhunt* by John Steuart Curry, *Sweatshop* by William Gropper, *Reviewing Stand* by Russell Limbach, *City Wharves* by Charles Locke, *Waterfront Scene* by Raphael Soyer.

Strike battle in the coal country.

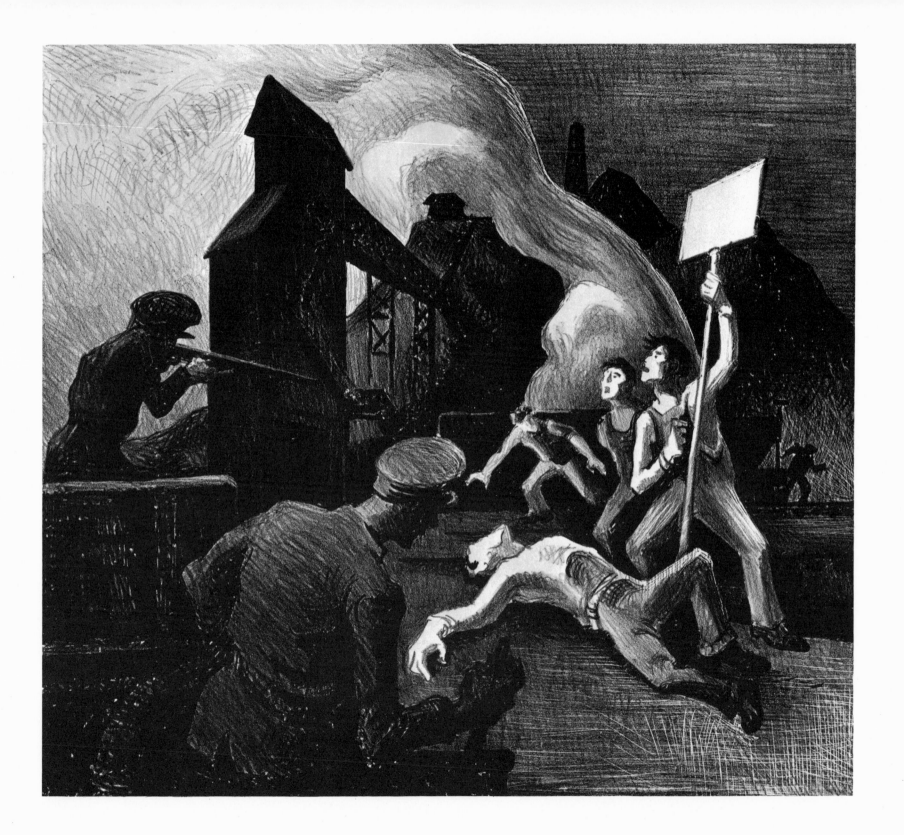

GOING WEST

also titled *Express Train*

22½ x 11½
1934
Edition of 75
Circulated by Ferargil Galleries, New York City.

This lithograph was included in the Municipal Art Exhibition at Rockefeller Center, New York City, in March 1934. It also appeared in the American Print Makers Exhibition in New York City in December 1934.

My first pictures were of railroad trains. Engines were the most impressive things that came into my childhood. To go down to the depot and see them come in, belching black smoke, with their big headlights shining and their bells ringing and their pistons clanking, gave me a feeling of stupendous drama, which I have not lost to this day. I scrawled crude representations of them over everything (Thomas Hart Benton, *An Artist In America*).

Imaginative conception of a fast moving train. Steam powered rail road trains were fascinating all my life. The Diesels have never had the same interest for me

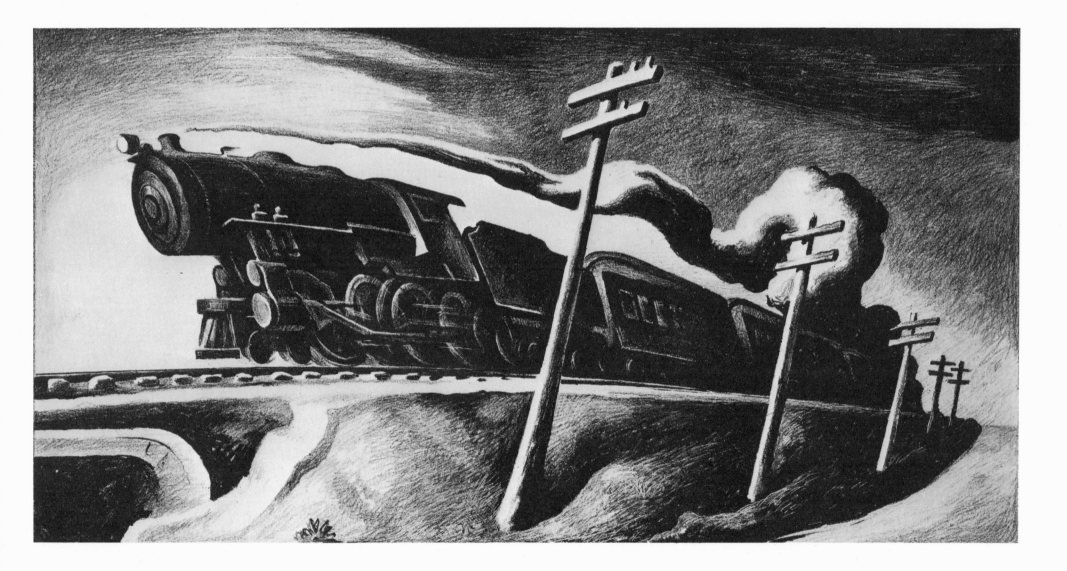

MINSTREL SHOW

11⅝ x 8¹⁵⁄₁₆
1934
Edition of 100
Circulated by Ferargil Galleries, New York City.

This lithograph was included in the "Fifty Modern Prints Exhibition" of outstanding prints done in 1934 held at the Weyhe Gallery in New York City in February 1935.

A painting *Minstrel Show* was completed after the lithograph in 1934. The painting is in the collection of the artist.

Date of drawing 1934. West Virginia Mts.
Description of theme in "Artist in America" — chapter on
"the Mountains"

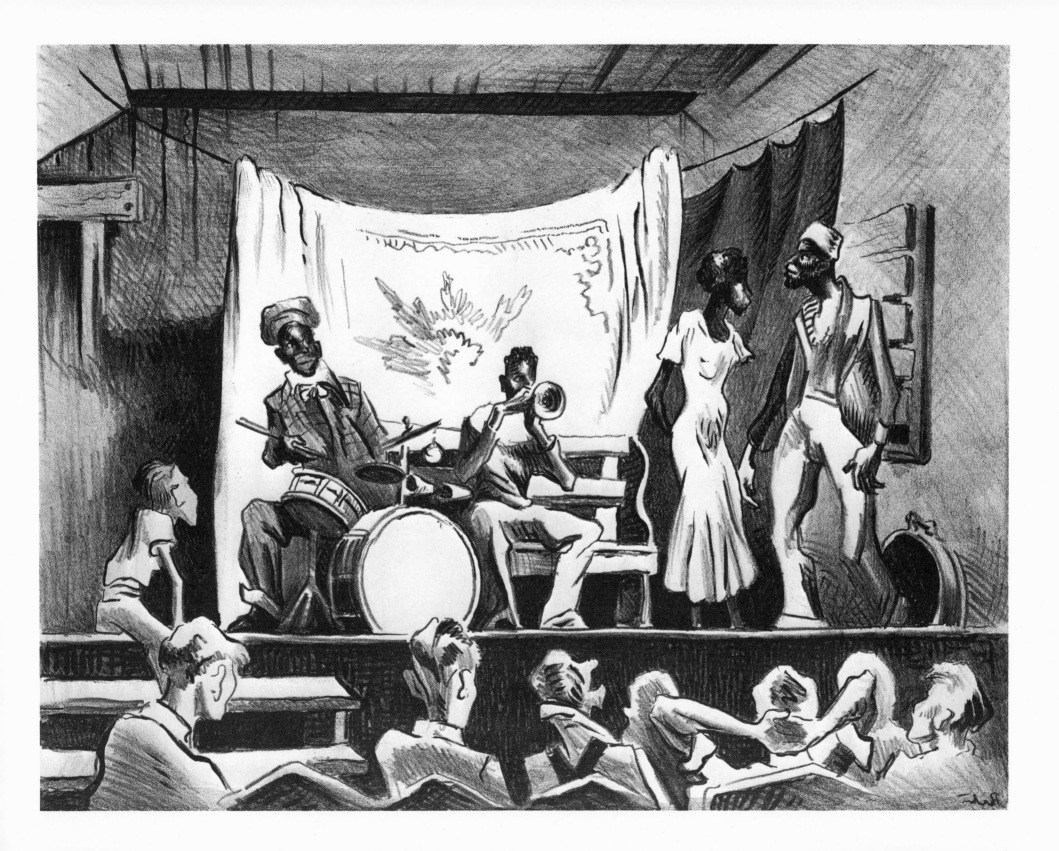

PLOWING IT UNDER

also titled *Ploughing*

13⅜ x 8
1934
Edition of 250

First lithograph by Benton to be circulated by Associated American Artists, New York City, under the title *Ploughing*.

A painting *Plowing It Under* was also done in 1934. The painting is in the collection of the artist.

The mule is **a** damned dramatic animal. (Thomas Hart Benton)

One of the cornerstones of Franklin D. Roosevelt's New Deal in 1933 was the Agricultural Adjustment Administration, popularly called the "Triple A." The legislation endeavored to increase farmers' incomes by reducing acreages and output of farm commodities and, by so limiting supply, to raise prices. By the time the Act of Congress passed and was signed by F.D.R. on May 12, 1933, spring crops had already been planted, and in order to accomplish anything that year 10.4 million acres of cotton were plowed under. Later in 1933 the AAA bought 6.2 million pigs and 220,000 sows, which were processed for food fertilizer. These were the only phases of the AAA program which resulted in destruction of farm products. However, the groans of the cotton bolls and the squeals of the little pigs "plowed under" were used by the Chicago *Tribune* and Hearst press in a campaign of derision against Secretary of Agriculture Henry Wallace and Under-Secretary Rexford Guy Tugwell which lasted for years and made "Triple A" and "plowed under" part of the political vocabulary of the time.

Drawing made in South Carolina in 1934 — showing Tugwells' program in operation.

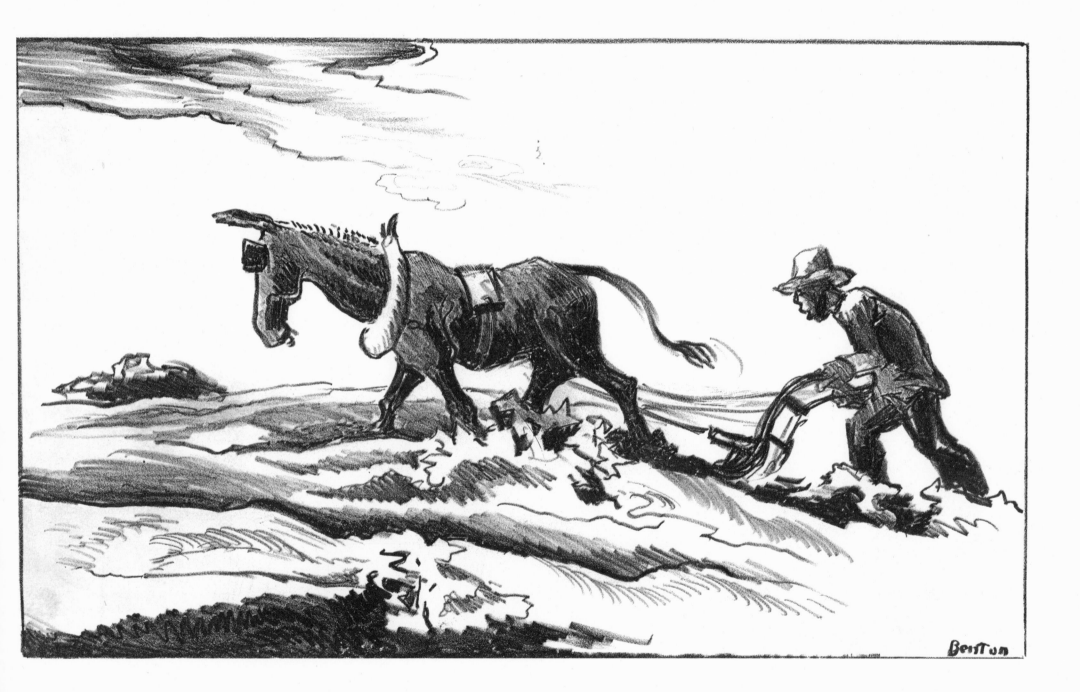

WAITING FOR THE REVOLUTION

7⁹⁄₁₆ x 4
1934
Edition of 10

Tenant farmer sitting on the hood of an old car
out in the middle of nowhere

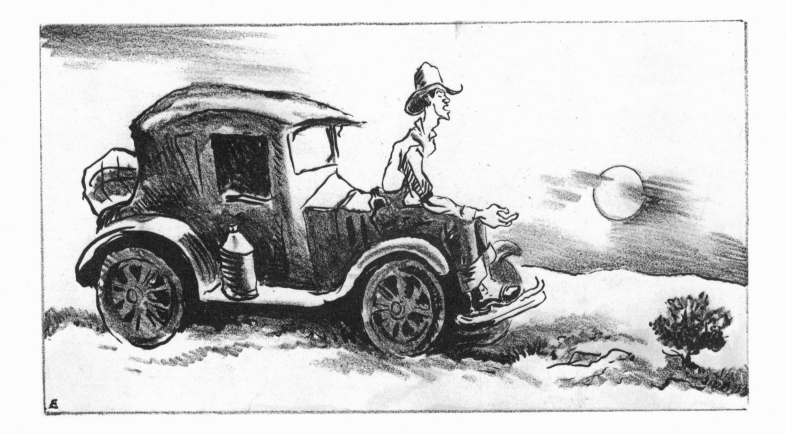

The Missouri State Capitol Mural series

MISSOURI FARMYARD

also titled *Kansas Farmyard*

16 x 10⅛
1936
Edition of 250
Circulated by Associated American Artists, New York City.

 Two hundred and forty-seven new prints by ninety-seven American artists have been submitted for review in this issue. . . . I consider "Kansas Farmyard" the most distinguished print that has been submitted for review in this issue. It is a compact design, unified by meaningful rhythms. Each passage is imaginatively handled so that it is an organic part of the complete conception. Its force and vitality are such that the error in the published title of this Ozark scene seems negligible. Though appreciation of the design is not dependent upon familiarity with the locality from which it was derived, this lithograph is definitely an interpretation of a specific phase of life in the United States (Aline Kistler, "Prints of the Moment," *Prints* [October, 1936]).

Drawn from a section of Missouri Mural. at State Capitol in Jefferson City, MO. Shows a sorghum mill in middle ground - mule powered

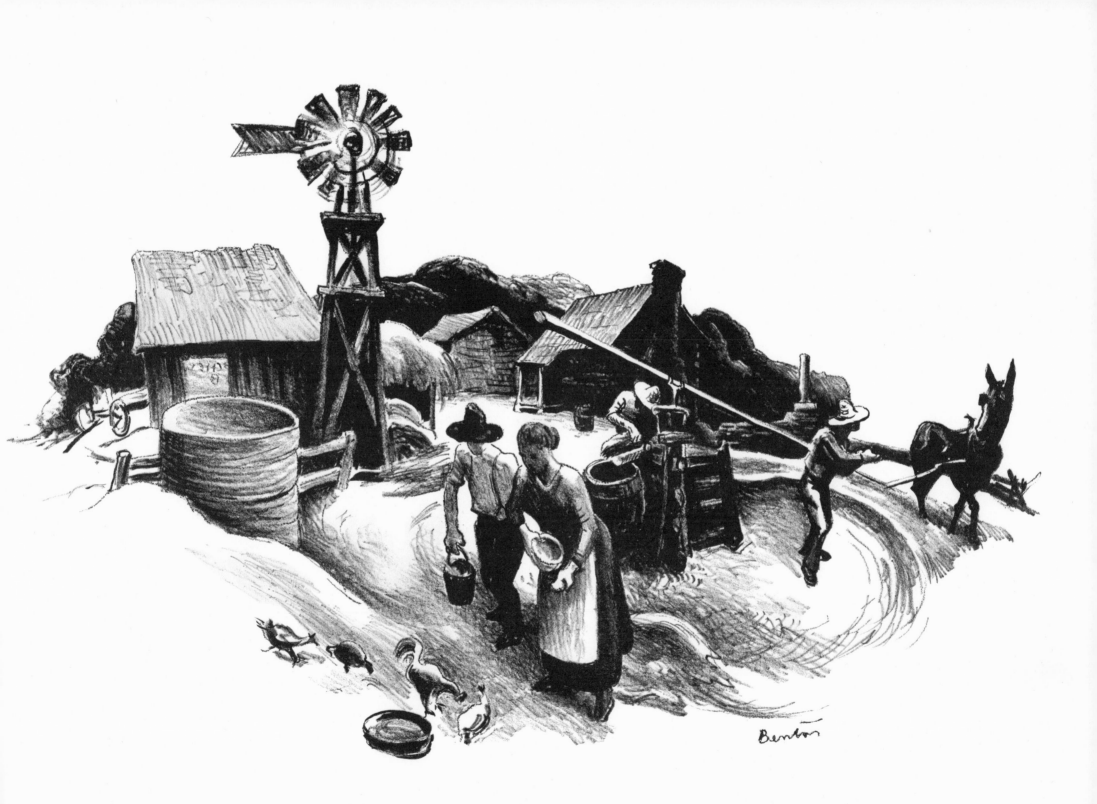

The Missouri State Capitol Mural series

FRANKIE AND JOHNNIE

22⅛ x 16⅜
1936
Edition of 100
Circulated by Associated American Artists, New York City.

Frankie and Johnnie

Frankie and Johnnie were lovers,
Oh, Lordy, how they did love.
Swore to be true to each other,
Just as true as the stars above.
 He was her man,
 But he done her wrong.

Frankie went down to the bar-room,
To get a bucket of beer.
She said, "Oh, Mr. Bartender,
Has my loving man Johnnie been here?"
 He is my man,
Wouldn't do me no wrong.

"Don't want to cause you no trouble,
Don't want to tell you no lies;
Saw your man half an hour ago
Making Love to Nellie Bly.
 He's your man,
 But he's doing you wrong."

Frankie went down to the hock-shop,
She bought herself a little forty-four.
She aimed it at the ceiling,
Shot a big hole in the floor.
 He was her man,
 But he done her wrong.

Frankie went back to the bar-room,
As she rang the bar-room bell,
She said, "Clear out all you people,
I'm gonna blow this man to hell.
 He was my man,
 But he done me wrong."

Johnnie he grabbed off his Stetson,
"Oh-my-God, Frankie, don't shoot."
But Frankie put her finger on the trigger,
And her gun went root-a-toot-toot.
 She shot her man,
 'Cause he done her wrong.

First time she shot him he staggered,
Second time she shot him he fell,
Third time she shot him, Oh, Lordy,
There was a new man's face in hell.
 She shot her man,
 'Cause he done her wrong.

This story has no moral,
This story has no end,
This story only goes to show
That there ain't no good in men.
 He was her man,
 But he done her wrong.

From Section of Missouri Mural at MO. State Capitol Jefferson City, MO. The incident according to legend happened in St. Louis though the Tune in various forms is earlier than the 1890 St. Louis story. Anyhow the story is a part of Missouri mythology like the Jesse James and Huck Finn stories.

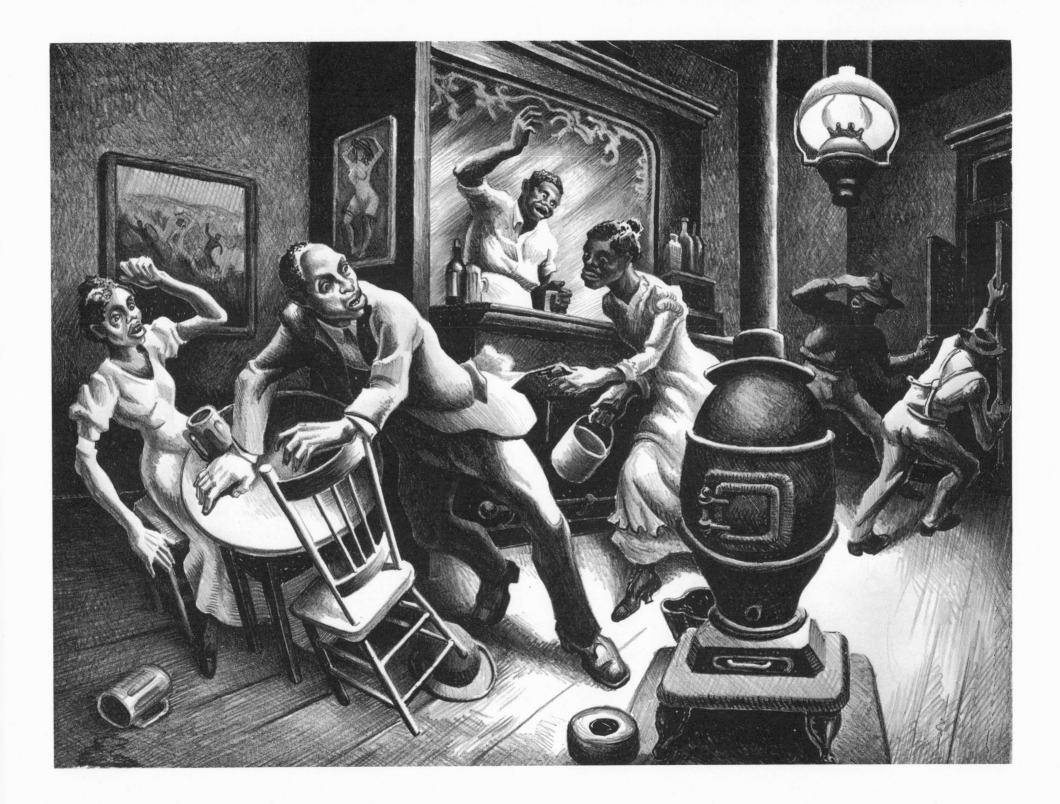

The Missouri State Capitol Mural series

HUCK FINN

21⅝ x 16¼
1936
Edition of 100
Circulated by Associated American Artists, New York City.

These large lithographs, in which Benton has repeated the substance of three of his mural panels at the Missouri State Capitol, are full-throated versions of the Frankie and Johnny, Jesse James and Huck Finn legends, stories as deeply imbedded in American association as were the saint and secular tales repeated time and again by the early European printmakers. Therefore, to anyone who is a product of America, these great lithographs do essentially what the works of Robetta, Schongauer and Beham did three and four centuries ago. They retell in pictures what has almost too often been repeated in song and story. These are not illustrations, but substitutes for the texts themselves, and to them goes the full measure of response that must ever go to such restatements in graphic form. Should others repeat the same themes, finer conceptions might in time be found, cleverer treatments, more accomplished welding of the story elements; but Benton's prints will remain the first modern pictured versions and, as such, they will establish a basis for future comparisons. They are not perfect but their imperfections may be virtues. Benton's exaggerations, confused compositions and forced contrasts may bring intellectual criticism but these very over-statements are so in keeping with the themes, that, although we might get what some would consider "perfect prints" without them, such could not be the vital pictures that these are (Aline Kistler, "Prints of the Moment," *Prints* [April, 1937]).

There is something about flowing water that makes for easy views. Down the river is freedom from consequence. All one has to do is jump in a skiff at night and by the morrow be beyond the reach of trouble. In the past this was a sure method of ridding one-self of difficulty, and fellows who had been too handy with the knife or gun or who found their children too many or their wives too troublesome could float off into a new world and begin again.

It is not only for those of reckless or antisocial proclivities, however, that the river waters are suggestive of release. Their currents sing of feedom to everyone. The thought of floating effortlessly away on running water has an irresistible charm whether or not there is any real purpose or end set to it. In *Hucklebery Finn*, Mark Twain has caught the spirit of this, and back of the adventures of Huck and Jim and those with whom they meet there is always the moving river and the promises and hopes that lie around its unfolding bends (Thomas Hart Benton, *An Artist in America*).

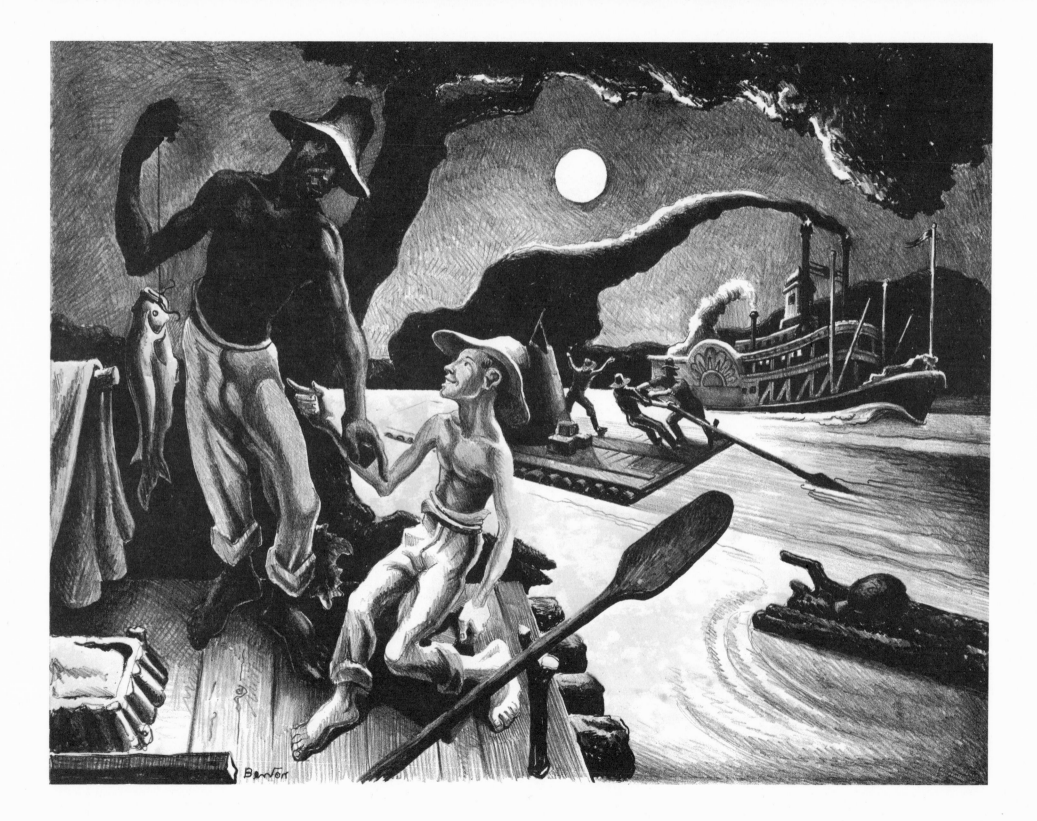

JESSE JAMES

22⅛ x 16⅜
1936
Edition of 100
Circulated by Associated American Artists, New York City.

Jesse James

Jesse James was a man who traveled through the land,
 Stealing and robbing was his trade;
But that dirty little coward that shot Mr. Howard
 Has laid poor Jesse in his grave.

Jesse said to his brother Frank, "Will you stand by my side
 Till the Danville train passes by?"
"Yes, I'll stand by your side and fight one hundred men till I die
 And the Danville train has rolled by."

Jesse and his brother Frank robbed the Chicago bank,
 They held up the Danville train.
He robbed from the rich and he gave to the poor,
 He'd a hand and a heart and a brain.

It was Robert Ford, that dirty little coward,
 He shot poor Jesse on the sly;
He ate of Jesse's bread and he slept in Jesse's bed,
 Then laid poor Jesse in his grave.

Poor Jesse had a wife to mourn for his life,
 Three children, they were brave;
But that dirty little coward that shot Mr. Howard
 Has laid poor Jesse in his grave.

Also from Mo. State Capitol Mural.
The foreground figure was posed by Dan James an
actual descendant of the James clan.

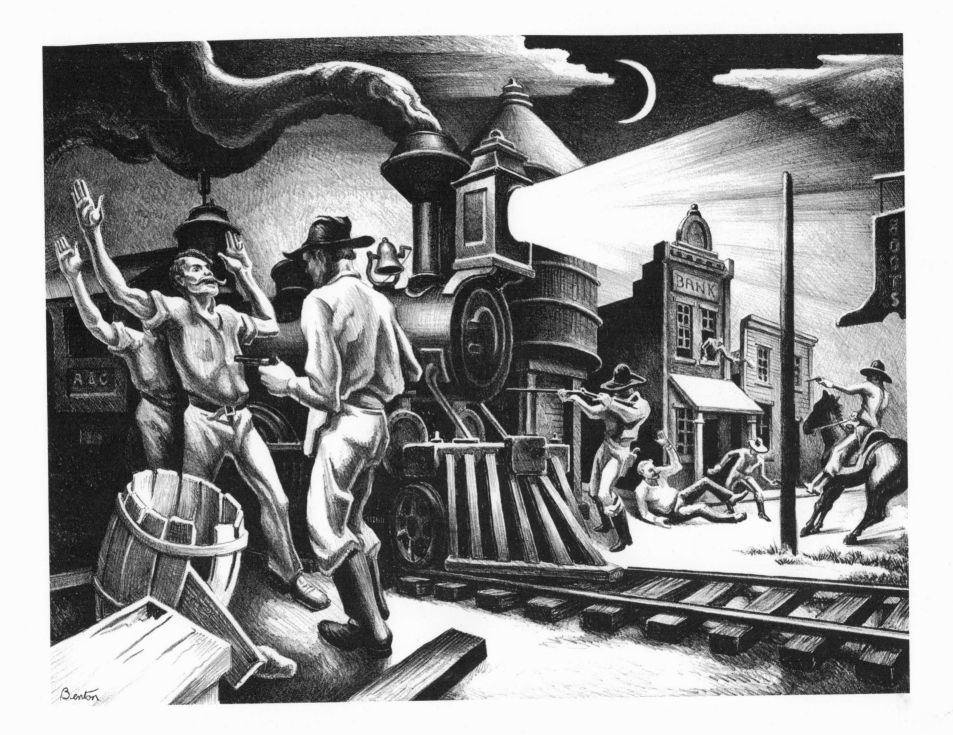

GOIN' HOME

12 x 9⅜
1937
Edition of 250
Circulated by Associated American Artists, New York City.

This lithograph was honored by the Jury of the "Fall 1937 Prints Survey" as one of the outstanding prints of the year.

 A painting *Goin' Home* was done in 1929. It is in a private collection in New York City.

From a drawing made — 1928 — in North Carolina. Smokey Mountain country. With a companion driving the car I followed these mill people 'till the drawing was finished.

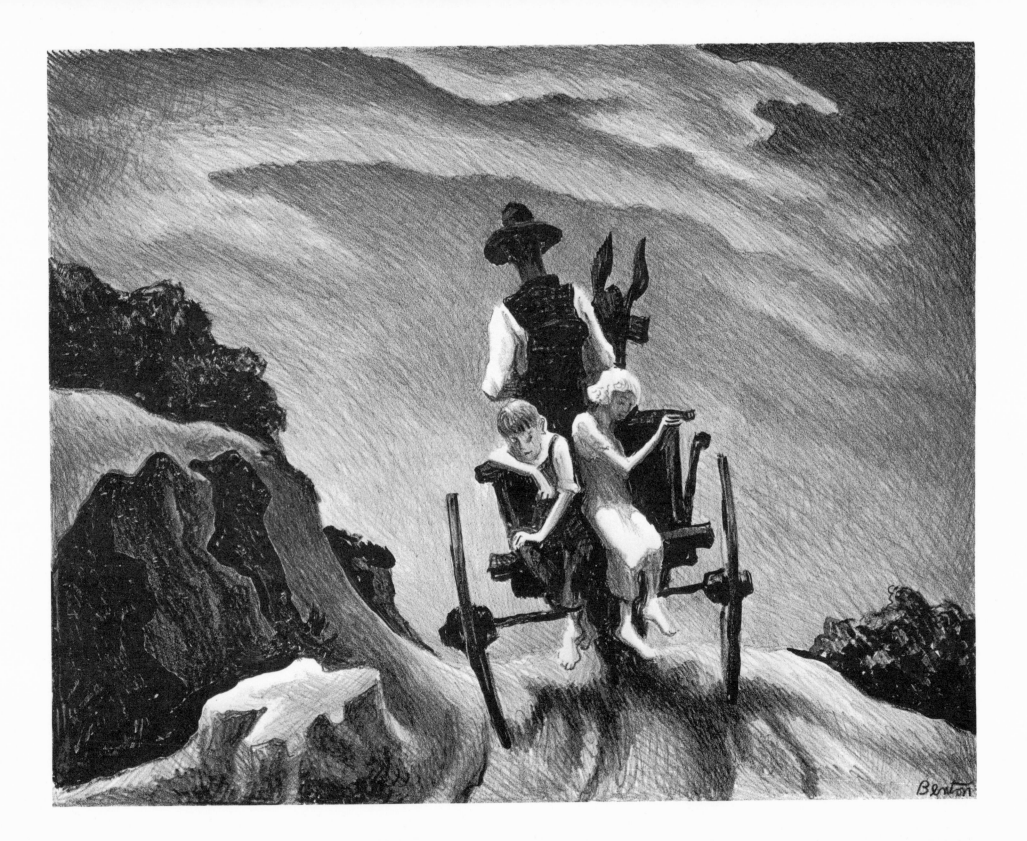

A DRINK OF WATER

14¼ x 10
1937
Edition of 250
Circulated by Associated American Artists, New York City.

A painting *A Drink of Water* was completed after the lithograph
in 1937. The painting is in the collection of the artist.

Ozark hill scene, made from a drawing. The house
is abandoned but the well is still usable.

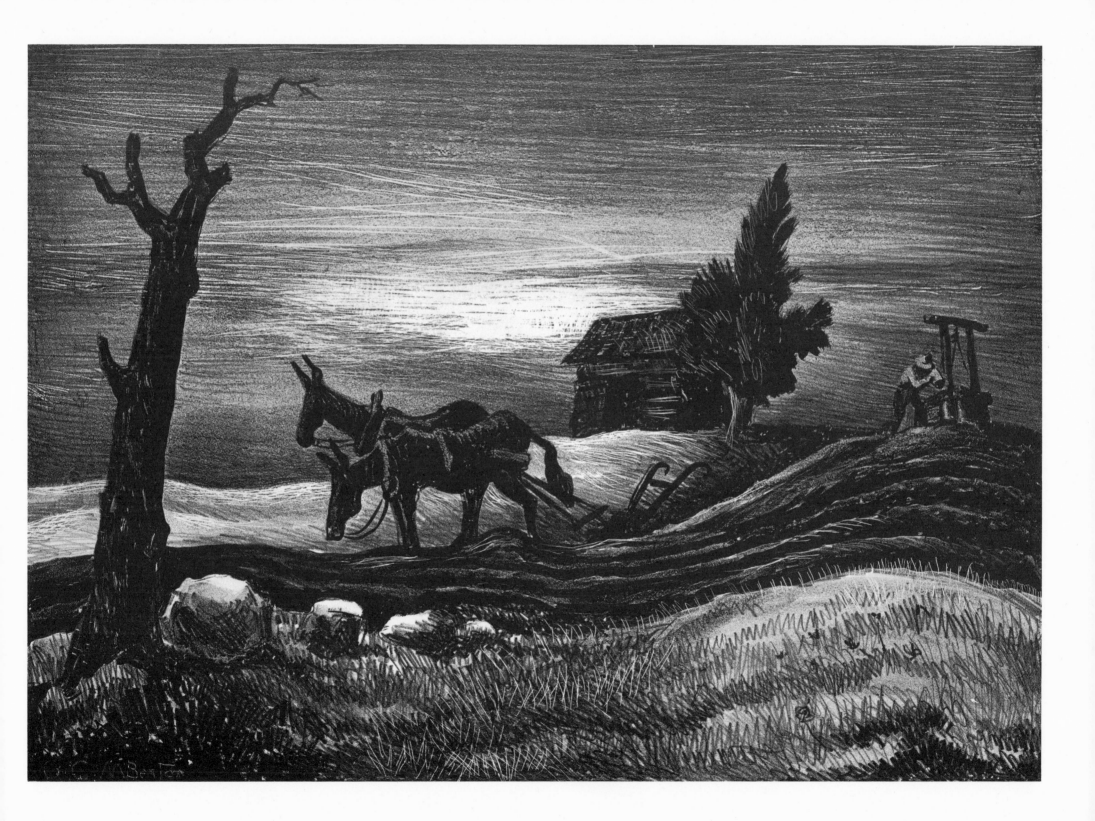

FLOOD

12¼ x 9¼
1937
Edition of 196
Circulated by Associated American Artists, New York City.

Ohio-Mississippi floods of 1937.
Made in the bootheel of Missouri.
The '37 flood brought under water great sections of
the lowlands of S.E. Missouri. Many farms and
farm houses were under water. The two women are
looking over their own home as the muddy water
rushes by.

A series of drawings were made
of conditions there for the Kansas City STar and the St.
Louis Post Dispatch. The lithograph is from one of the
drawings.

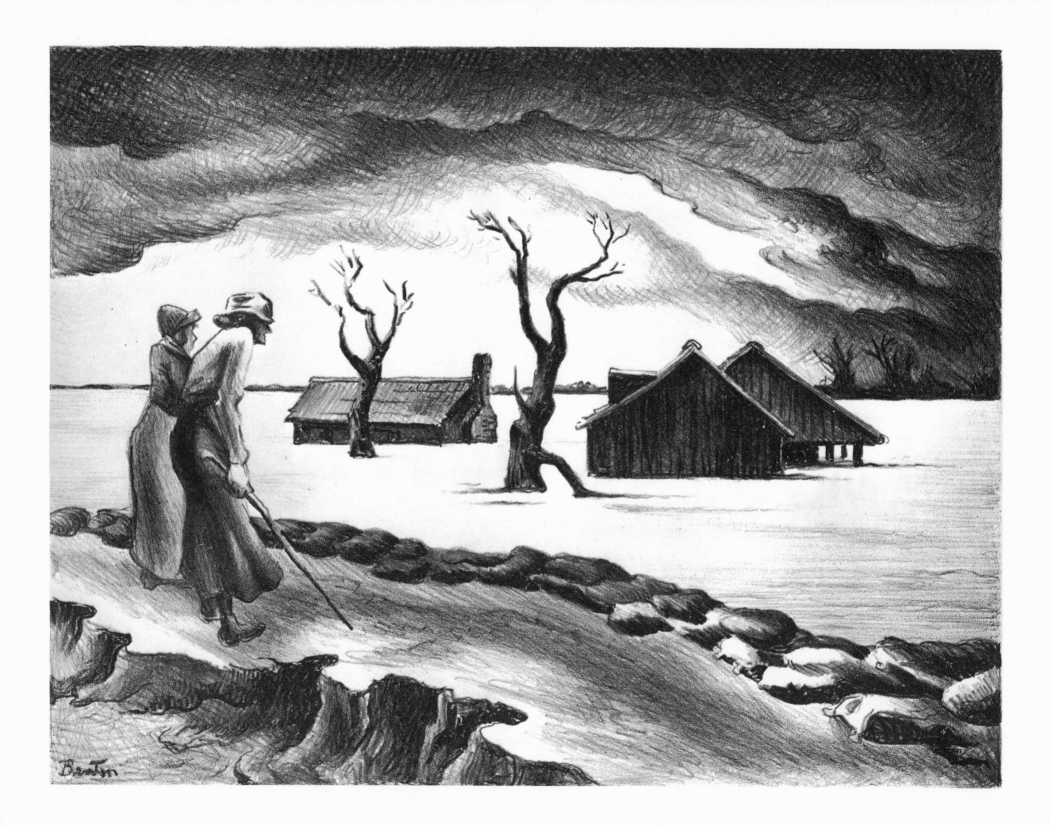

INVESTIGATION

12⅝ x 9⅜
1937
Edition of 193
Circulated by Associated American Artists, New York City.

Drawings of the flood of '37 – Ohio & Mississippi
were commissioned by Kansas City Star and St. Louis
Post Dispatch. The area – south east Missouri, sometimes
called swamp east, and the Boothheel.

This lithograph, originally called "Investigation" was
made from one of the '37 flood drawings.

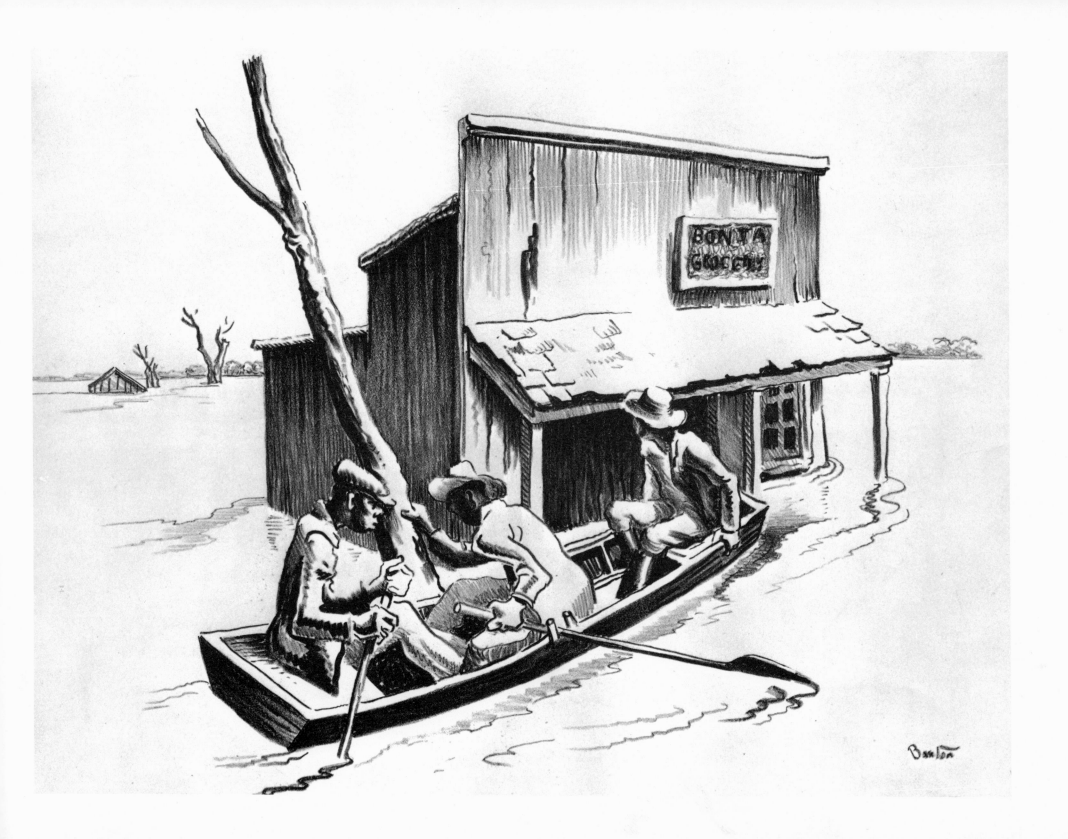

LONESOME ROAD

12½ x 9¾
1938
Edition of 250
Circulated by Associated American Artists, New York City.

A painting *Lonesome Road* was done in 1927. The painting is in
The University of Nebraska Art Galleries, University of Nebraska,
Lincoln, Nebraska.

Drawing made in Arkansas in 1926. I had
come up river, on a tow boat from New Orleans to Helena, Arkansas
where I took a train to little Rock. The train stopped
over a road crossing and out of the window I
saw this negro with his donkey cart on the hot
dusty road. I made the drawing from the train
window,

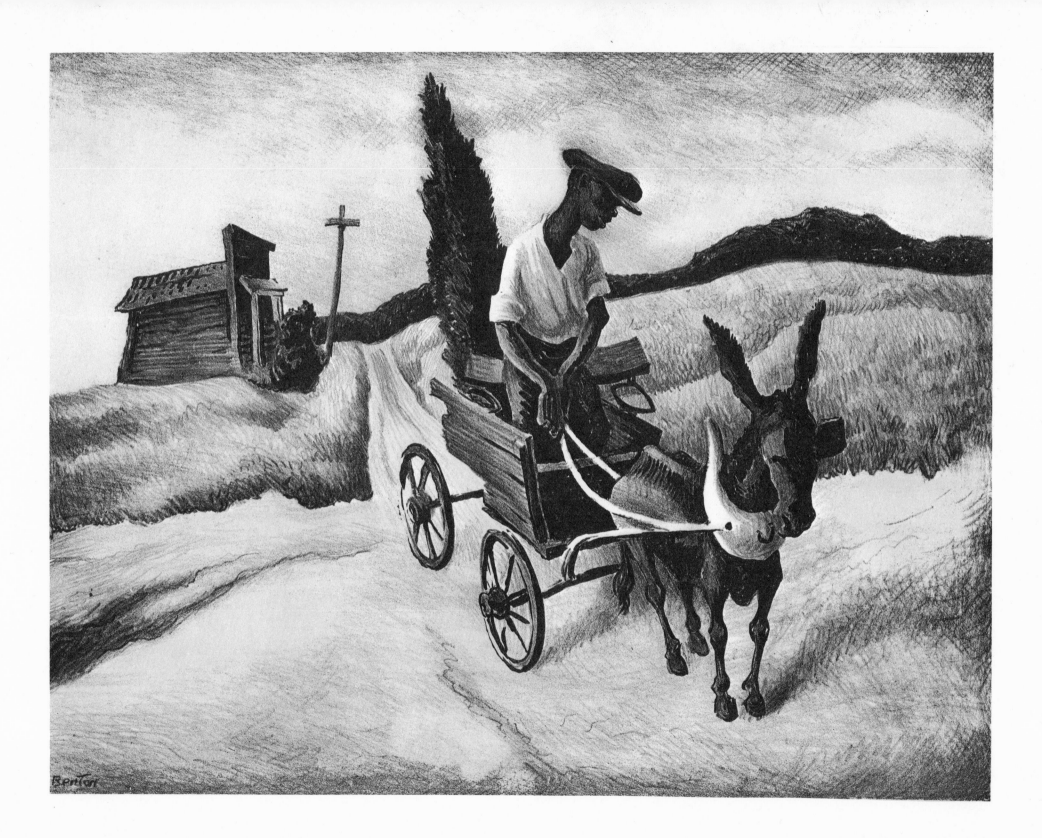

I GOT A GAL ON SOURWOOD MOUNTAIN

9⅛ x 12½
1938
Edition of 250
Circulated by Associated American Artists, New York City.

Sourwood Mountain

I got a gal on Sourwood Mountain,
 Hi-diddy-O-diddy-diddy-I day.
She won't come and I won't call her,
 Hi-diddy-O-diddy-diddy-I day.

Chickens a-crowding on Sourwood Mountain,
 Hi-diddy-O-diddy-diddy-I day.
So many pretty girls, that I cain't count 'em,
 Hi-diddy-O-diddy-diddy-I day.

My true love is a blue-eyed daisy,
 Hi-diddy-O-diddy-diddy-I day.
If I don't get her, I'll go crazy,
 Hi-diddy-O-diddy-diddy-I day.

Old man, old man, I want your daughter,
 Hi-diddy-O-diddy-diddy-I day.
To bake my bread and carry my water,
 Hi-diddy-O-diddy-diddy-I day.

I have always looked for musicians when in the hill country. I like their plaintive, slightly nasal voices and their way of short bowing the violin. I like the modal tunes of the old people and the odd interludes, improvisations, often in a different key, which they set between a dance tune and its repetition. I've played with, and for, the hill folks on a harmonica and have picked up unwritten tunes and odd variants of those which have found their way into music books. I've heard *Old John Hardy, Chuck Ole Hen, Shortenin' Bread, Shoot Ole Danny Dugger, Old Smoky, Wild Bill Jones, Pretty Polly, Sourwood Mountain,* and a large number of ballads played and sung in many different ways, modes, and times and I have come to the conclusion that there is no right way for the rendering of any of them (Thomas Hart Benton, *An Artist in America*).

From a tempera painting made in 1937—now owned by Hyimen Cohen, lawyer of N.Y. City. A color reproduction was made of this picture in England sometime in the middle '30s for the International Studio. a magazine then published in London.

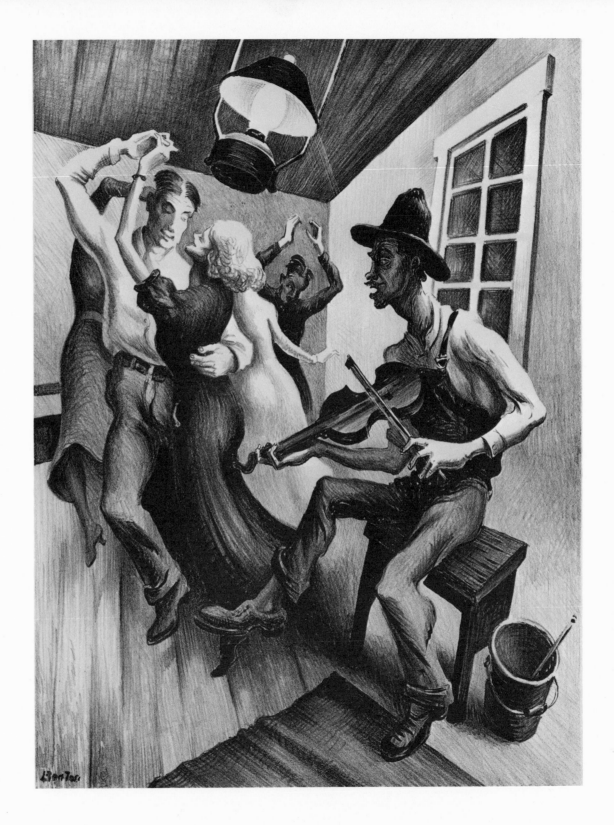

HOMESTEAD

also titled *In the Ozarks*

13⅛ x 9
1938
Edition of 250
Circulated by Associated American Artists, New York City.

This lithograph appeared in the exhibition "Fifty American Prints," 1938, American Institute of Graphic Art. It is after a painting *Nebraska Farm* which was made in 1934. The painting is in The Museum of Modern Art, New York, N.Y.

Drawing made in 1939 of a west Nebraska farm yard.

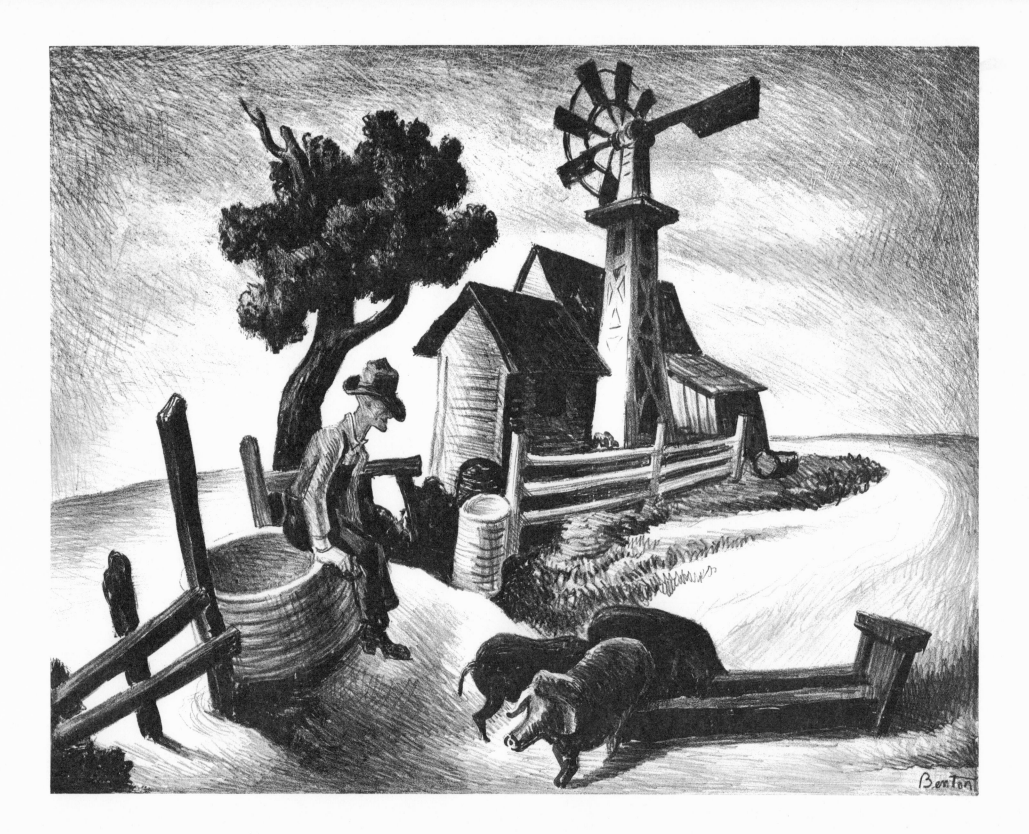

HAYSTACK

12⅞ x 10⅜
1938
Edition of 250
Circulated by Associated American Artists, New York City.

The lithograph is after a painting *Haystack* that was made earlier
in 1938. Present location unknown.

Date of drawing 1928. Building a hay stack on
a North Carolina hill farm. There is a painting of
this subject. Owner unknown to me.

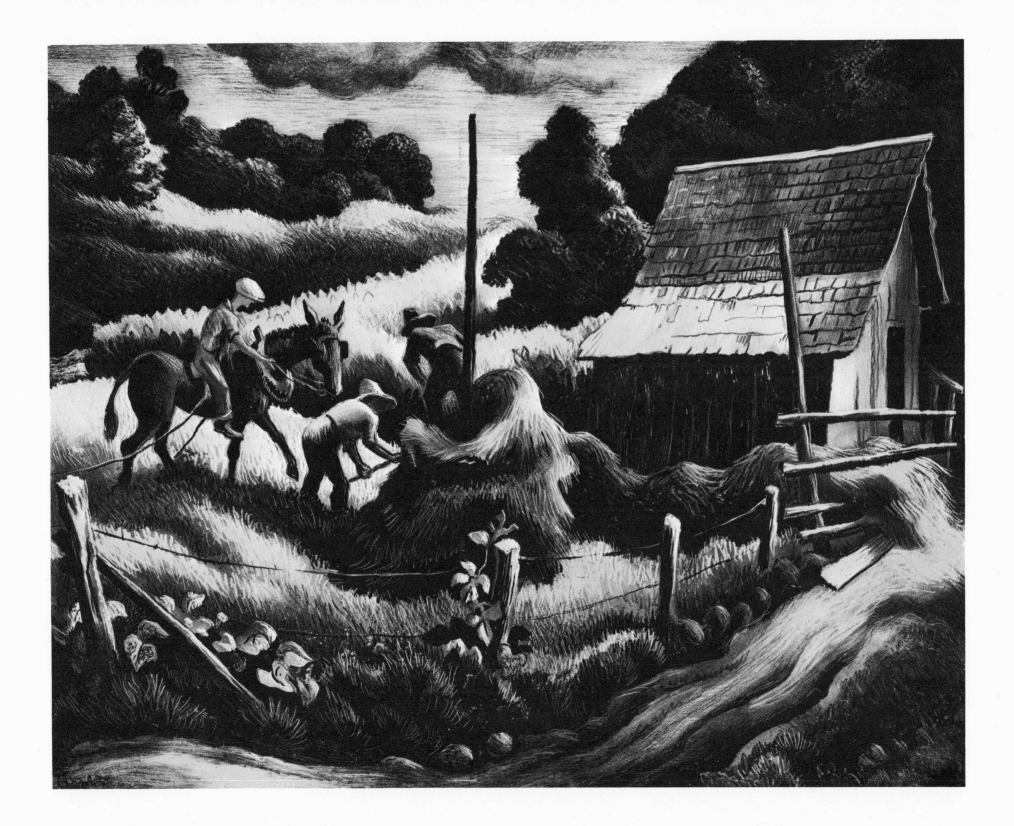

EDGE OF TOWN

10¾ x 9
1938
Edition of 250
Circulated by Associated American Artists, New York City.

Drawing made of the outskirts of a small town
on the banks of the Missouri River northwest of
Kansas City

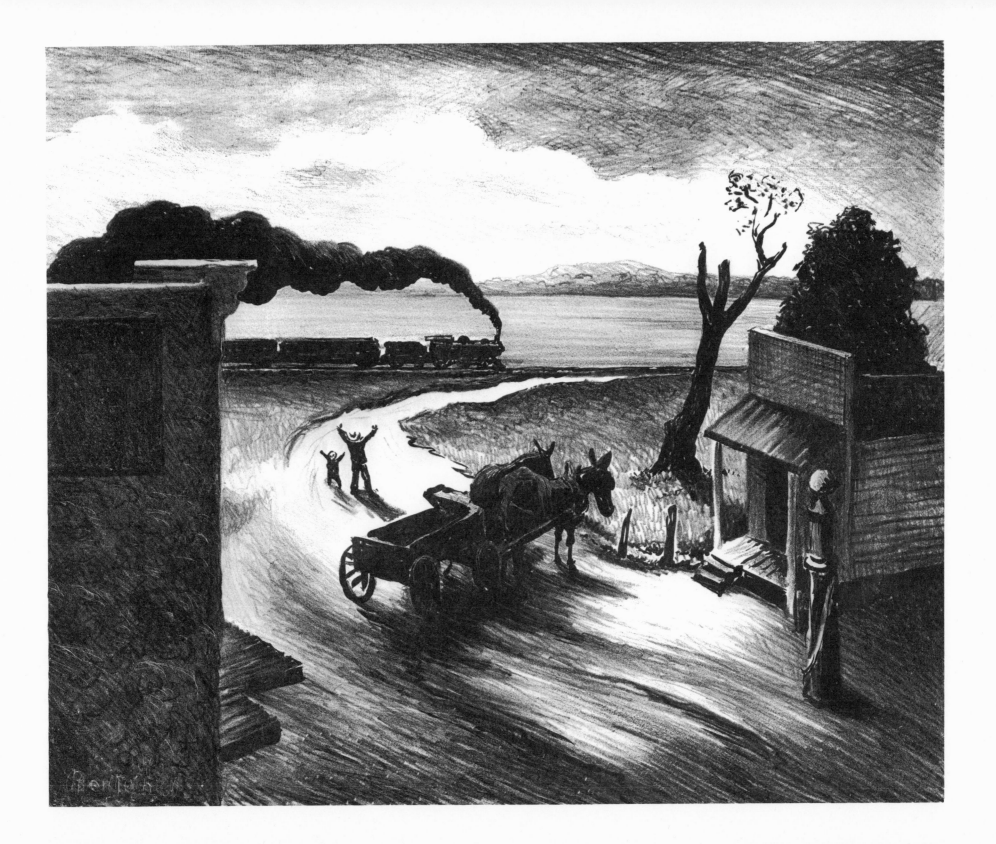

RAINY DAY

13⅜ x 8¾
1938
Edition of 250
Circulated by Associated American Artists, New York City.

The lithograph is after a painting *Rainy Day* which was made first
in 1938. The painting is in the collection of Mrs. John P. Marquand,
Cambridge, Massachusetts.

Drawing, painting and litho of this Missouri
farm yard made one after the other. Do not
know location of painting things I still own
original drawing

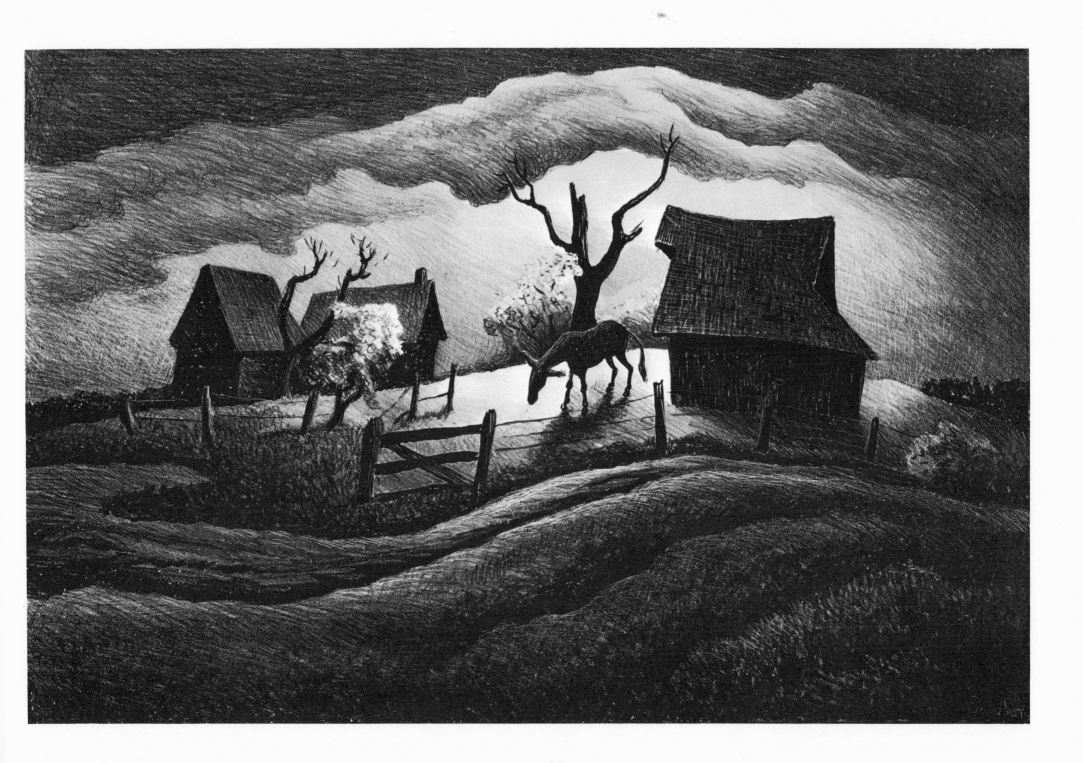

THE POET

12⅜ x 8⅞
1938
Edition of 75
Circulated by the artist.

One of a series of 40 drawings of the movie industry made in the summer of '37 for Life magazine. This is a picture of a script writer in his cubbyhole. He was also a poet of some kind. I've forgotten his name.

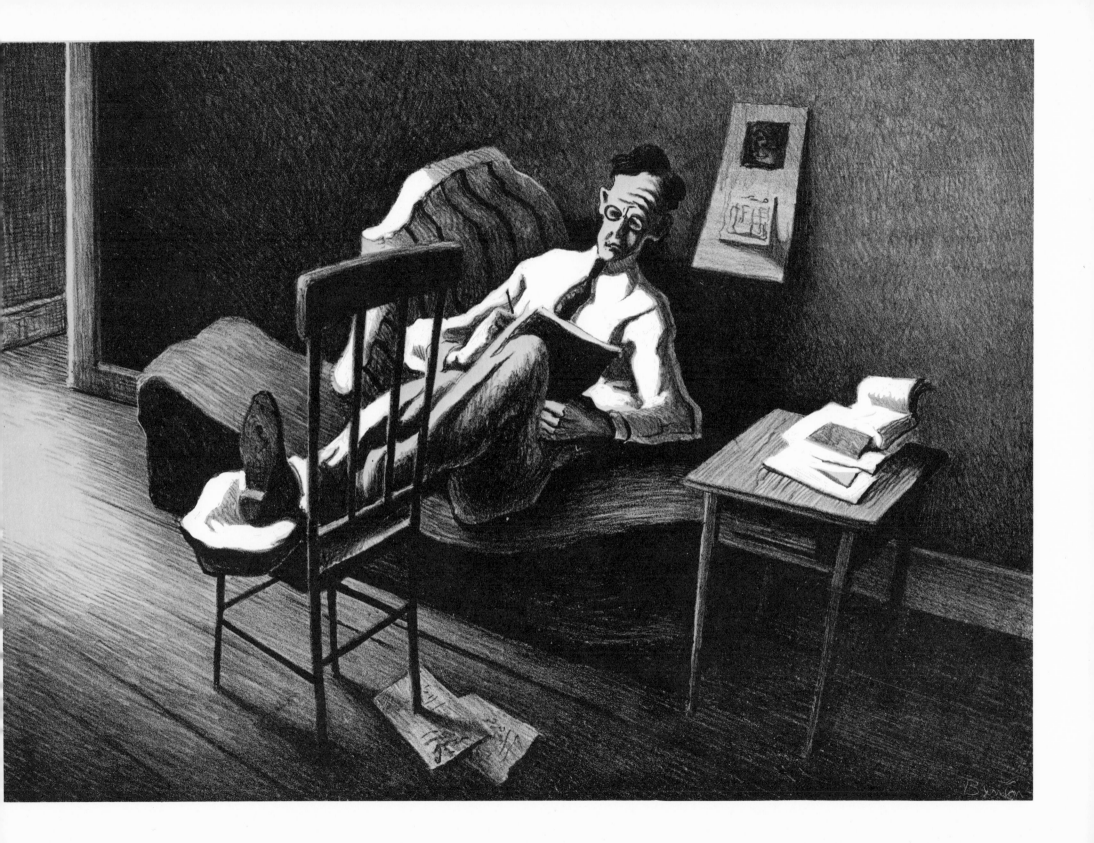

APPROACHING STORM

also titled *Noon*

12⅞ x 9¾
1938
Edition of 200

This lithograph was commissioned by The Print Club of Cleveland (Ohio) as the eighteenth annual presentation print to Print Club members. Of the edition of 200, ten impressions were retained by the artist and the remaining 190 impressions were distributed to the members of the Print Club in 1940.

The lithographic plate (zinc) was made by Benton in November 1938. It was selected by the Print Club in December, and the edition was printed by George C. Miller in New York in April 1939. The edition was given to members of the Print Club in February 1940.

In correspondence with the Print Club, Mr. Benton referred to the plate as *The Storm,* then in correspondence in January 1940 settled on the final title. In a letter of May 8, 1939, he wrote the following about the subject: "The only thing I have relating to your litho is the first sketch of the motif. There was a small black and white oil painting of the subject and also a full size painting which was purchased from the Associated American Artists last month. Your litho differs from the painting in that a dark sky was substituted for the light sky where there was not enough difference in value between tree and sky for an effective lithographic rendering."

The canceled zinc plate of this lithograph is now in the collection of the Department of Prints and Drawings of The Cleveland Museum of Art, Cleveland, Ohio.

Hill plowing in North Carolina. Drawing and a painting of subject done in 1938. Painting was sold by A.A.A. in 1939. Litho is much like painting. Do not know present location of painting

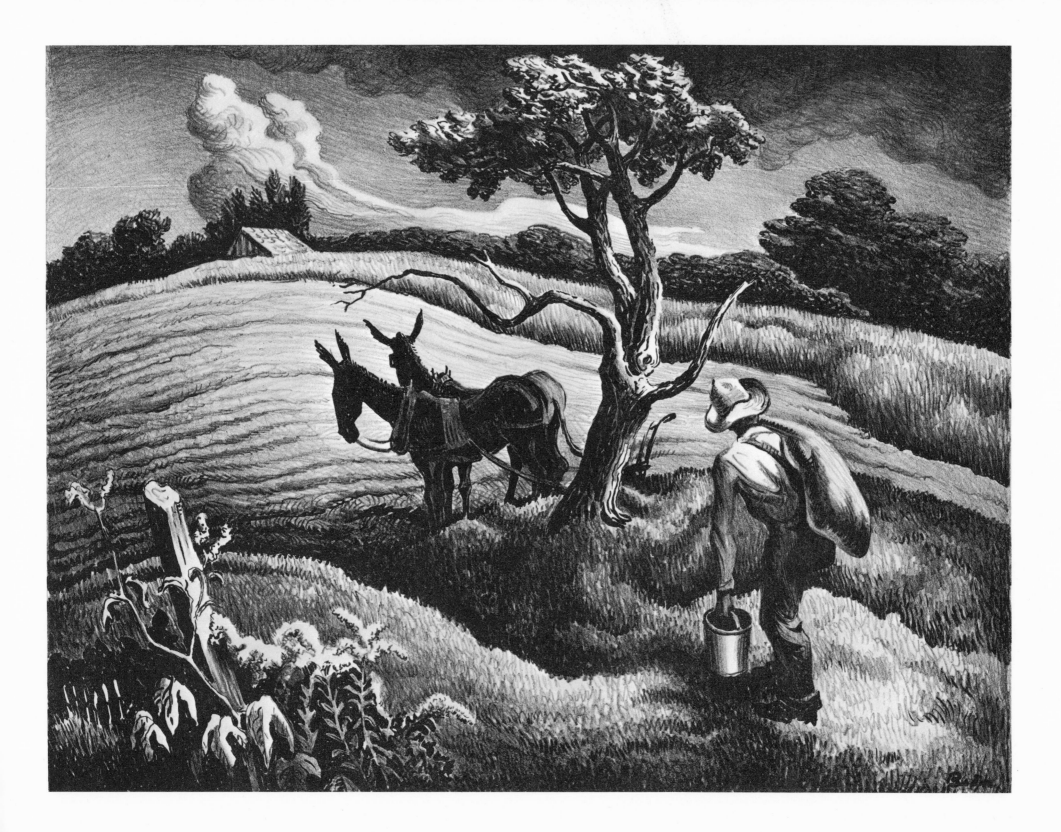

SUNDAY MORNING

12⅜ x 9⅝
1939
Edition of 250
Circulated by Associated American Artists, New York City.

From a drawing made in south Arkansas in 1938. Characteristic negro church of the time.

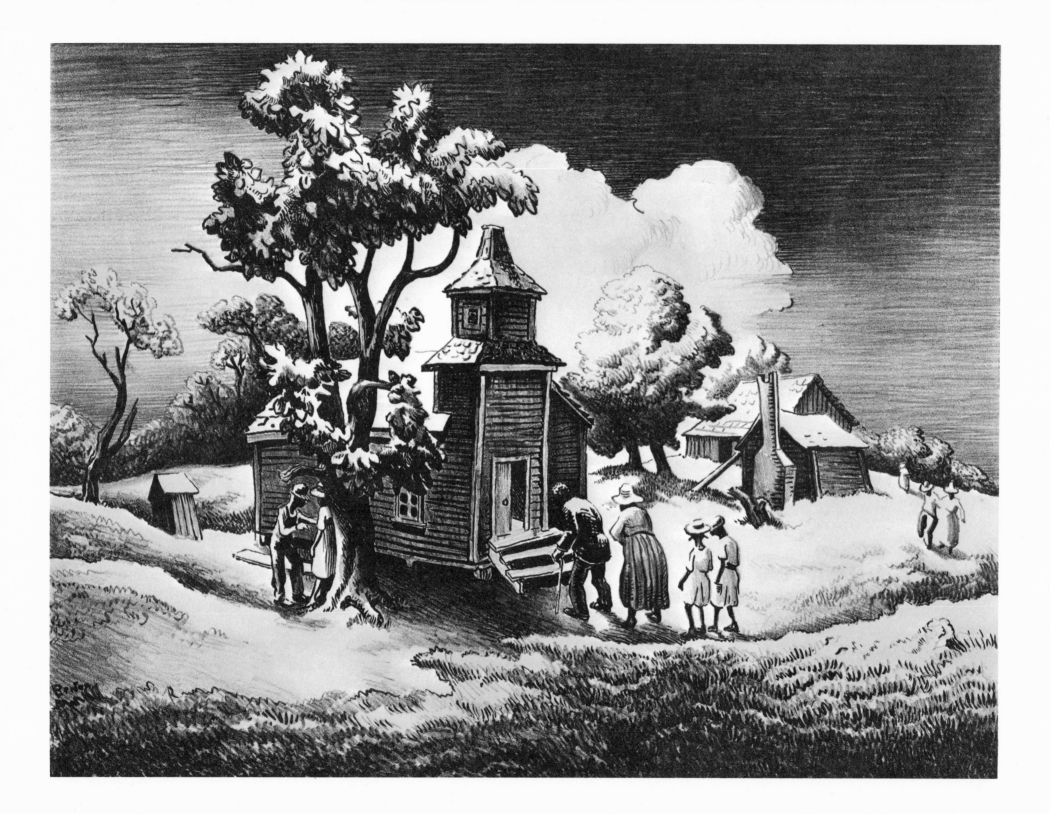

CRADLING WHEAT

12 x 9¾
1939
Edition of 250
Circulated by Associated American Artists, New York City.

The lithograph is after a painting *Cradling Wheat* which was made in 1938. The painting is in the City Art Museum of St. Louis, St. Louis, Missouri.

Scene in the hill country of East Tennessee in 1928. A painting of this 30" x 40" is owned by the St Louis Museum.

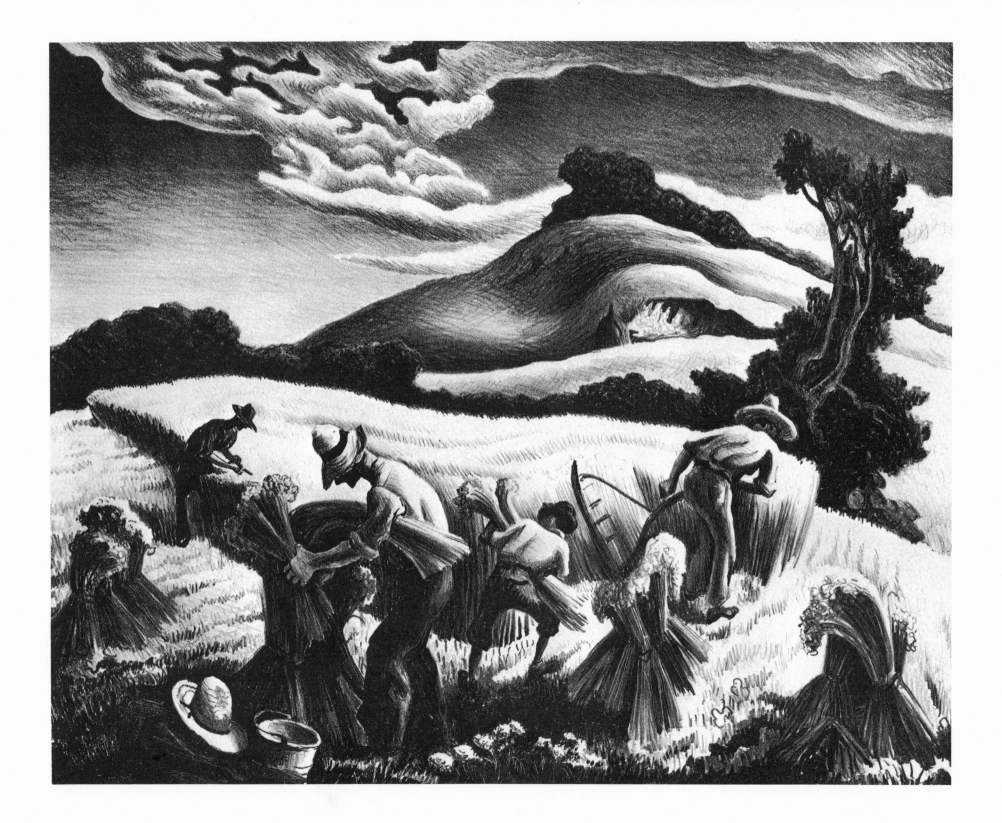

PLANTING

also titled *Spring Plowing*

12½ x 10
1939
Edition of 250
Circulated by Associated American Artists, New York City.

The lithograph is after a painting *Planting* which was also made in
1939. The location of the painting is not known.

From a drawing made in southern Arkansas
in 1938. The man plows, the woman sows.
Common enough scene up to very lately —
maybe it is still to be found. Old ways
don't die easily.

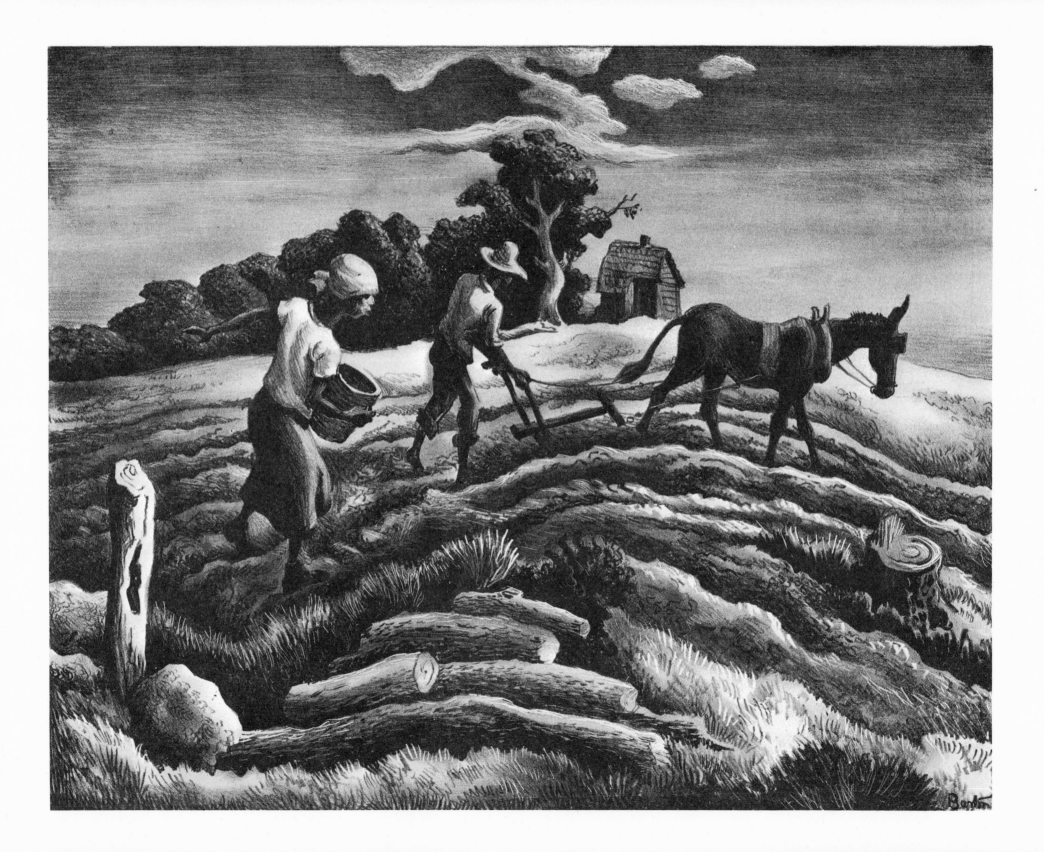

PRODIGAL SON

13¼ x 10
1939
Edition of 250
Circulated by Associated American Artists, New York City.

The lithograph was a study for a painting made in 1940. The painting *Prodigal Son* is in the Dallas Museum of Fine Arts, Dallas, Texas.

Study for a painting – owned by Dallas Museum.
Picture of the belated return of the "son".

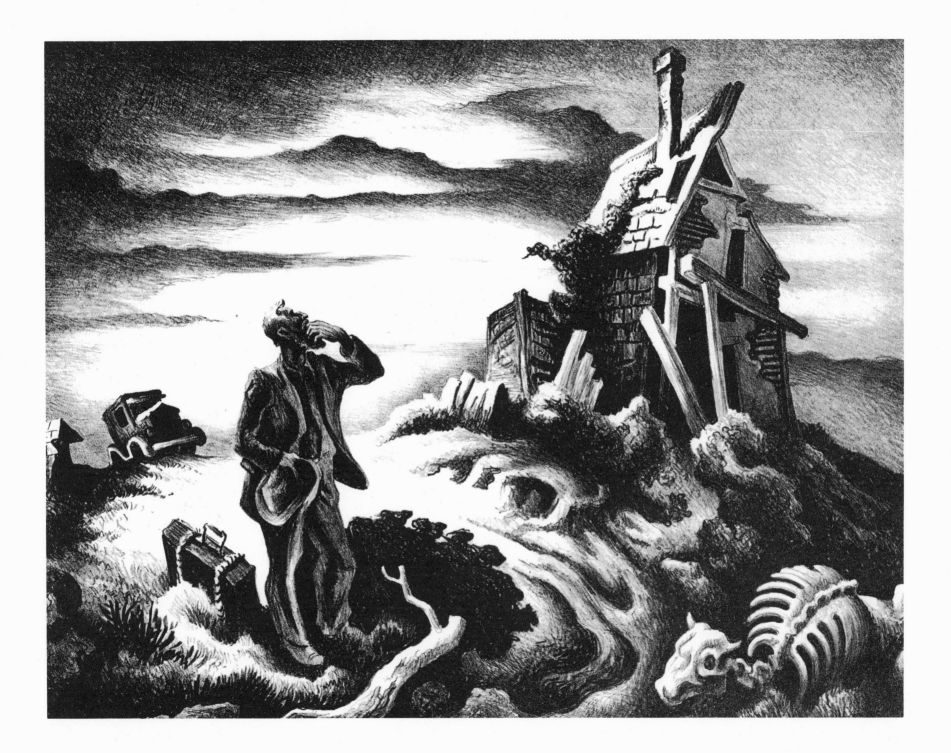

FRISKY DAY

12¾₁₆ x 7¹³⁄₁₆
1939
Edition of 250
Circulated by Associated American Artists, New York City.

The lithograph was a study for a painting *Frisky Day* which was made in 1940. The painting is in the collection of Mrs. W. Gates Lloyd.

young colt in the Spring. South Missouri farm country.

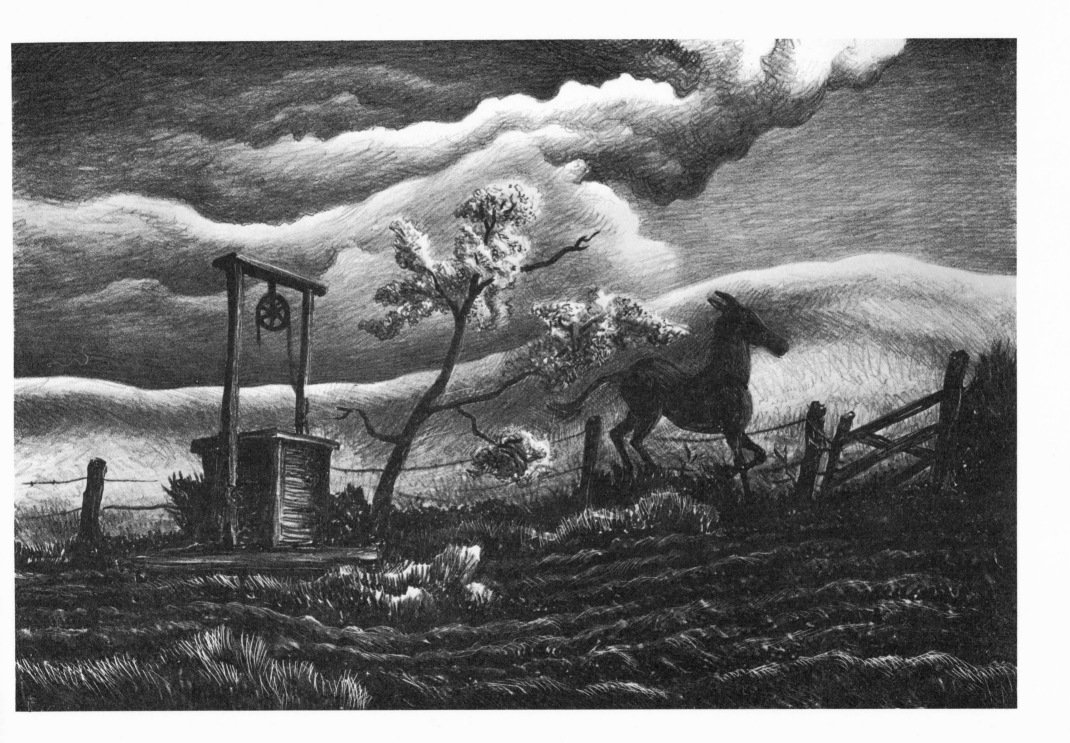

THE WOODPILE

also titled *Wood Cutter*

10⅞ x 8¾
1939
Edition of 250
Circulated by Associated American Artists, New York City.

The lithograph was a study for a small painting that was made in
1940. Present location unknown.

Missouri farm set up in the winter,
splitting wood for the kitchen stove.

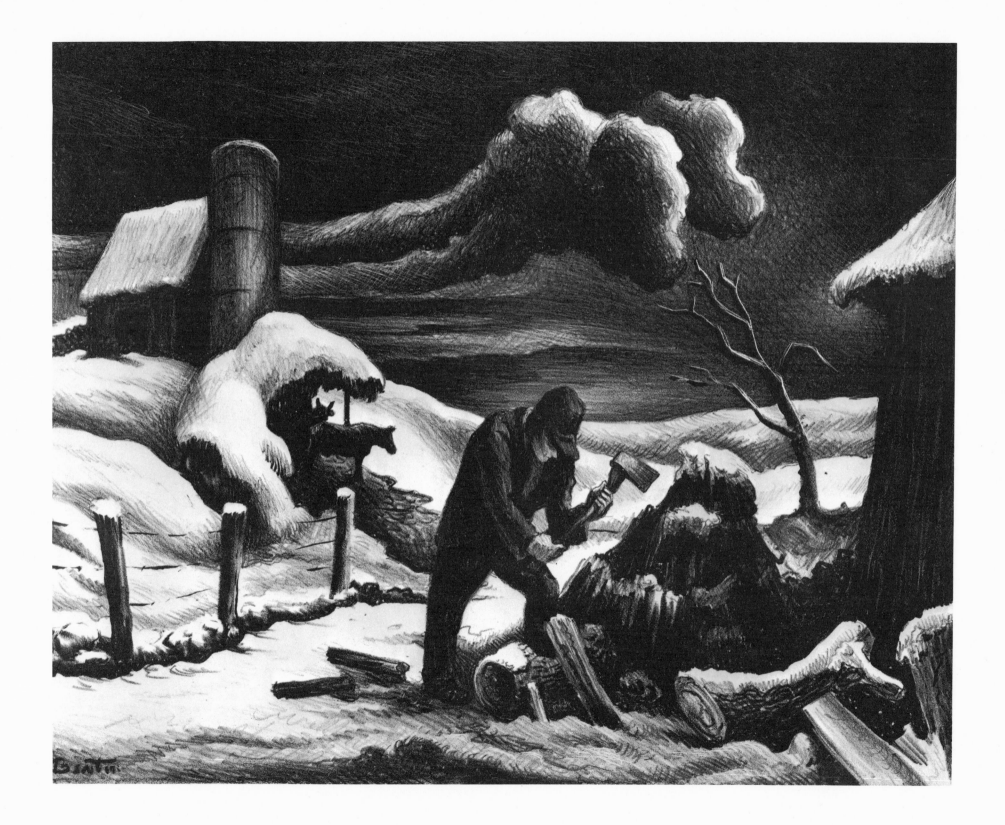

SHALLOW CREEK

9⅟₁₆ x 14¼
1939
Edition of 250
Circulated by Associated American Artists, New York City.

A painting *Shallow Creek* was made in 1938. The painting is
in the collection of Mrs. John P. Marquand, Cambridge,
Massachusetts.

Original drawings, of Ozark creek made in 1938.
A painting the same year. This is my son
wading across. litho was made in '39 - I believe.
This picture is very characteristic of the small
clear water creeks of the Ozarks!
Painting in possession of Marquand family of
Boston.

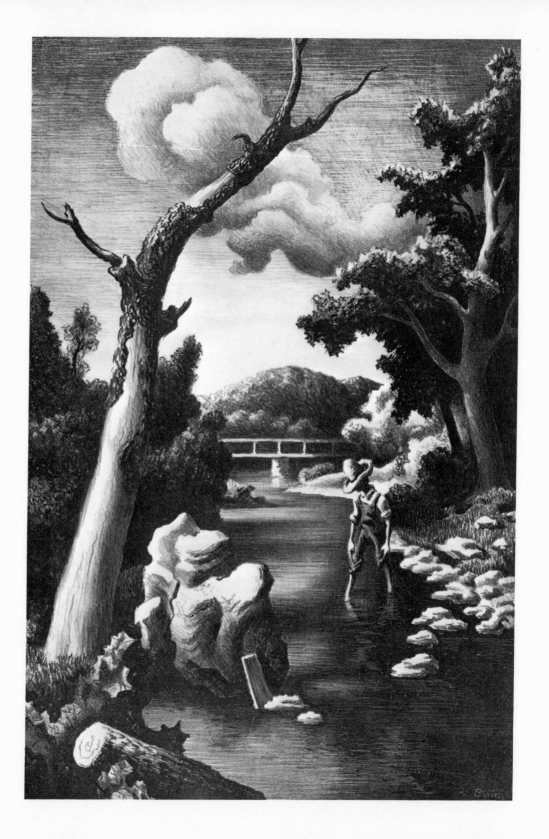

DOWN THE RIVER

also titled *The Young Fisherman*

10 x 12½
1939
Edition of 250
Circulated by Associated American Artists, New York City.

A painting *The Young Fisherman* was made in 1962. It is in
the collection of the artist.

A scene on the White River in the Ozarks. Drawings
for it were made in August 1939 while on a
float trip down the river. The area presented is now
under seventyfive feet of water, due to the construction
of Bull Shoals dam. However, such scenes are still
common on the clear water Ozark rivers which remain
free flowing. Twice yearly, Spring and Autumn, I
have floated these rivers for many years, fishing,
camping out on the sand bars and gravel and just watching
the river banks go by. The boy in the picture is
my son T. P. Benton.

Also Called "The Young Fisherman"

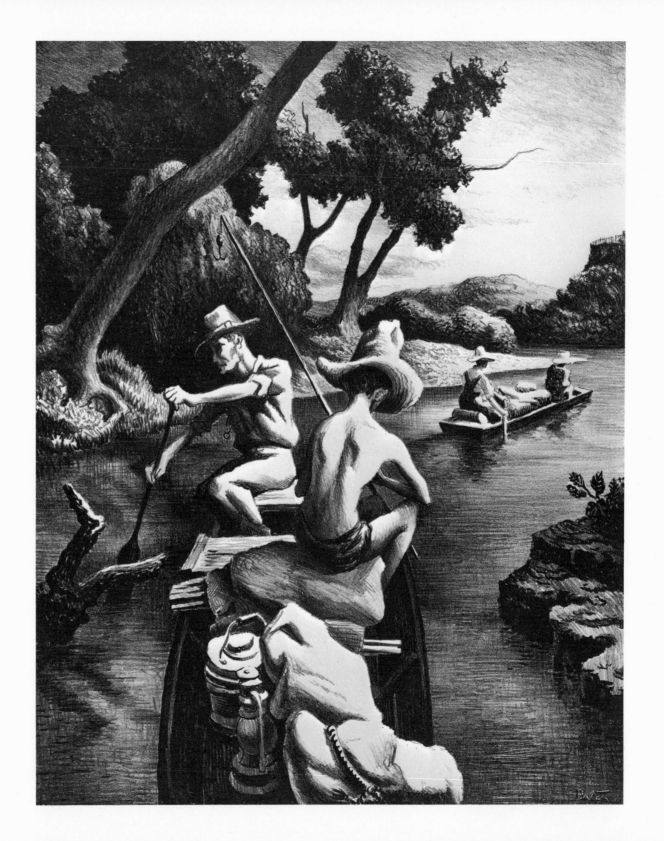

DEPARTURE OF THE JOADS

18¼ x 12¾
1939
Edition of 100

In 1939 Benton was commissioned by Twentieth-Century Fox Film Corporation to make a series of characterizations portraying the main characters of John Steinbeck's *The Grapes of Wrath*. This commission resulted in the following six lithographs which were used to publicize the motion picture.

A painting *Departure of the Joads* was also made. The painting is in the collection of the artist.

Scene from Steinbeck's "Grapes of Wrath." a large reproduction (bill board size) was made to advertize a Fox Co. movie made from the book. a painting was also made of this subject which is still in my hands.

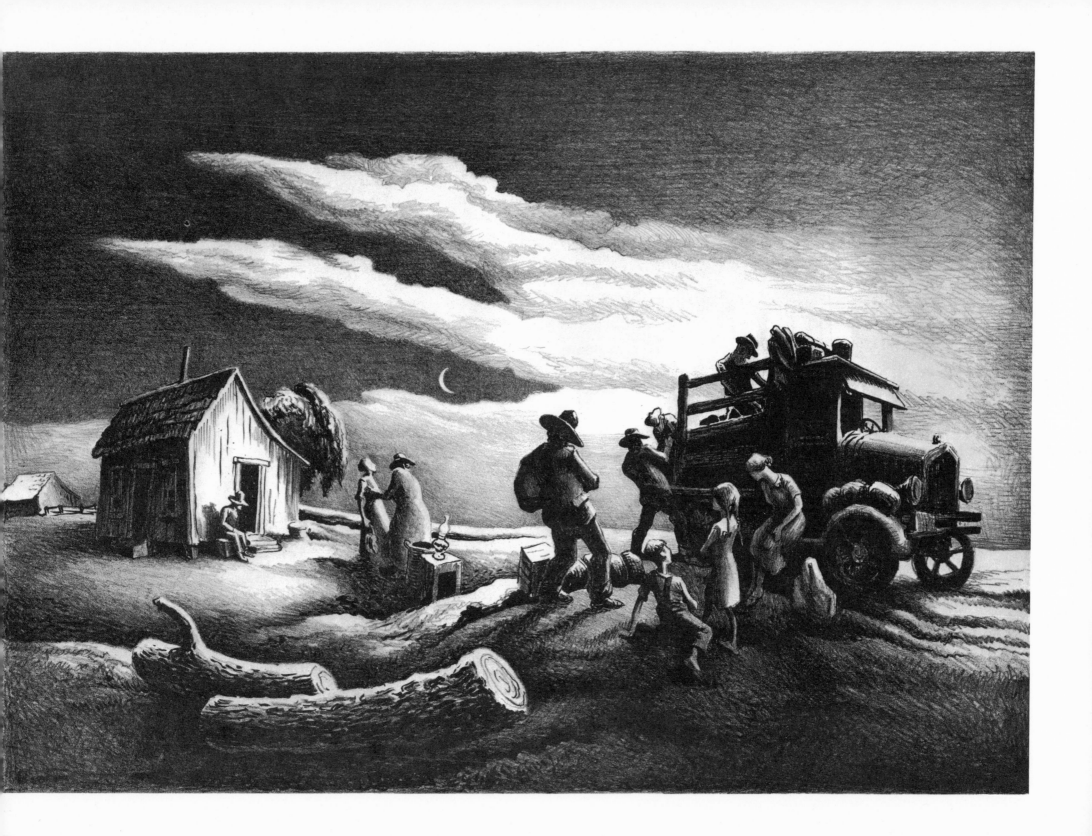

MA JOAD

6¾ x 6¾
1939
Edition of 25

. . . Ma was heavy, but not fat; thick with child-bearing and work . . . Her thin, steel-gray hair was gathered in a sparse wispy knot at the back of her head . . . Her full face was not soft; it was controlled, kindly. Her hazel eyes seemed to have experienced all possible tragedy and to have mounted pain and suffering like steps into a high calm and a superhuman understanding. She seemed to know, to accept, to welcome her position, the citadel of the family, the strong place that could not be taken. And since old Tom and the children could not know hurt or fear unless she acknowledged hurt and fear, she had practiced denying them in herself. And since, when a joyful thing happened, they looked to see whether joy was on her, it was her habit to build up laughter out of inadequate materials. But better than joy was calm. Imperturbability could be depended upon. And from her great and humble position in the family she had taken dignity and a clean calm beauty (John Steinbeck, *The Grapes of Wrath*).

Again John Steinbeck - Grapes of Wrath.
I was asked by the Fox Film Co. to make studies
of how the Grapes of Wrath "people" should appear.
This is one of these. The original drawings of these
people were made in Eastern Oklahoma and
with western Arkansas.

The Grapes of Wrath series

PA JOAD

7 x 9½
1939
Edition of 25

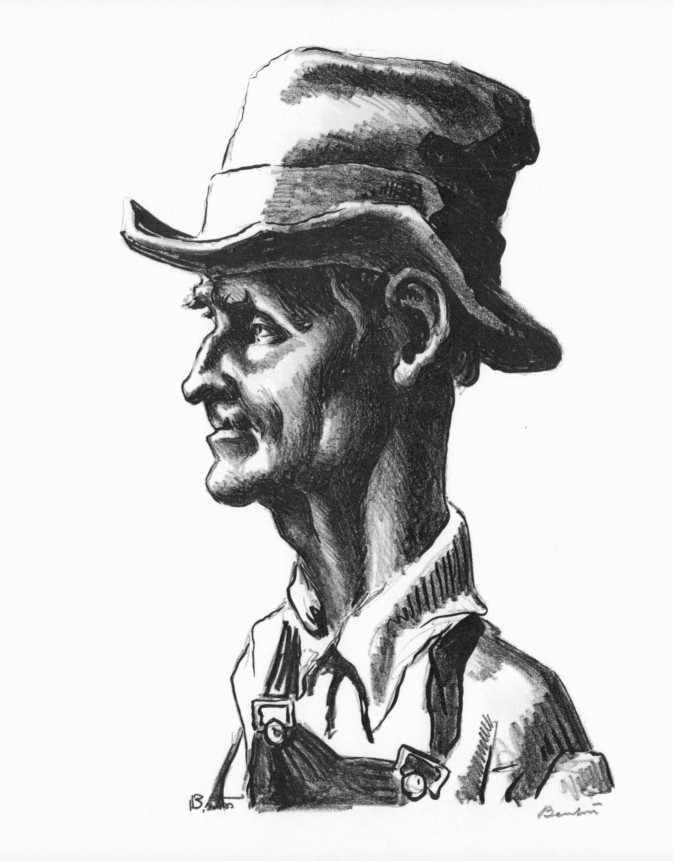

SHARON JOAD

6 x 7½
1939
Edition of 25

Steinbeck names this character "Rose of Sharon" or "Rosa-sharn."

 Her hair, braided and wrapped around her head, made an ash-blond crown. Her round soft face, which had been voluptuous and inviting a few months ago, had already put on the barrier of pregnancy, the self-sufficient smile, the knowing perfection-look; . . . (John Steinbeck, *The Grapes of Wrath*).

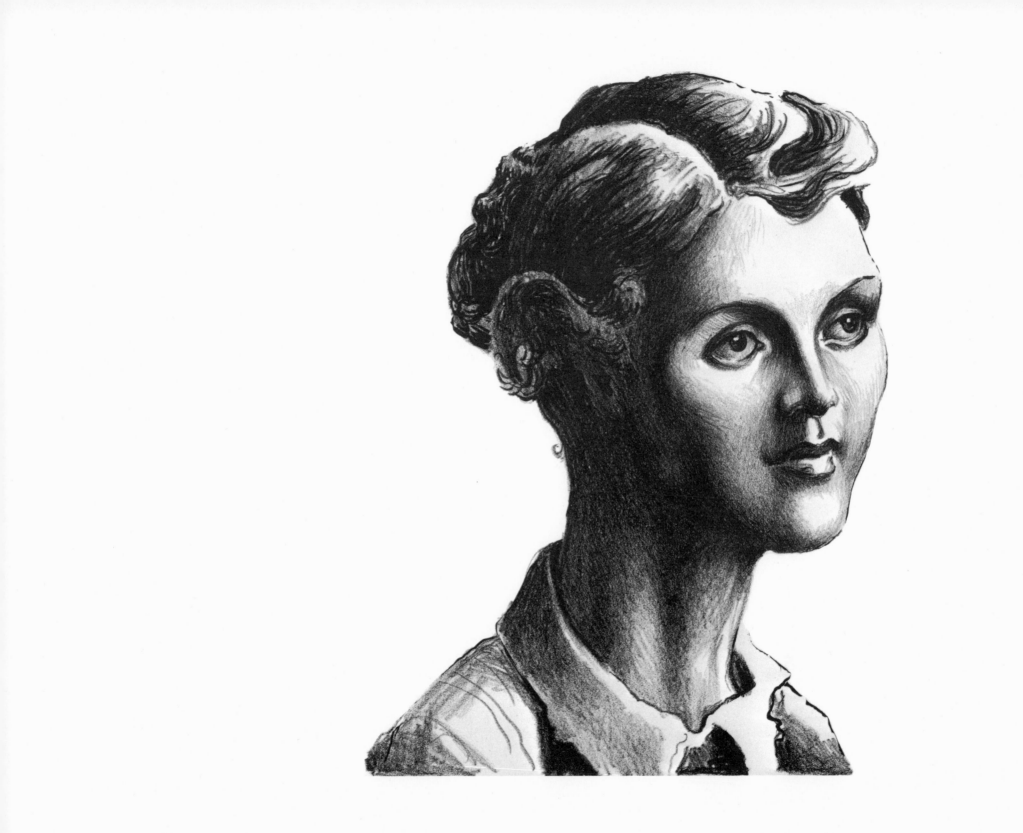

TOM JOAD

6¾ x 9½
1939
Edition of 25

He was not over thirty. His eyes were very dark brown and there was a hint of brown pigment in his eyeballs. His cheek bones were high and wide, and strong deep lines cut down his cheeks, in curves beside his mouth. His upper lip was long, and since his teeth protruded, the lips stretched to cover them, for this man kept his lips closed (John Steinbeck, *The Grapes of Wrath*).

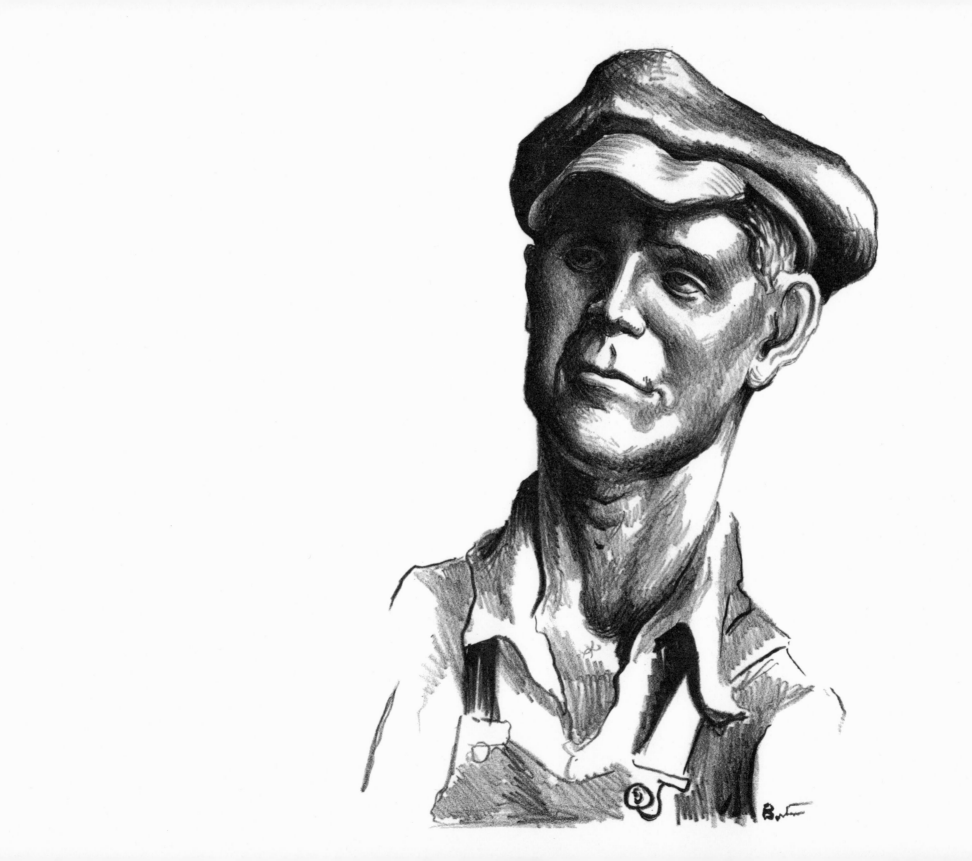

CASY or THE REVEREND JIM CASY

4½ x 8¼
1939
Edition of 25

It was a long head, bony, tight of skin, and set on a neck as stringy and muscular as a celery stalk. His eyeballs were heavy and protruding; the lids stretched to cover them, and the lids were raw and red. His cheeks were brown and shiny and hairless and his mouth full—humorous or sensual. The nose, beaked and hard, stretched the skin so tightly that the bridge showed white. There was no perspiration on the face, not even on the tall pale forehead. It was an abnormally high forehead, lined with delicate blue veins at the temples. Fully half of the face was above the eyes. His stiff gray hair was mussed back from his brow as though he had combed it back with his fingers (John Steinbeck, *The Grapes of Wrath*).

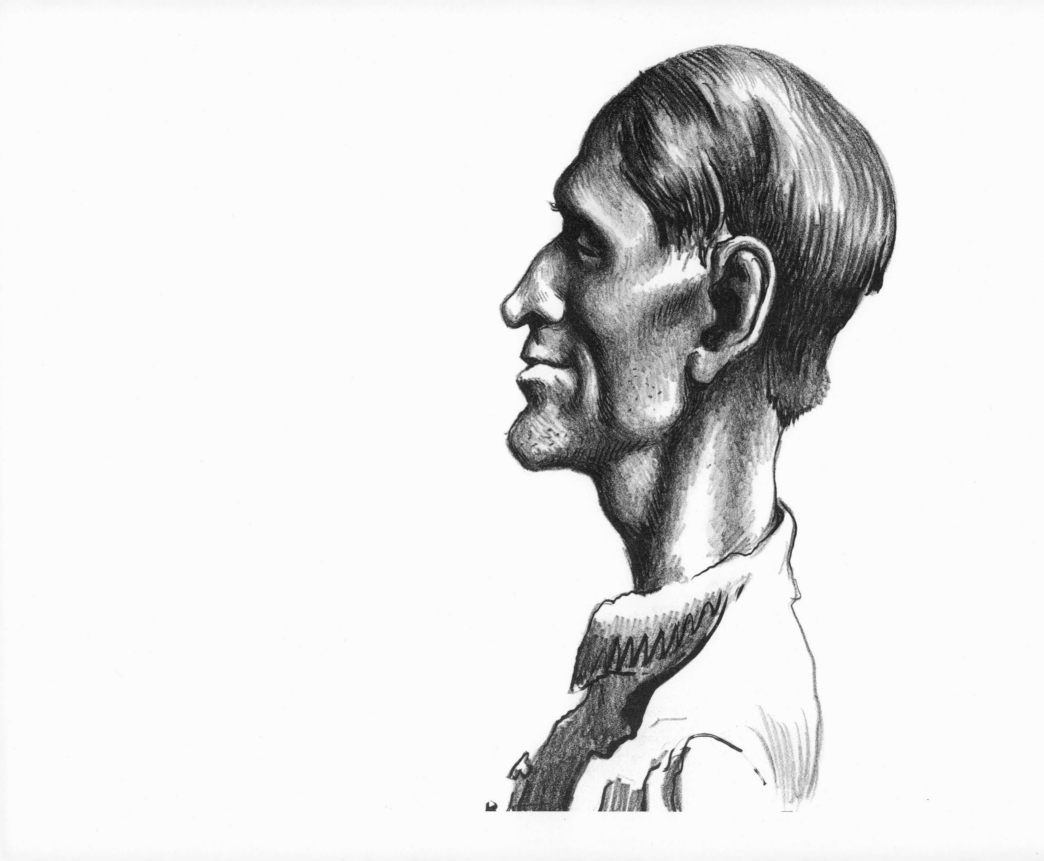

THE FENCE MENDER

14 x 10
1940
Edition of 250
Circulated by Associated American Artists, New York City.

The lithograph was a study for a small painting *The Fence Mender*. Present location unknown.

Common scene where there are barbed wire fences. This one was found in middle Nebraska in 1939 - on the trip where the horses were bought for the French light artillery.

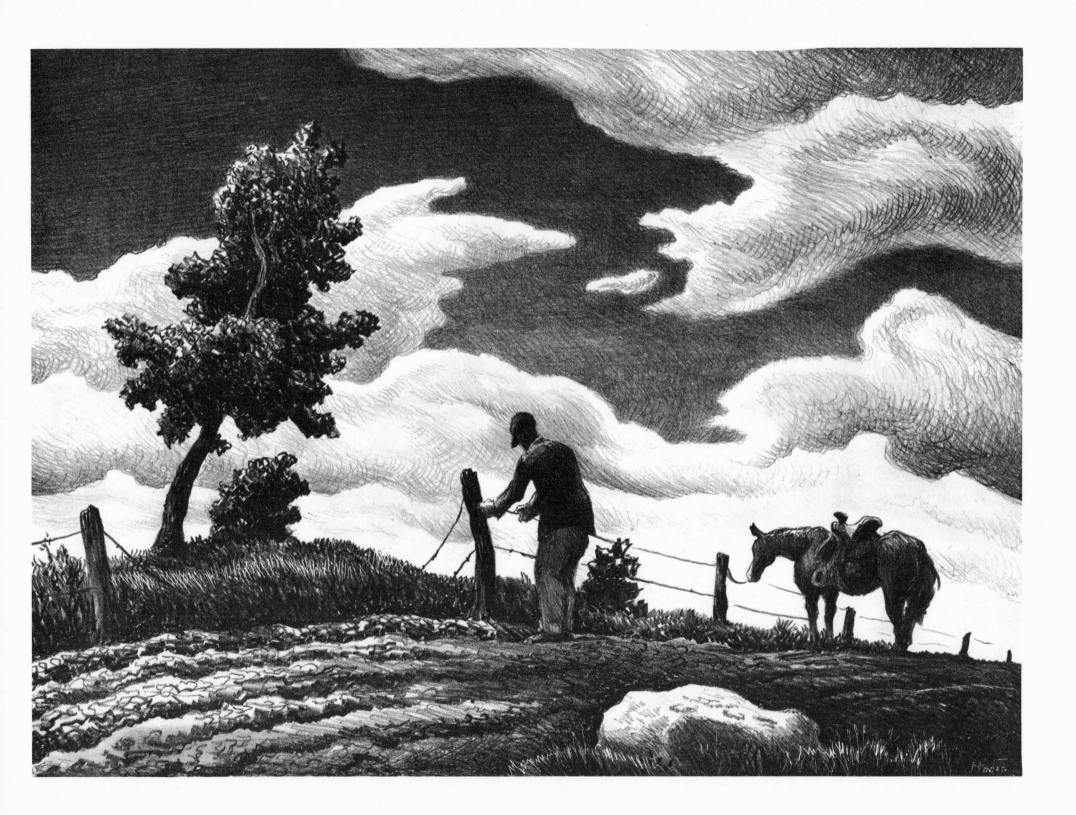

INSTRUCTION

12⅝₆ x 10⅞₆
1940
Edition of 250
Circulated by Associated American Artists, New York City.

A painting *Instruction* was made prior to the lithograph in 1940.
The painting is in the collection of Arthur M. Loew, Great Neck,
New York.

A painting of this was made in 1940 directly from life. One of my students at the K.C. Art Institute found the man selling snake medicine in the pool halls of 12th St in downtown K.C. He caught rattle snakes and let them rot and ferment in gallon jars and sold the result as an aphrodisiac. He was also a preacher and conducted a Sunday school class. This picture shows him telling about the Bible.

The painting is in the Loew collection, Great Neck N. Y.

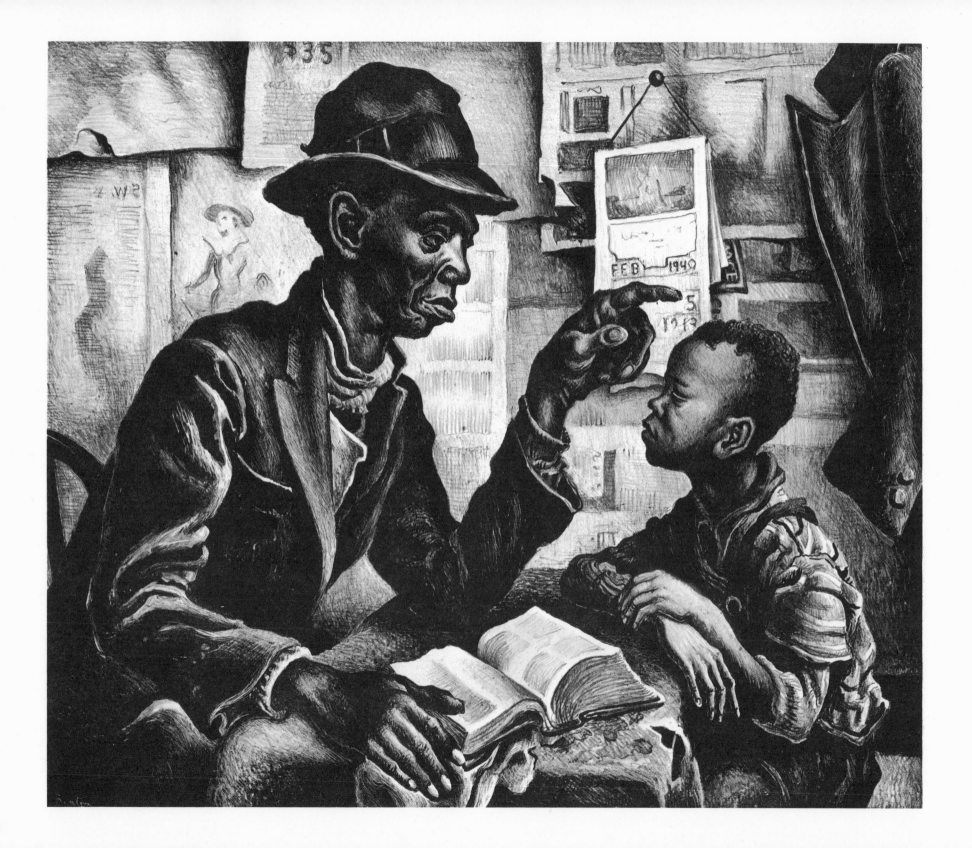

AARON

9⁷⁄₁₆ x 12⁷⁄₈
1941
Edition of 250
Circulated by Associated American Artists, New York City.

A painting *Aaron,* a three-quarter-length portrait with staff, was
made in 1940. The painting is in The Pennsylvania Academy of
the Fine Arts, Philadelphia, Pennsylvania.

"Aaron" with his staff.
This old negro man was picked up by one of
my students on East 18th St in Kansas City and
was persuaded to come to my class at the Kansas
City Art Institute to pose. I painted a ¾ length
portrait of him with both hands showing around
the staff. The portrait was purchased by the
Philadelphia Academy in the early '40s. This
lithographic head was done from the painting.

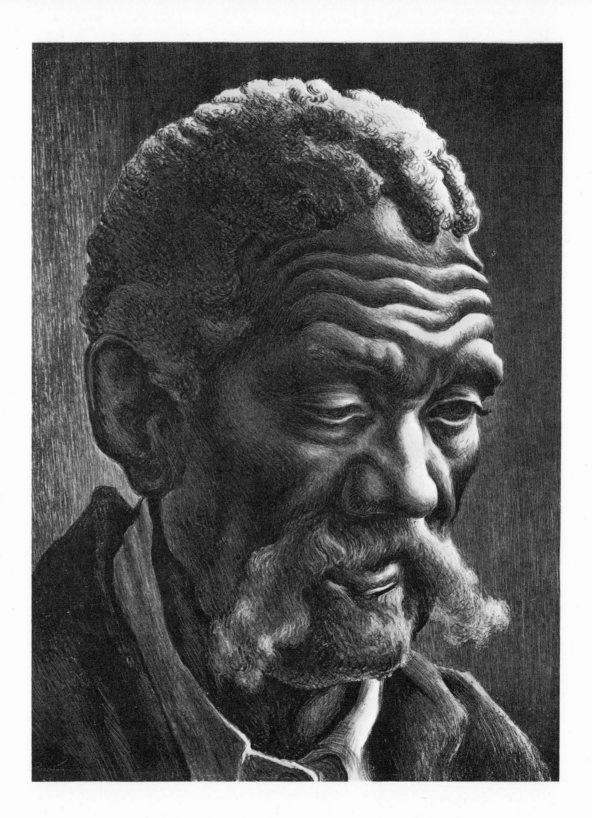

SUNSET

13⅛ x 10
1941
Edition of 204
Circulated by Associated American Artists, New York City.

The lithograph was a study for a painting titled *A Cow, A Tree, A Pond and a Sunset*. The painting is in the collection of David Soslan, Kansas City, Missouri.

Study for a painting. Effort to make a real picture out of an old "chromo" and calender subject

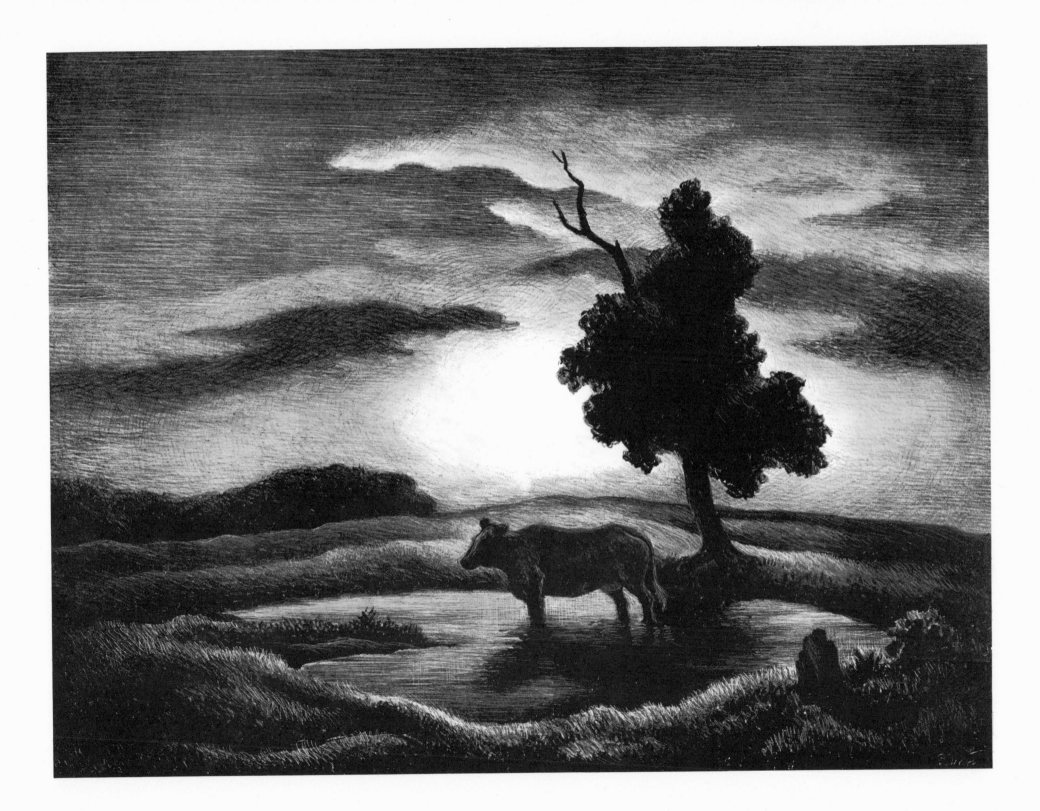

OLD MAN READING

12⅛ x 10
1941
Edition of 250
Circulated by Associated American Artists, New York City.

My Kansas City art students acted as scouts to find good models for our classes. This old man was from one of the small towns near K.C. A painting was made directly from life - the litho was made from the painting. The last I heard of this painting it was in India in the collection of an American doctor who resided there.

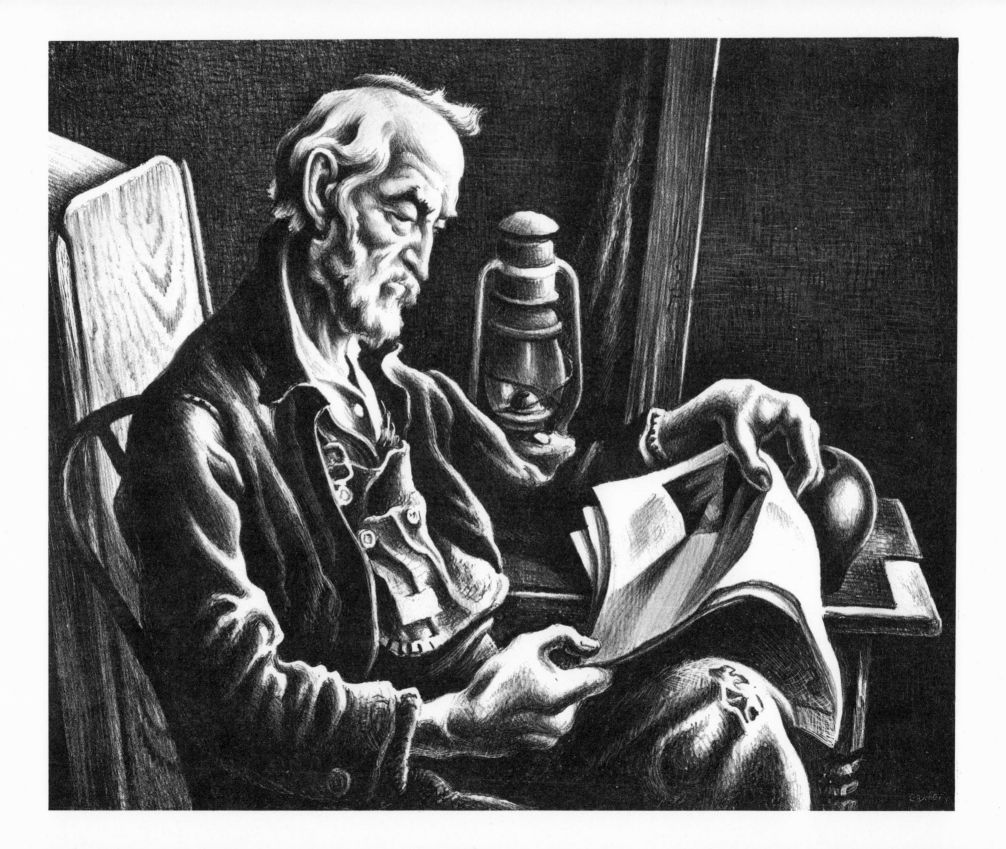

NEBRASKA EVENING

also titled *Arkansas Evening*

13 x 10
1941
Edition of 250
Circulated by Associated American Artists, New York City.

A painting *Nebraska Evening* was made in 1940. The paint-
ing is in the collection of the artist.

Drawing made in 1939., again on horse buying trip.

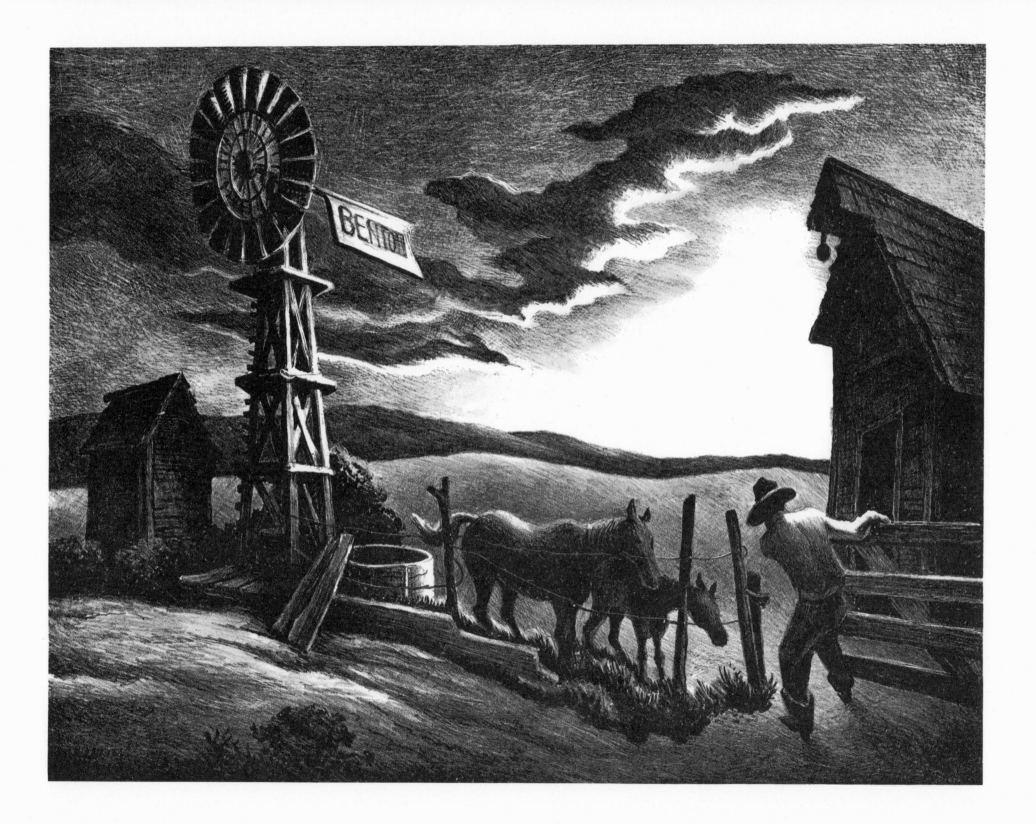

SLOW TRAIN THROUGH ARKANSAS

12¾ x 10
1941
Edition of 250
Circulated by Associated American Artists, New York City.

A painting *Slow Train Through Arkansas* was made in 1929 and was initially owned by Thomas Beer. Its present location is not known.

You are not the only pebble on the beach for there is a little rock in Arkansas. It was down in the state of Arkansas I rode on the slowest train I ever saw. It stopped at every house. When it came to a double house it stopped twice. They made so many stops I said, "Conductor, what have we stopped for now?" He said, "There are some cattle on the track." We ran a little ways further and stopped again. I said, "What is the matter now?" He said, "We have caught up with those cattle again" (Thomas W. Jackson, *On A Slow Train Through Arkansas*).

Illustrates one of the stories in the old joke book "Slow Train Through Arkansas". This book was a popular sales item on most of the trains in Missouri, Arkansas, Oklahoma and Texas in the days of my youth.

112

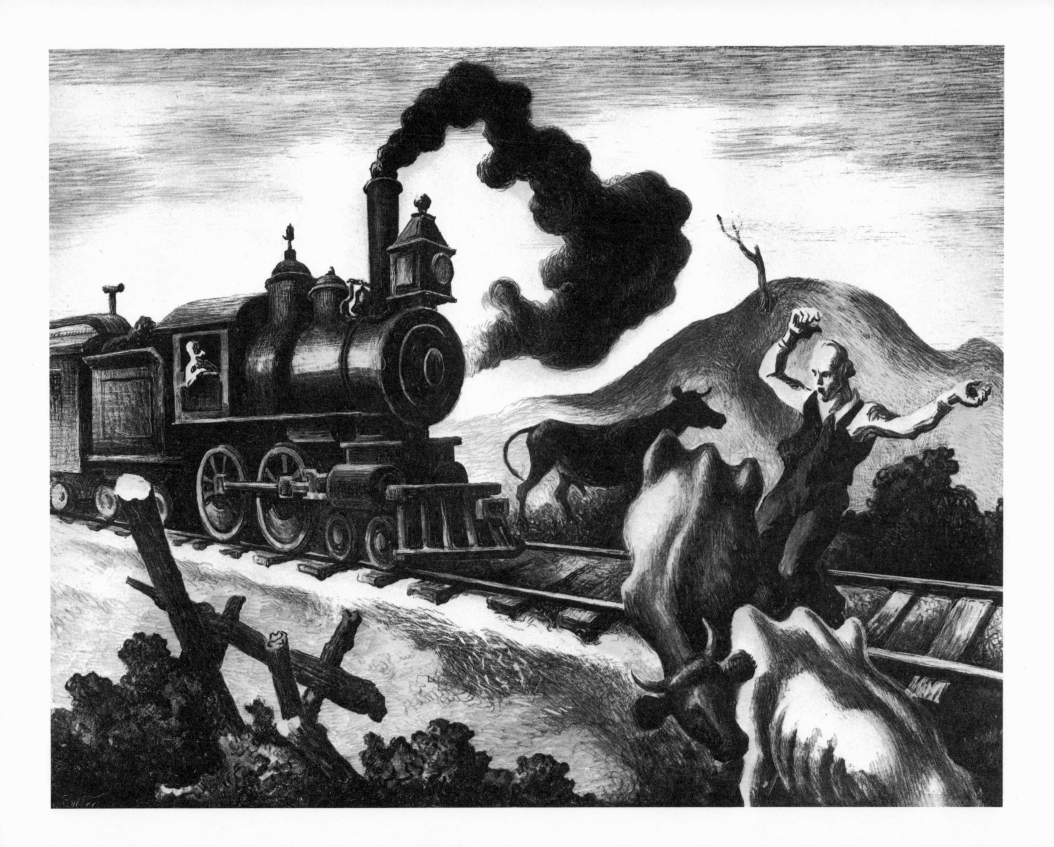

THE MEETING

11½ x 8⅞
1941
Edition of 250
Circulated by Associated American Artists, New York City.

This print is more like a drawing than the
other lithos and shows the interior of a country
church with a man preaching.

Meeting house in the mountains of West Virginia.
Drawing made in 1928. litho. reproduces
drawing almost exactly. litho probably made in
'38.

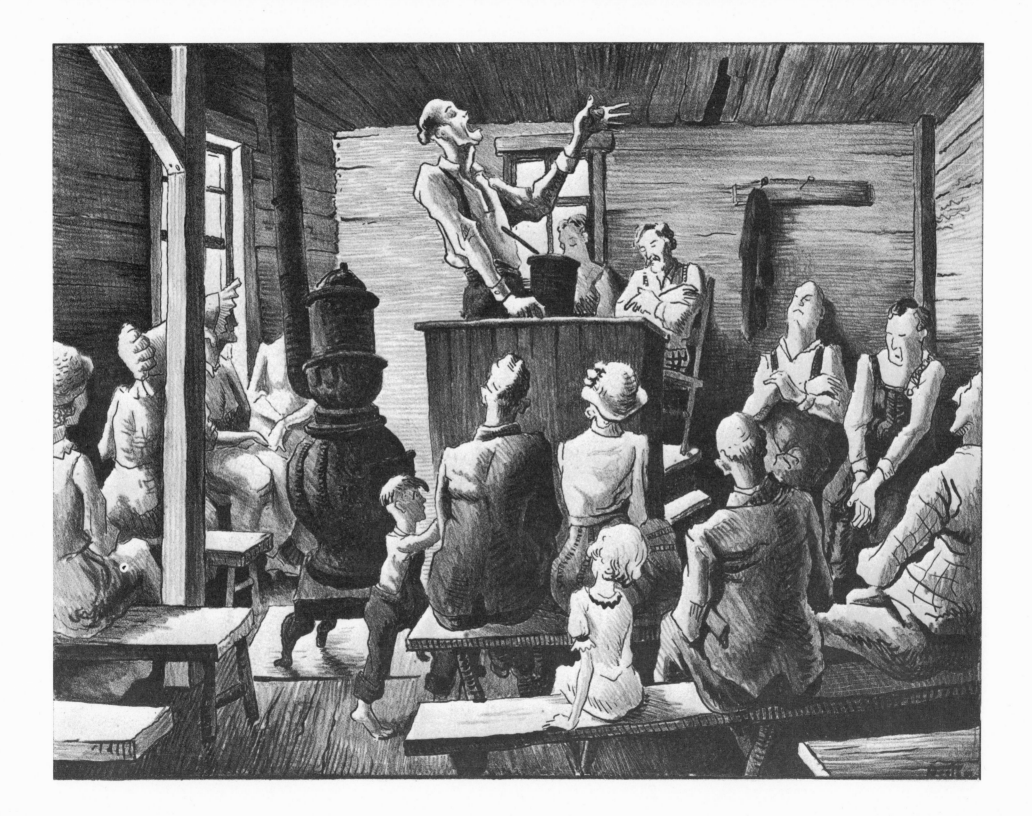

THRESHING

14 x 9¼
1941
Edition of 250
Circulated by Associated American Artists, New York City.

A painting *Threshing Wheat* was made in 1938. The painting is
in the Sheldon Swope Art Gallery, Terre Haute, Indiana.

Made from a series of drawings and a
painting done in 1938. The scene represents the
last ~~stereo~~ steam thresher engine to be operated
in Johnson County, N.E. Kansas. The area re-
presented is within 25 miles of my K.C.
home. We were still near the country here in
1938. I'd bet every bit of this land is now
sprouting ranch houses and swim pools and
teen age protestants.

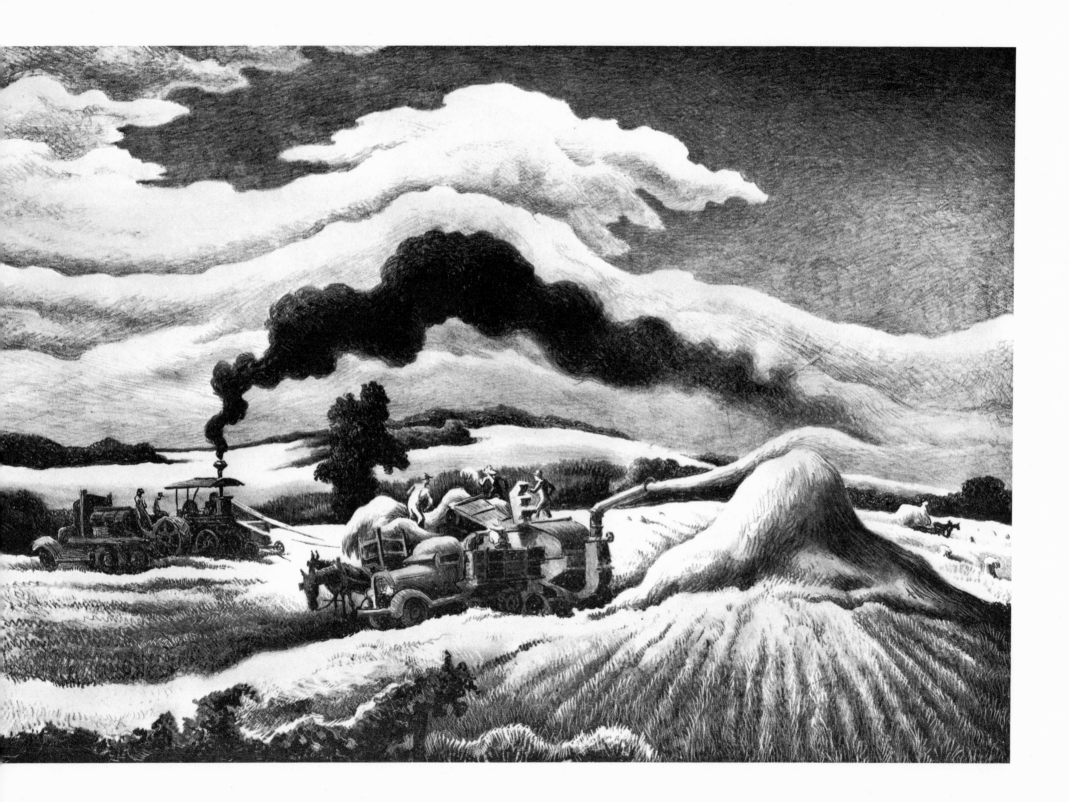

Swamp Water series

SWAMPLAND

also titled *The Swamp*

12¾ x 17¾
1941
Edition of 100

In 1941 Benton was commissioned by Twentieth-Century Fox Film Corporation to do a series of lithographs portraying the habitat and main characters of Vereen Bell's *Saturday Evening Post* novel *Swamp Water*. This was the first American film of the great French motion picture director Jean Renoir. The commission resulted in the following six lithographs which were used to publicize the motion picture.

Nothing on the face of the earth has a more forbidding beauty than a cypress swamp. The trees with their fat curling bases rise out of the dark water like enormous fungi. As a rule they have little foliage, and that is transparent, fragile, and lacy. From their branches long whiskers of moss hang in gray veils. Sometimes a dead tree stands up stark, like a piece of white sculpture (Thomas Hart Benton, *An Artist In America*).

Made for a movie dealing with southern swamp lands. The drawing, minus the skull, was made in south Louisiana — area forgotten — within 50 or 60 miles of Abbeville, La.

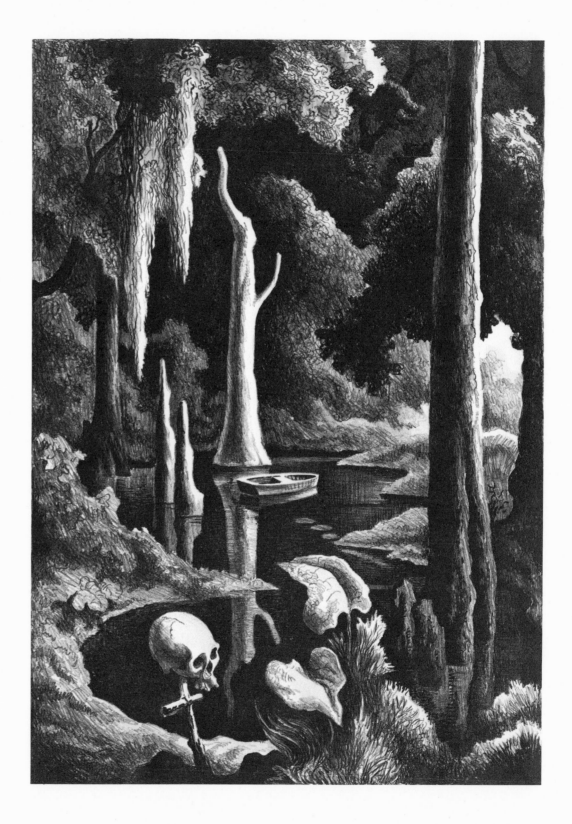

BEN RAGAN AND TROUBLE

also titled *The Hunter, Man and Dog*

7¼ x 11
1941
Edition of 100

Young Ben Ragan, trapper and woodsman, and his dog "Trouble."
"Trouble," crossbred, with perhaps a trace of bird dog in him, was
recognized as the best hound along the upper Suwannee River.

adapted from Vereen Bell's *Swamp Water*

This could be for almost any story of the rural south.

Swamp Water series

TOM KEEFER

also titled *Man*

7½ x 9
1941
Edition of 100

Tom Keefer was a buckskin clad reversion to primitive man,
an escaped murderer hiding out in the great Okefenokee
Swamp.

adapted from Vereen Bell's *Swamp Water*

Original Drawing made at Jasper Arkansas in 1926
shortly after drawing of lonesome road. at this
time, early summer, I took a walking trip through
the north west Arkansas Ozarks from which came
a book of drawings and an article in Travel
Magazine. The article led to the McBride Publishing
House commission to write "Artist in America"

Swamp Water series

THURSDAY RAGAN

8 x 8
1941
Edition of 25

Thursday Ragan was the father of young Ben Ragan. A pow-
erful man and slow to anger, but set in his ways.

adapted from Vereen Bell's *Swamp Water*

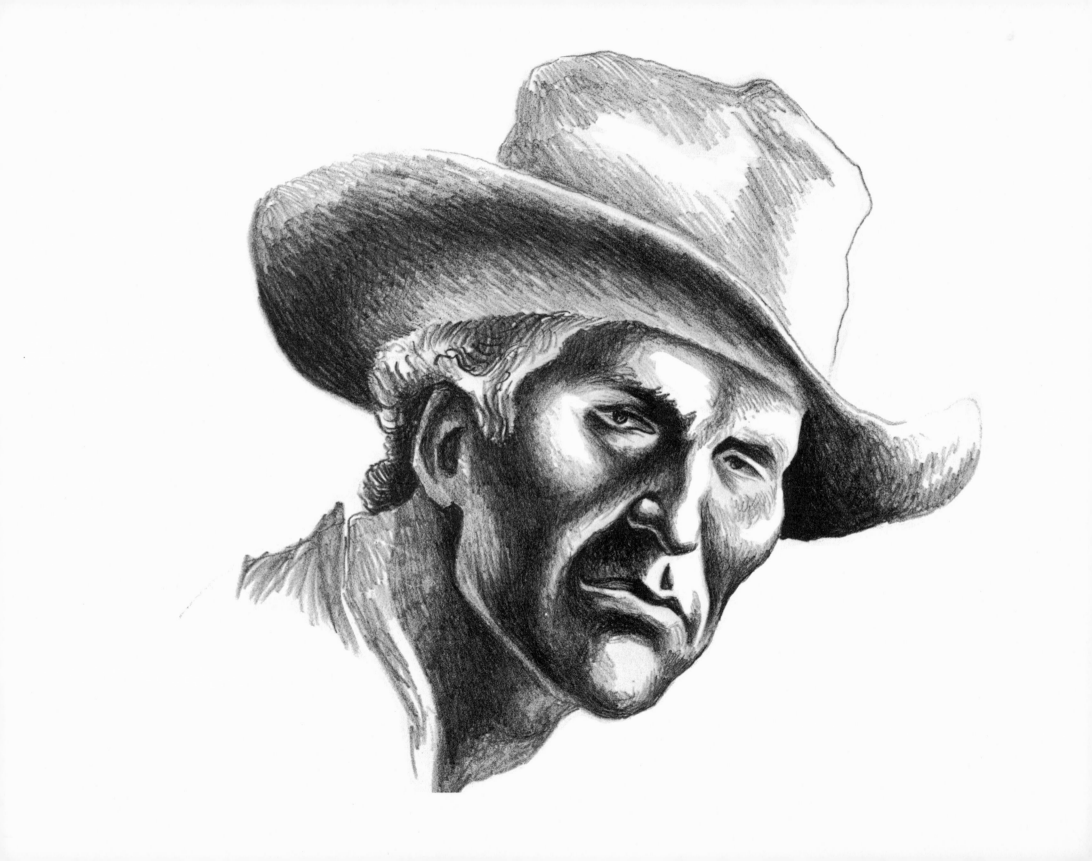

Swamp Water series

JESSIE WICK

6⅛ x 9⅞
1941
Edition of 25

Jessie Wick was a guitar-playing local minstrel who lived on
the edge of Okefenokee Swamp.

adapted from Vereen Bell's *Swamp Water*

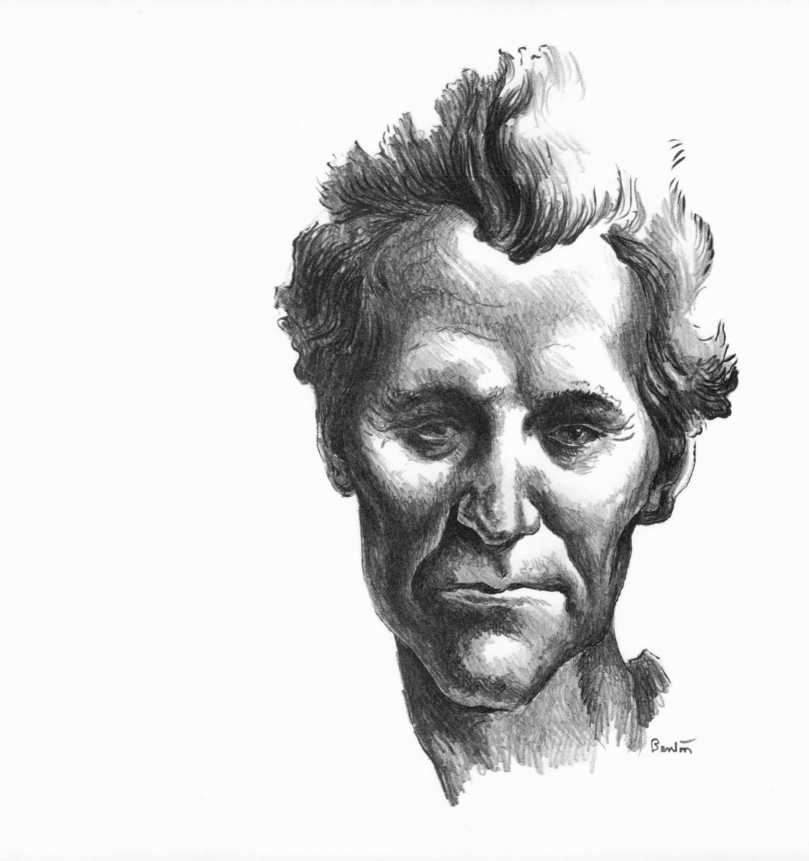

Swamp Water series

JULIE GORDON

8⁵⁄₁₆ x 9
1941
Edition of 25

Julie Gordon was a quiet, strange sort of a girl, to whom
young Ben Ragan felt a powerful attraction.

adapted from Vereen Bell's *Swamp Water*

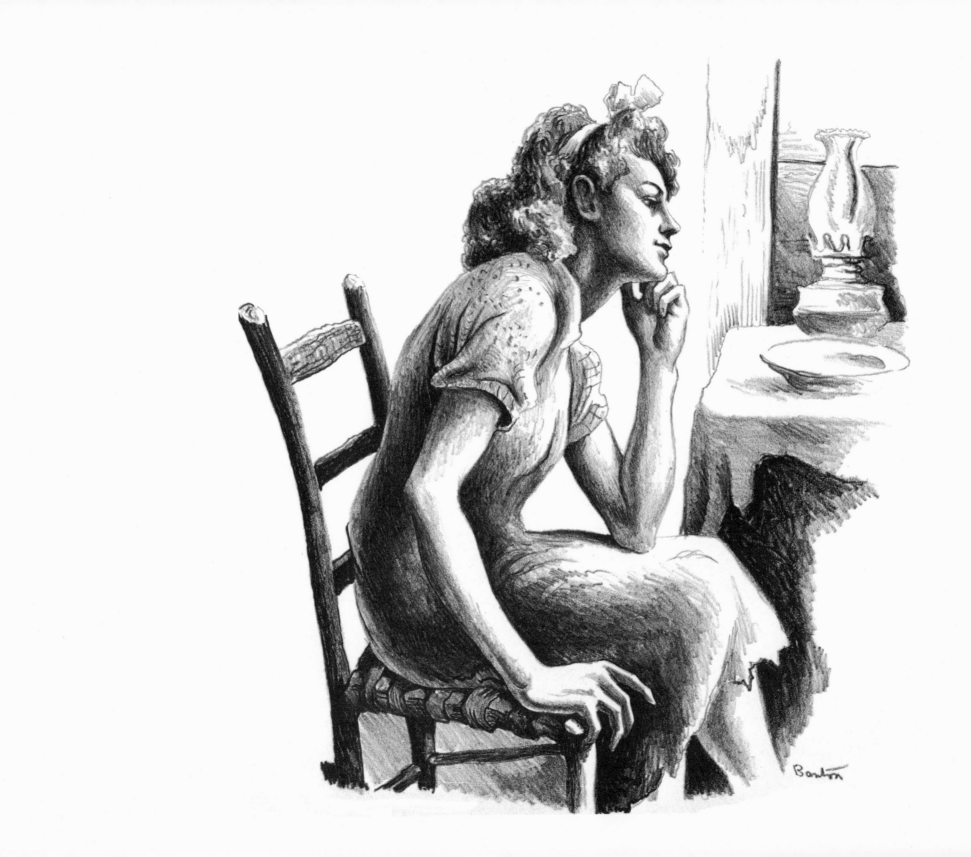

JESSIE AND JAKE

9⅞ x 13⅜
1942
Edition of 250
Circulated by Associated American Artists, New York City.

Painting of this subject made in 1941 when daughter Jessie was three yrs old. Our shepherd dog Jake impersonated the wolf in this Red Riding Hood theme. The area depicted is in our wood lot on Martha's Vinyard and shows a path leading to my mother's place there. Trees, white oak, grow thick at the trunk but do not get very high on our part of the Island because of the winds. Painting in my procession. Litho was made from it at request of A.A.A.

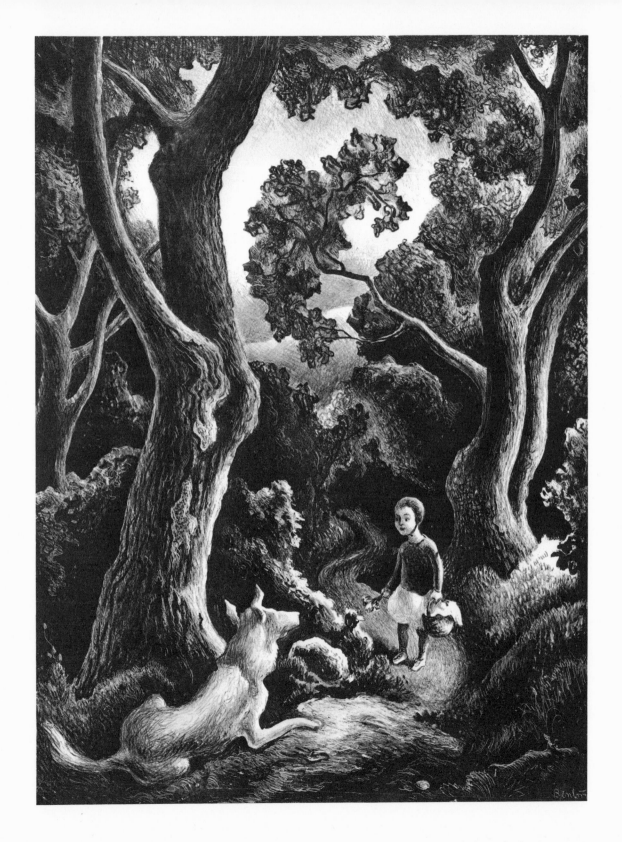

THE RACE

also titled *Homeward Bound*

13³⁄₁₆ x 9¹⁵⁄₁₆
1942
Edition of 250
Circulated by Associated American Artists, New York City.

The lithograph was a study for a painting *Homeward Bound*.
The location of the painting is not known.

Common enough scene in the days of the steam ~~train~~ engine. Why did horses so often run with the steam trains while they now pay no attention to the Diesels?
Study for a painting made in the early '40s. Later turned over to A.A.A.

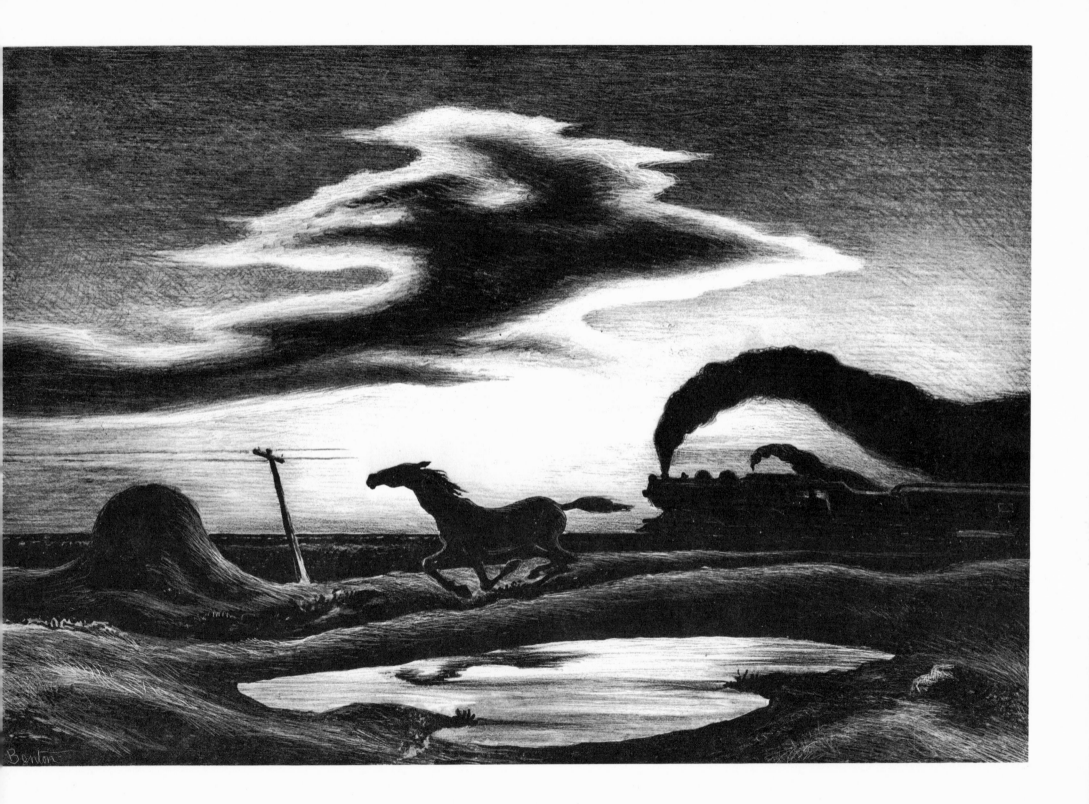

NIGHT FIRING

also titled *Tobacco Firing*

13⅛ x 8¾
1943
Edition of 250
Circulated by Associated American Artists, New York City.

The lithograph was a study for a painting *Night Firing,* which
is in the collection of Mr. and Mrs. Lee Constable, Kansas
City, Missouri.

Drawing made in 1943. in North Carolina - part
of a series of the Tobacco industry made at
request of American Tobacco Co. The shed is
where the Tobacco is dried out with night and day
slow fires beneath. There is a painting of this owned
by Mr. & Mrs. Constable of Kansas City

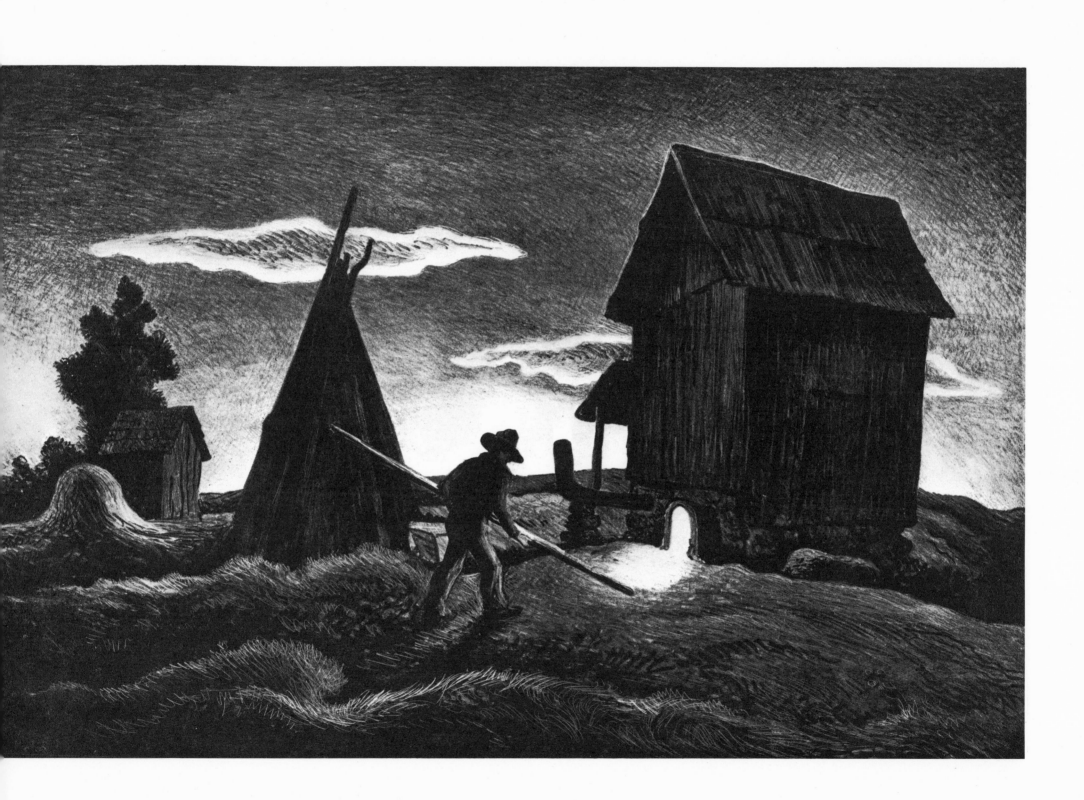

MORNING TRAIN

also titled *Soldier's Farewell*

13½ x 9⅜
1943
Edition of 250
Circulated by Associated American Artists, New York City.

Soldier leaving a small plains town. This litho was also called "going west" which in soldiers argot meant going to die. This secondary title was dropped during the war years. Drawing of water tank, track and station made in late 1942.

Also called 'Soldiers Farewell'

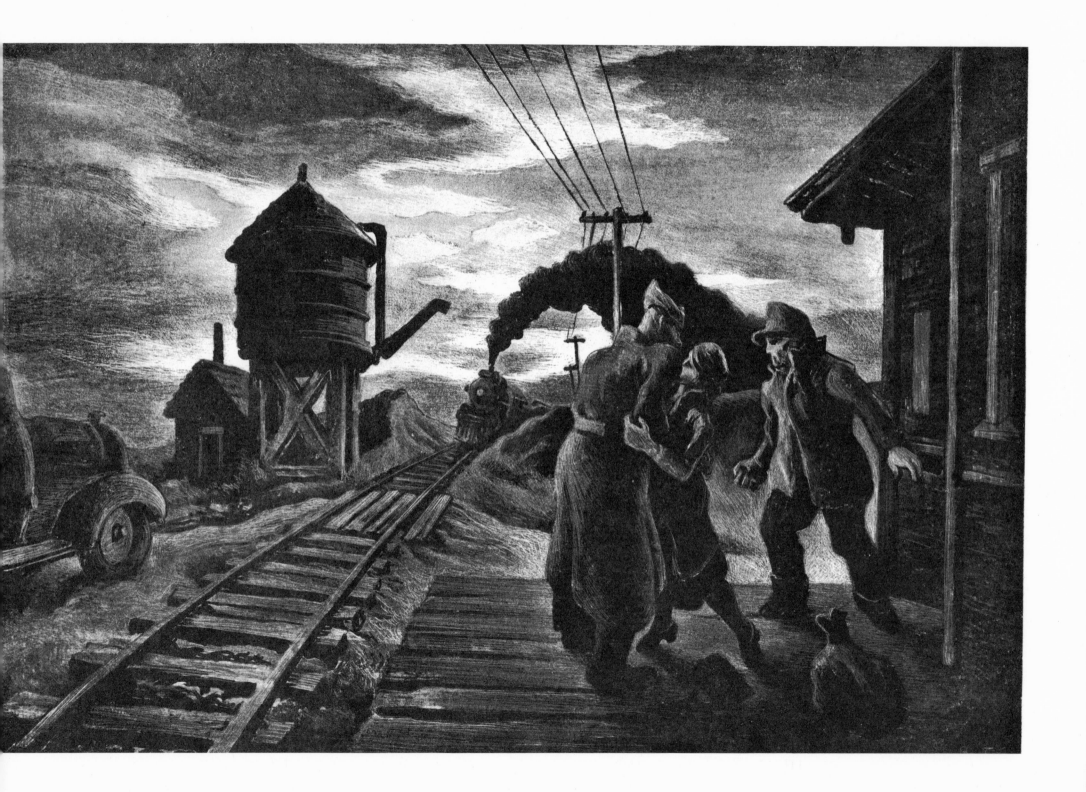

LETTER FROM OVERSEAS

13⅛ x 9⅝
1943
Edition of 250
Circulated by Associated American Artists, New York City.

Drawing made in '43 — Then a litho study for light and shade. Then a small painting about 10" by 14" — the painting in the collection of "Hildegarde", the singer.

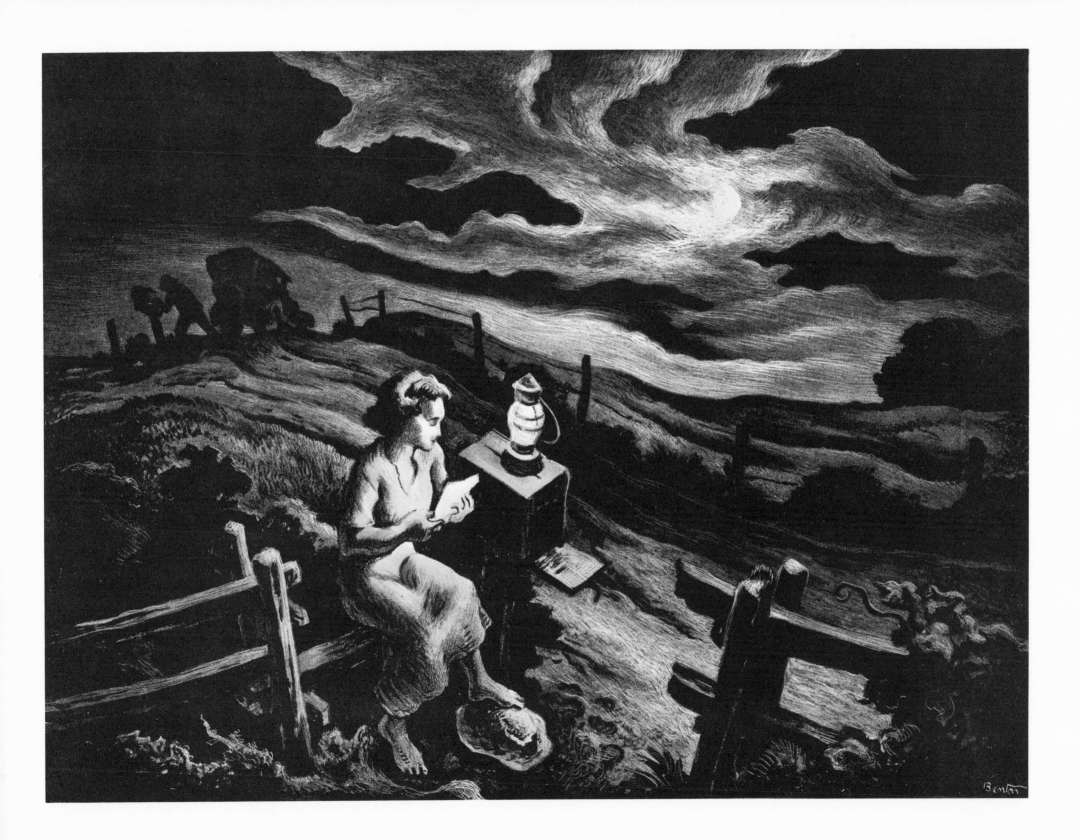

THE MUSIC LESSON

12½ x 10⅛
1943
Edition of 250
Circulated by Associated American Artists, New York City.

 Gale Huntington and his little daughter Emily live in Chilmark on the island of Martha's Vineyard, off the coast of Massachusetts. In addition to farming, carpentry, fishing, and the thousand and one odd jobs which everybody does who lives in Chilmark, Gale plays the guitar and sings the songs of the whalers and old-time fishermen of the Island. Emily also sings them. She is learning the piano as well but under protest. She'd rather sing with Gale. Here she watches the chord sequences which underlie a new song (Thomas Hart Benton, *Patron's Supplement No. 26, Associated American Artists*).

litho made as study for a large, nearly life size painting which was executed on Marthas Vinyard in the middle '40s. The characters Gale Huntington Vinyard Folk singer and his daughter. Painting in the Koch collection, Wichita, Kansas.

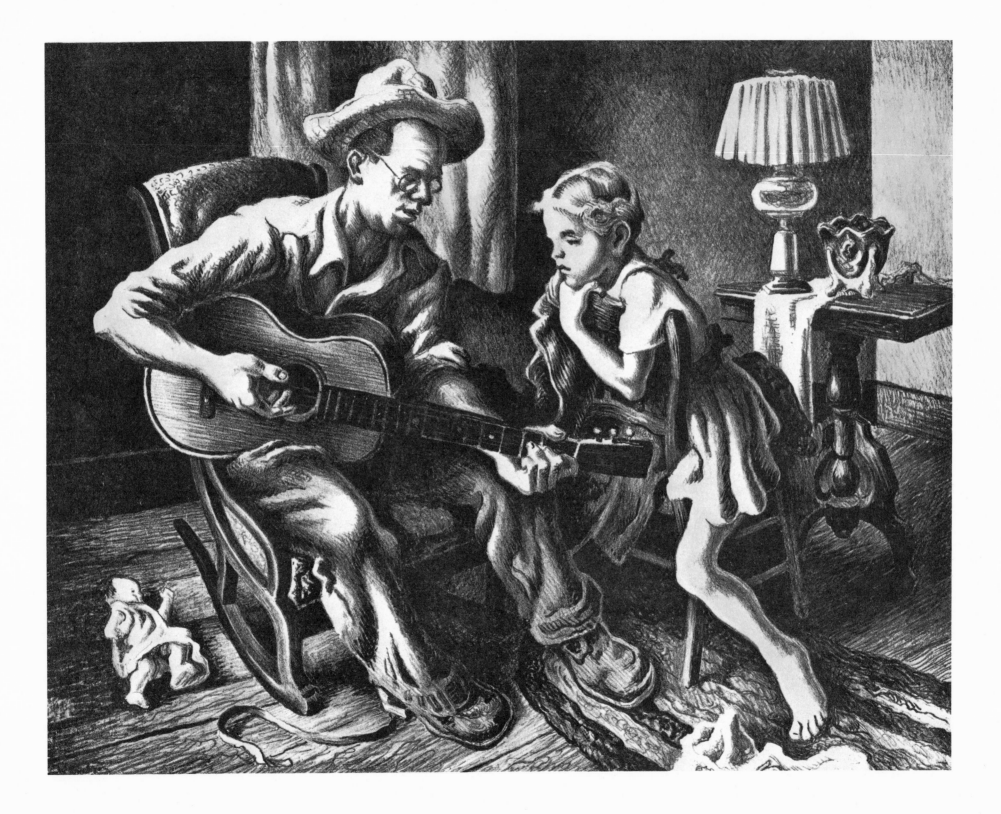

SPRING TRYOUT

13⅝ x 9½
1943
Edition of 250
Circulated by Associated American Artists, New York City.

A painting *Spring Tryout* preceded the lithograph. The paint-
ing is in the collection of Captain Albert Hailparn.

From a painting made in the middle forties.
Represents an incident of my boyhood when another
boy and myself took an old horse out one day for
a ride. He got frisky and I slid off his tail.

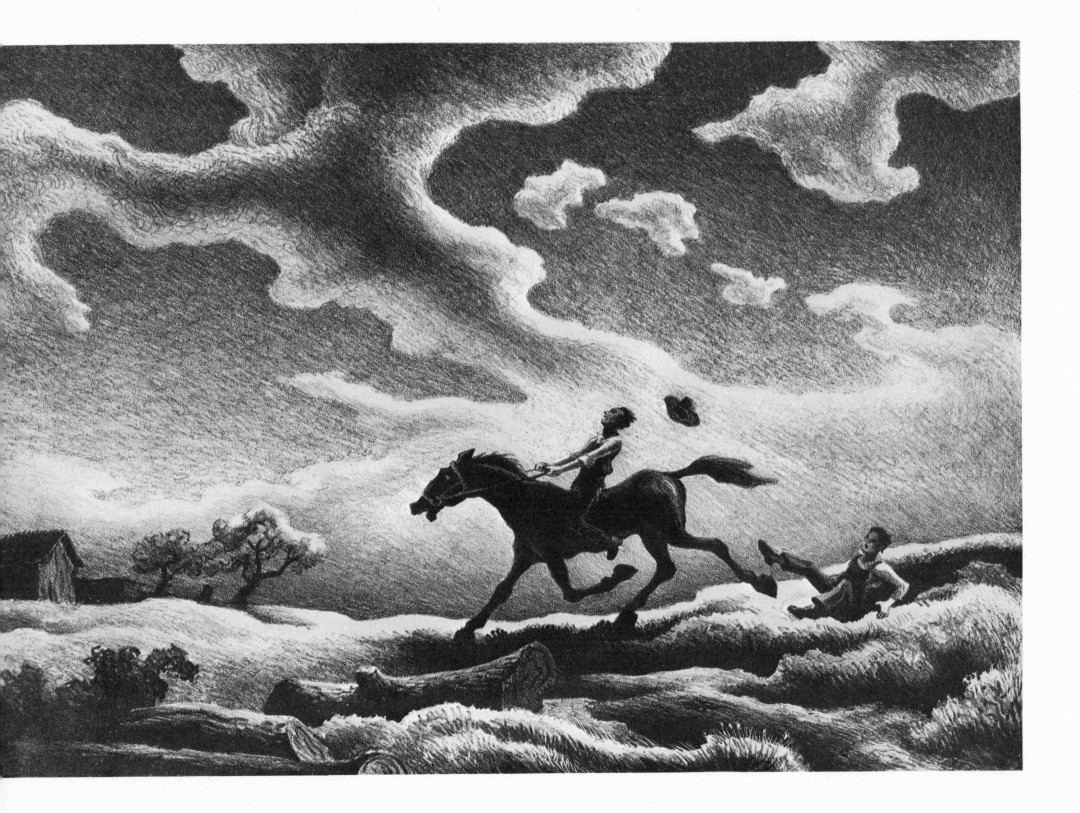

THE FARMER'S DAUGHTER

13⅛ x 9⅞
1944
Edition of 250
Circulated by Associated American Artists, New York City.

This lithograph was selected for "Fifty Prints of the Year, 1944."

Along the dirt roads that run at various angles off the highways of central Missouri, there are hundreds of houses which look just like this one. The tenant farmers who occupy them, for longer or shorter times, always have little children who play around the houses while the grownups work the fields. Even when the women folk are in the kitchen, the children of these places look lonely, lonely like the places themselves. The little girl who works the pump is doing so "just because." For the moment there is nothing else to do (Thomas Hart Benton, *Patron's Supplement No. 26,* Associated American Artists).

Tenant farmers house in the farm lands of northwest Missouri. Original drawing made in 1940.

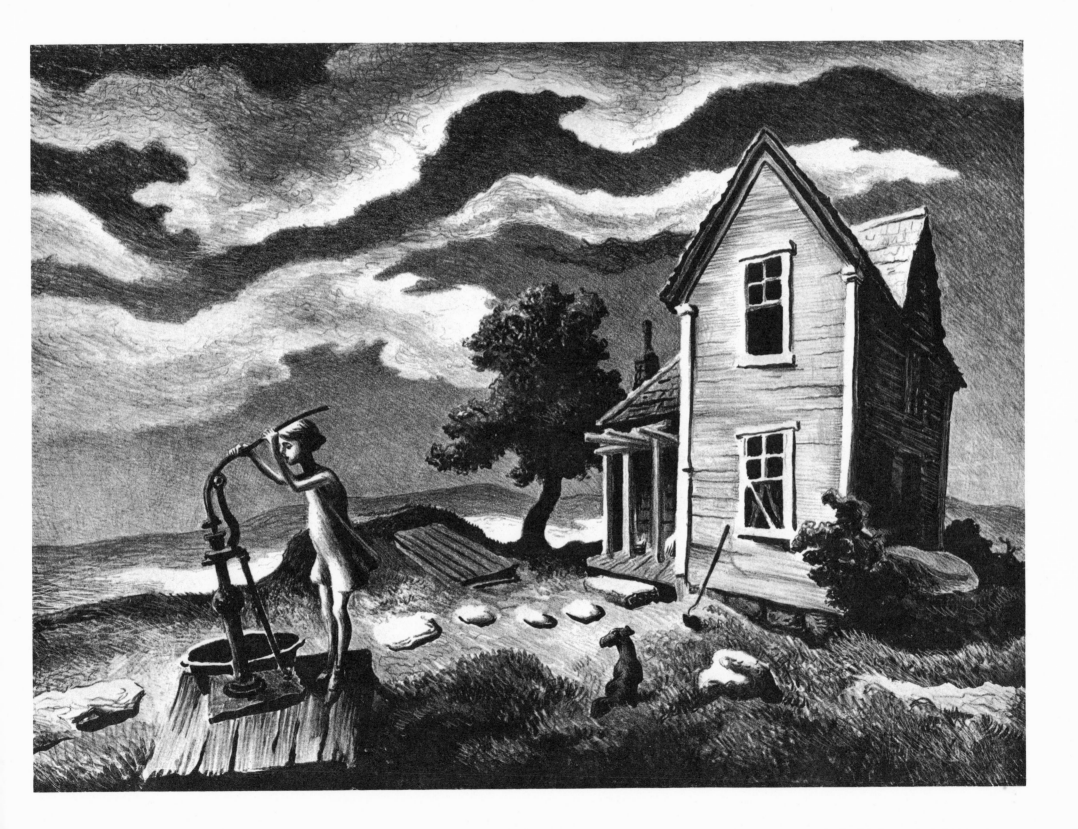

WRECK OF THE OL' 97

15 x 10¼
1944
Edition of 250
Circulated by Associated American Artists, New York City.

Everybody knows the song. It has been popular from one end of the country to the other. Cowboys sing it, people who live in the southern Appalachians sing it, as well as those who live in the Ozarks, and out on the prairie farms. It has even found its way to the fishing coasts of New England.

Goin' down grade at ninety miles an hour, Ol' 97 hit a broken rail and hell busted loose. This picture shows the moment just before the bust.

The song doesn't say who saw the affair, but somebody must have, and it could just as well have been people like those in the wagon. I put 'em in anyhow (Thomas Hart Benton, *Patron's Supplement No. 27,* Associated American Artists).

Wreck of the Ol' 97

(This song was inspired by a wreck of Southern Railroad's Train No. 97 at Stillhouse trestle just out of Danville, Virginia, September 27, 1903.)

They gave him his orders at Monroe, Virginia
Saying, "Steve, you're way behind time,
This is not Thirty Eight, but it's Ol' 97
You must put her in Spencer on time."

He looked around and said to his black greasy fireman,
"Just shovel in a little more coal,
And when we cross that White Oak Mountain
You can watch Ol' 97 roll."

It's a mighty rough road from Lynchburg to Danville,
And a line on a three-mile grade;
It was on that grade that he lost his air brakes
And you see what a jump he made.

He was going down grade making 90 miles an hour,
When his whistle broke into a scream—Wooo, Wooo.
He was found in the wreck with his hand on the throttle,
Scalded to death with the steam.

Now, ladies, you must take warning,
From this time and on you must learn,
Never speak harsh words to your true loving husband,
He may leave you and never return.

"Famous "folk song" of the '20s. Not a "true" folk song but one of the "synthetics" of the time based on an old folk tune. Drawing made in winter of 1926-27 - either that made in early 40s painting of this subject was purchased by Sears Roebuck Co and a print of it was circulated by the firm during the 40's and early 50's. Don't know where the painting is now!

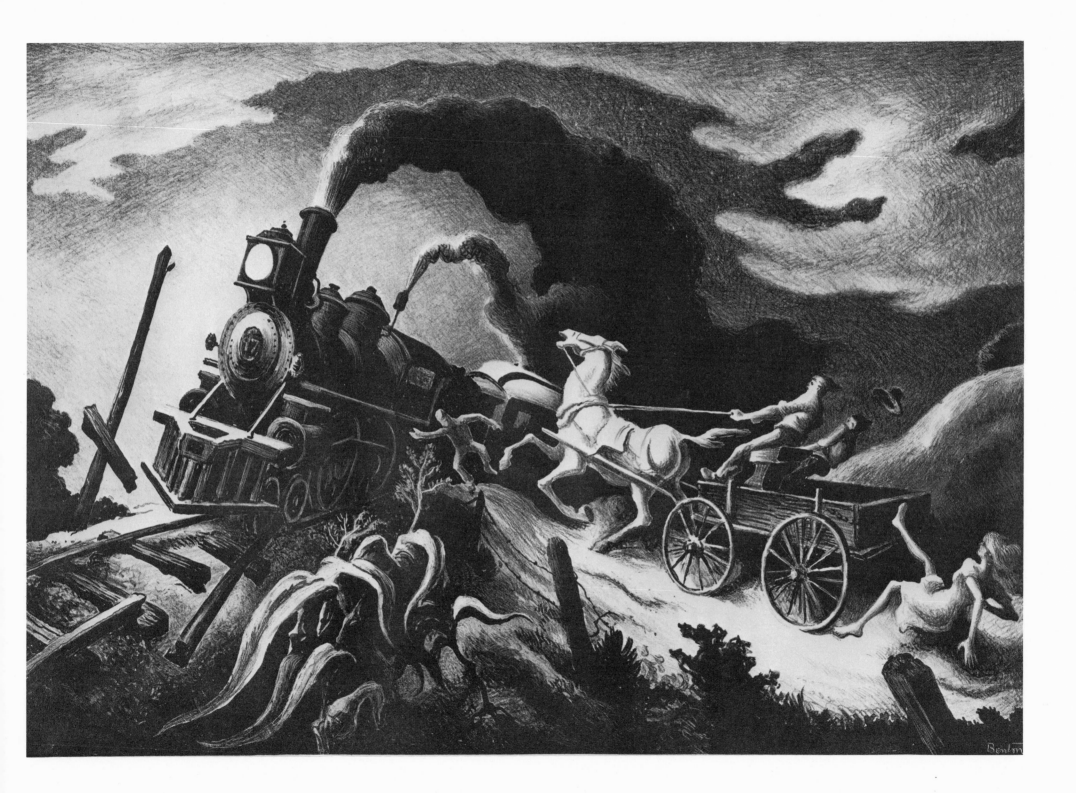

FIRE IN THE BARNYARD

13⅜ x 8¾
1944
Edition of 250
Circulated by Associated American Artists, New York City.

A painting preceded the lithograph. The painting is in the collection of Robert Strauss, Houston, Texas.

This picture was made from a memory of my childhood. My grandfather "Pappy" Wise had a cotton farm a few miles, 5 or 6, out of Waxahachie, Texas and one night when I was about 7 or 8 yrs old a great light appeared in the sky. It was so great that speculation about the end of the world was bruited about among the grown folks at the farm. As it turned out a straw stack had caught fire on an adjoining farm and some small tool sheds and part of a fence was burned. We all visited the place next morning and heard tell of how the farmer and his sons had got the scared horses out of the barn. Such things are immensely impressive to young uns.

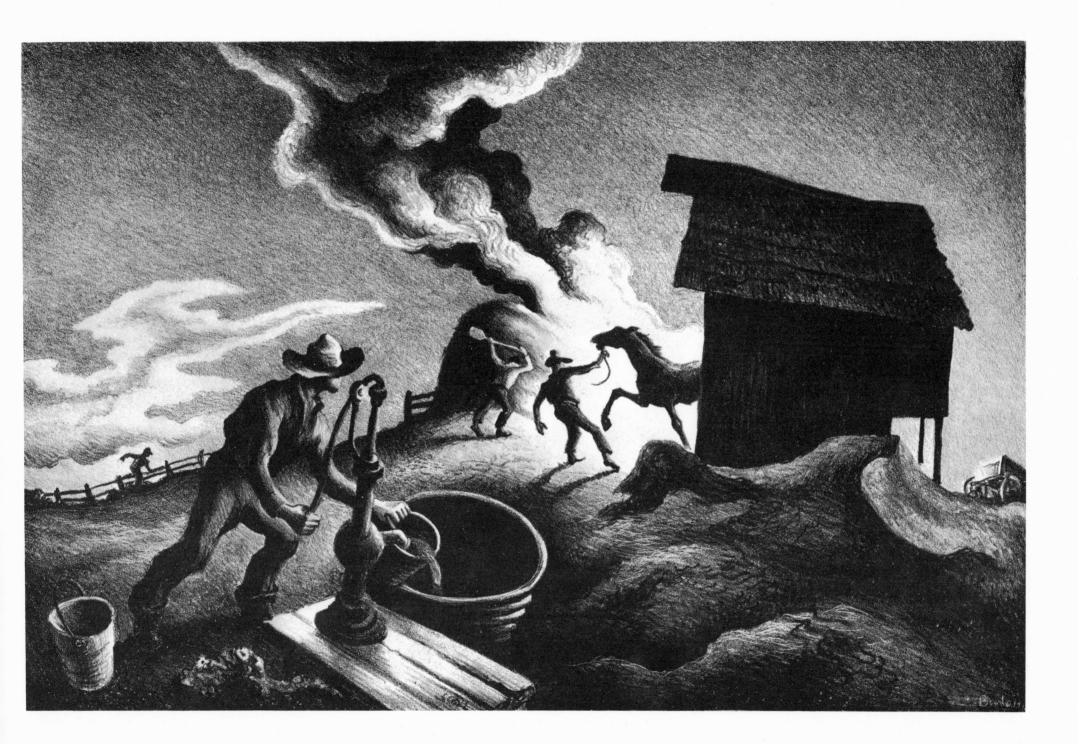

LOADING CORN

also titled *Shucking Corn*

13¼ x 10¼
1945
Edition of 250
Circulated by Associated American Artists, New York City.

The lithograph preceded a painting *Shucking Corn*. The present location of the painting is not known.

Dear Mr. Benton:

I think that your lithograph, "Loading Corn," is one of the most beautiful lithographs in the collection I have formed.

However, I would like to know your reasons for the sort of distortion you see in the corn shocks and the figures of the men. I realize that by this distortion you have given a more dramatic aspect to your drawing, but I do not completely understand the reason or reasons behind it. In reality to me clouds are puffy whirling masses of air. In your drawing clouds become hard and fixed shapes. Do clouds really look the way you draw them, or is it an intellectualized process which passes through your mind?

Very sincerely yours,
Mrs. Eugene O. Davenport

Dear Mrs. Davenport:

When, as you say, you "realize" that what you call distortion in the lithograph "Loading Corn" produces drama, it seems to me you understand perfectly the reasons for it. Distortion, however, is a difficult word. In common usage, it designates that which is disagreeable to attitudes of mind already set. Your political opponent distorts the truth. Of course, he does. His message is not the truth but an expression of an attitude toward it. So is your own message, if you have one. And so is mine.

The realities of your clouds are your own realities. In your letter you express them verbally. But you there express not what you see but what you know. Mostly I express what I see. I do so, also, in accordance with a logic of style and technique which aims not only to produce drama but to unify the different facts involved in the act of seeing. Reality can be found in an Art only if you accept the terms of its peculiar logic. This is because the artist's reality, like your own, for that matter, is an interior fact of the mind, and can only be expressed by logical structures also emanating from the mind. These structures do not give truth but cohesive statements about some of its aspects.

Art is not Nature, not facts, nor realities, nor truths existing outside man but the expression, imitation, or representation of these as man perceives them and organizes them so they may be presented as FORM in some objective material.

The clouds of "Loading Corn" are not "real" clouds, but representations of clouds in a logical scheme. They are forms within the total FORM of the whole lithograph (Thomas Hart Benton, *Bulletin* from *Patron's Supplement No. 33*, Associated American Artists).

Autumn in Missouri. To be seen on most hill farms. The problem with these subjects is not to find them, but to find them in a pictorially workable setting

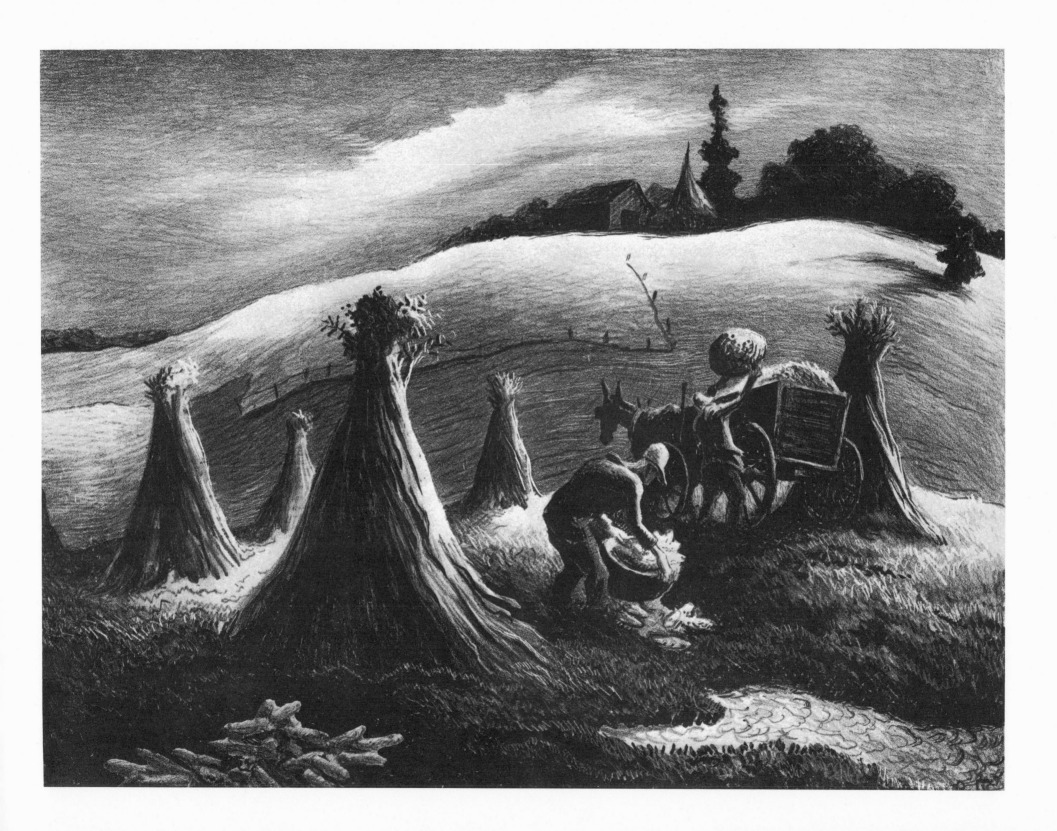

BACK FROM THE FIELDS

12⅞ x 9³⁄₁₆
1945
Edition of 250
Circulated by Associated American Artists, New York City.

The lithograph preceded a painting *Back from the Fields*.
The present location of the painting is not known.

This is a louisana scene. Cotton pickers returning home with the last bags picked

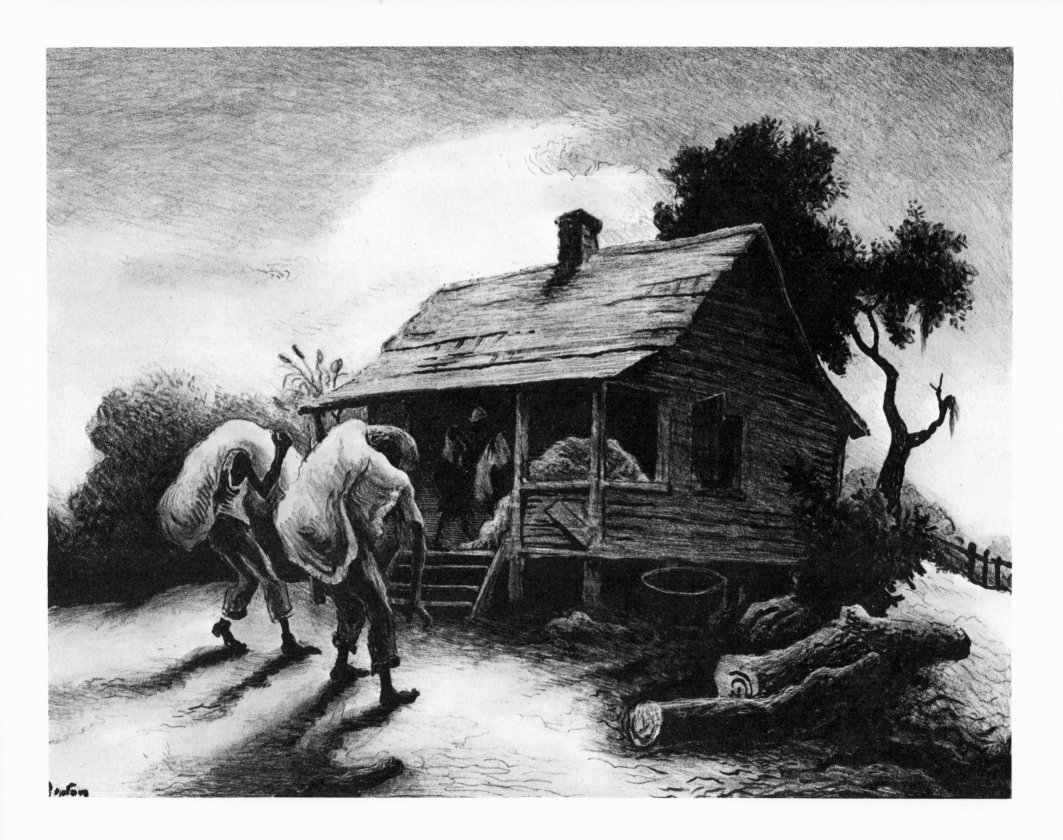

WHITE CALF

13¼ x 10¾
1945
Edition of 250
Circulated by Associated American Artists, New York City.

Henry Look of Chilmark, Martha's Vineyard
milking his cow. Henry had a good
deal selling his milk until some prying
summer persons found him straining it
in his snot filled handkerchief. Trade
with Henry dropped off after that.

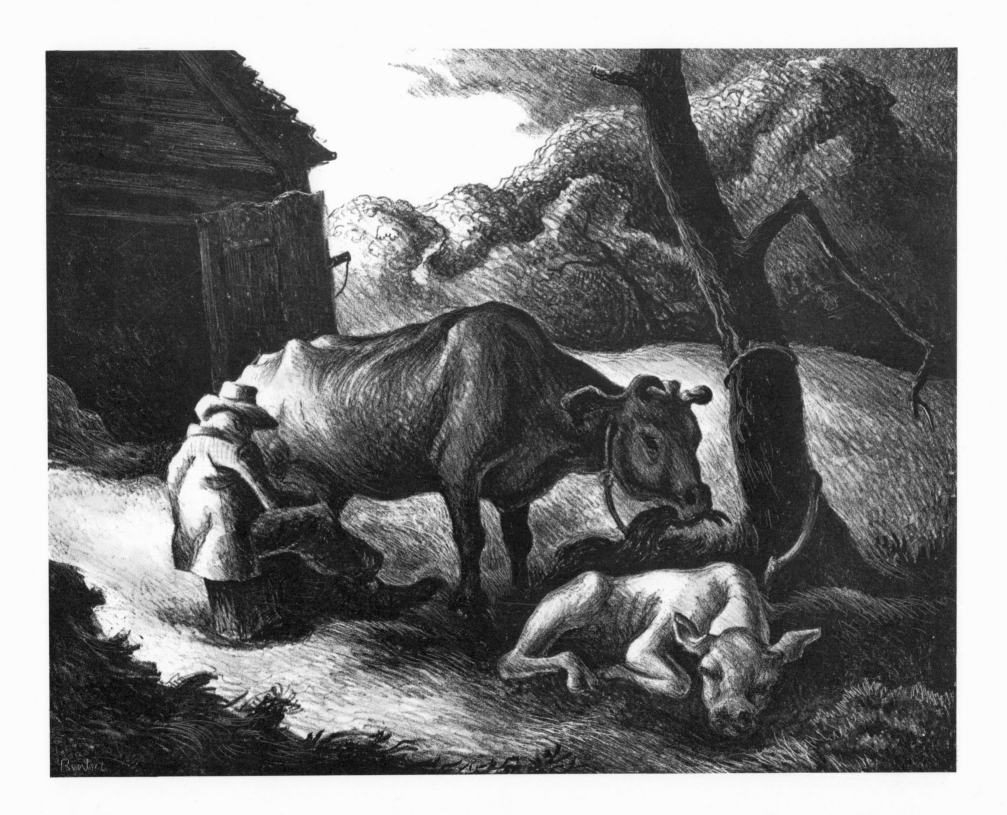

Benton

ISLAND HAY

12⅝ x 10
1945
Edition of 250
Circulated by Associated American Artists, New York City.

The lithograph was a study for a painting *Island Hay* which is in the collection of the artist.

In the uneven fields on [Martha's Vineyard] the reapers still mow with their long scythes, for the contour of the small fields makes a reaping machine impractical. Much of the land has never been completely plowed and leveled, and all kinds of obstacles stand in the way of modern machine methods (Thomas Hart Benton, *Patron's Supplement No. 34*, Associated American Artists).

Drawing was made on Marthas Vinyard in the middle twenties. Sythe cutting of hay was common there at the time — and is still resorted to for small patches.

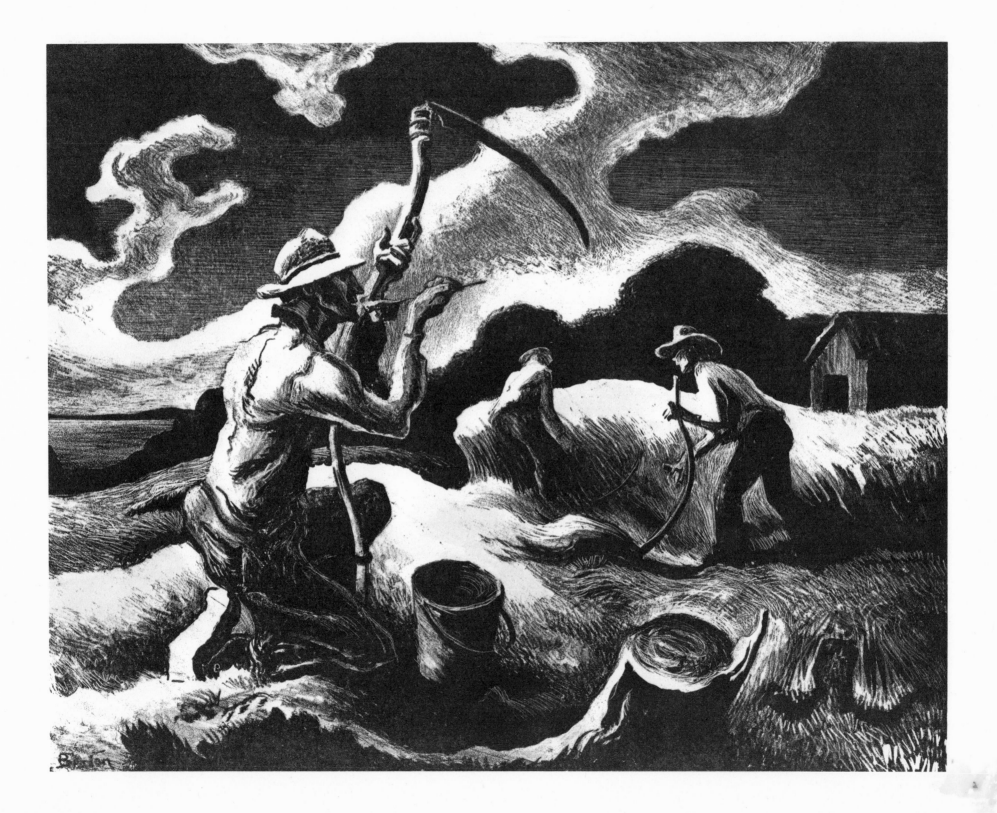

GATESIDE CONVERSATION

14 x 9⅞
1946
Edition of 250
Circulated by Associated American Artists, New York City.

A painting *Gateside Conversation* was made prior to the litho-
graph. The painting is in the collection of John Paxton, Fort
Worth, Texas.

From a drawing made in southern Louisiana
in the early 40s. A painting of this subject is owned
by John Paxton of Ft. Worth, Texas.

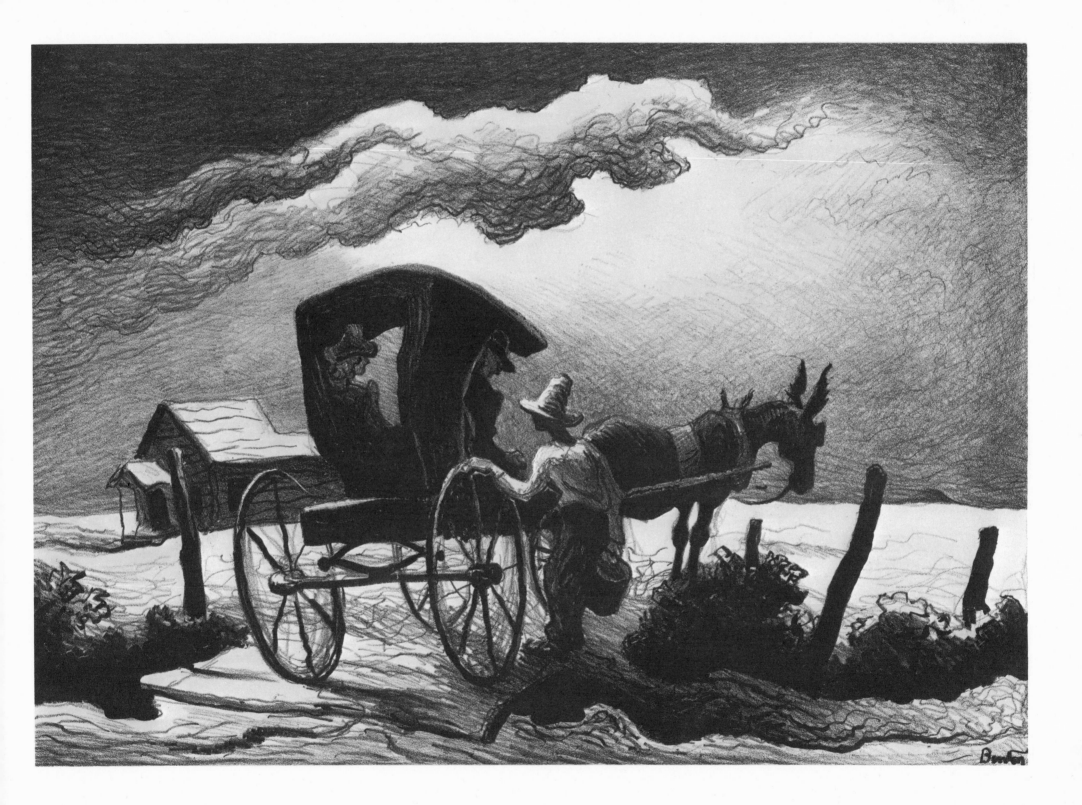

AFTER THE BLOW

13⅞ x 9¾
1946
Edition of 250
Circulated by Associated American Artists, New York City.

The lithograph preceded a painting *After the Storm* which was
completed in 1952. The painting is in the collection of Mr. and
Mrs. Walter J. Barkowitz, Kansas City, Missouri.

made for myself but eved The edition to A.A.A.

*On one of the hurricanes which hit Marthas Vineyard
in the early 40's this schooner came ashore. A life line
is being thrown to the men still aboard.*

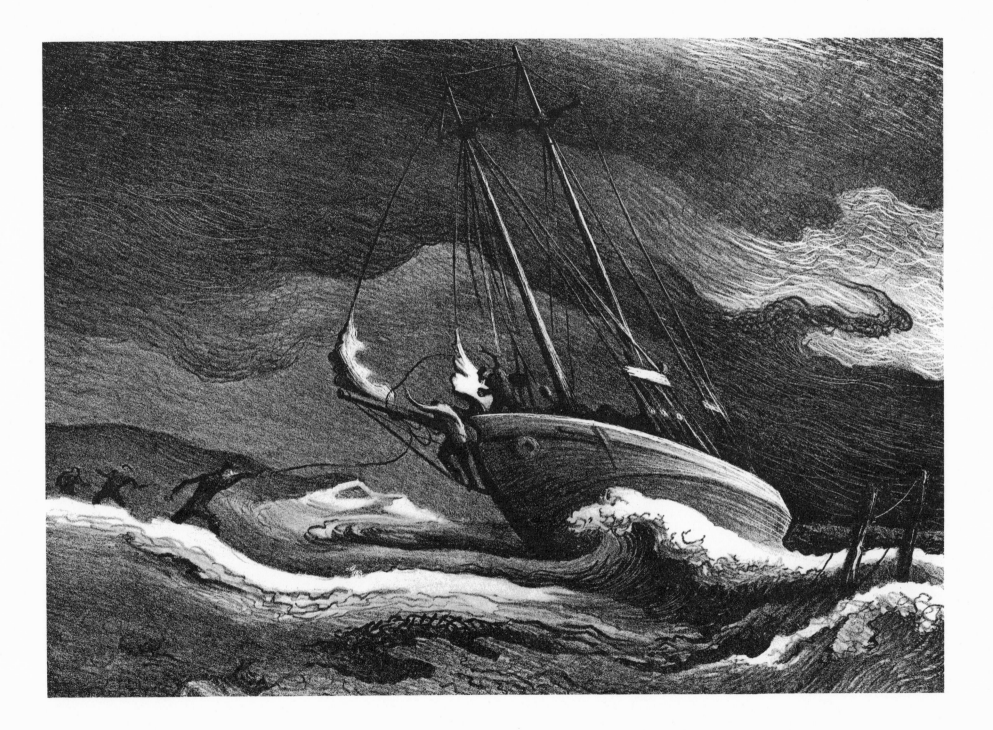

THE CORRAL

13⅝ x 9⅜
1948
Edition of 250
Circulated by Associated American Artists, New York City.

The lithograph preceded a painting *The Corral,* executed in tempera on paper. The present location of the painting is not known.

Done for myself but distributed by A. A. A.

Scene in eastern Nebraska - sand hills country.
It was made during a trip through the plains country, Neb. The Dakotas, Eastern Wyoming and Montana - with Col. Graham U.S.A. and a Veterinarian - buying quarter horses for French light artillery. Many drawings were done on this expedition. The trip was in the late summer of 1939.

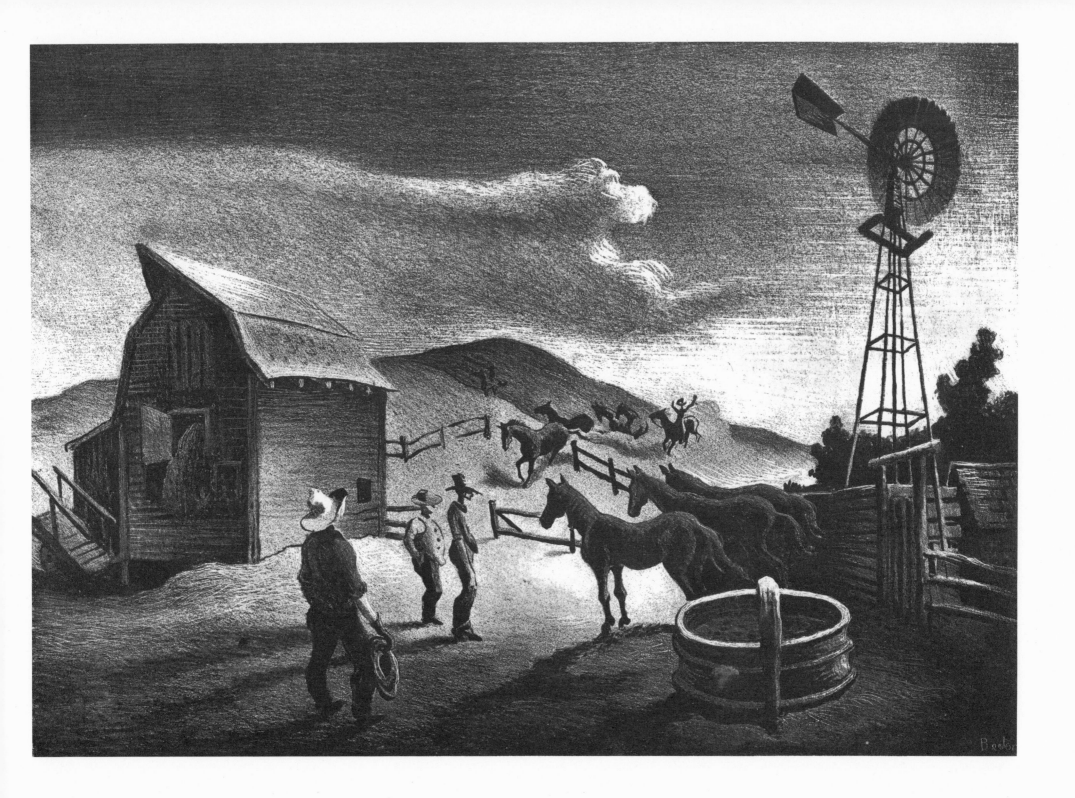

THE BOY

13¾ x 9½
1948
Edition of 250
Circulated by Associated American Artists, New York City.

The lithograph was a study for a painting *The Boy*. The painting is in the collection of Albert Hydeman, York, Pennsylvania, and Gay Head, Martha's Vineyard, Massachusetts.

Done for myself as study for a painting Edition sold to A.A.A.

Ozark boy setting out from home - to go to school or to find work. The folks and his horse say 'good bye'.

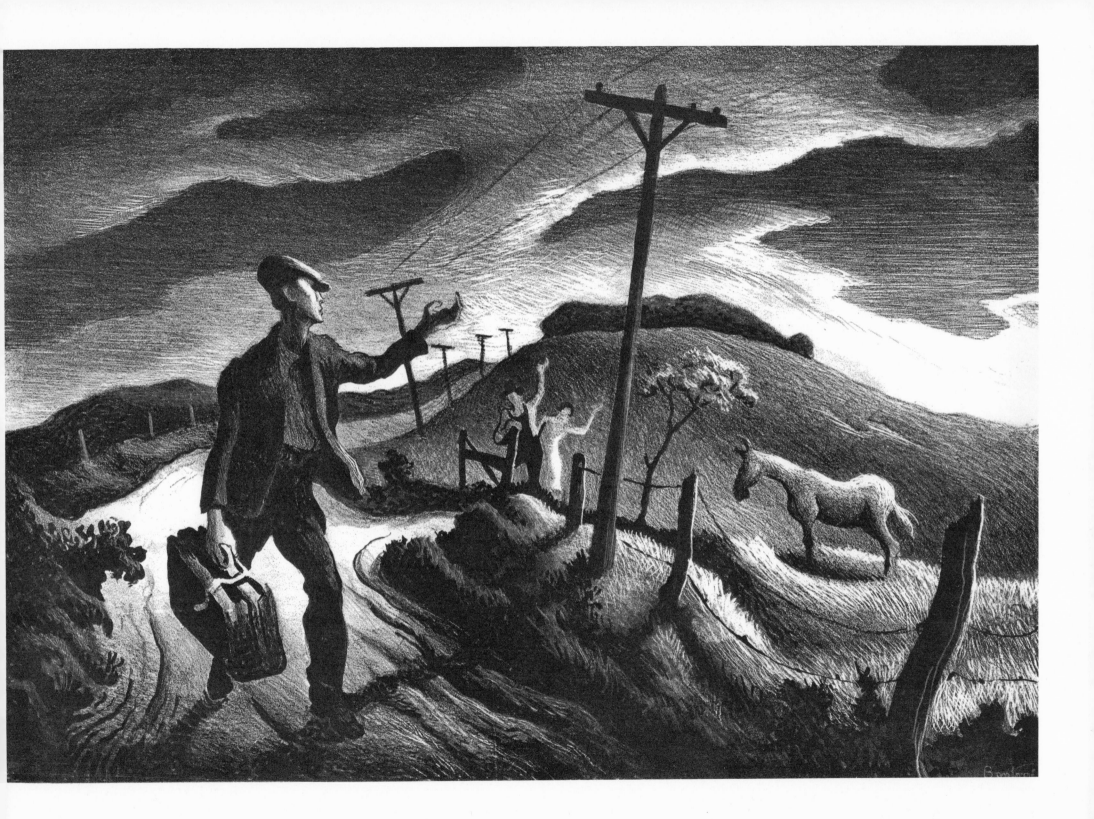

PRAYER MEETING

also titled *Wednesday Evening*

12⅜ x 9
1949
Edition of 300

Commissioned by Dr. Clarence R. Decker, President of the University of Kansas City, Kansas City, Missouri (now the University of Missouri at Kansas City), and circulated by the Bookstore of the University of Kansas City.

The lithograph was a study for a painting, *Wednesday Evening*. The painting is in the Museum of Fine Arts, Springfield, Missouri.

Wed. evening is prayer meeting time, in
the mid week, over all of the "Bible belt".
The scene could be anywhere south of the
Mason Dixon line

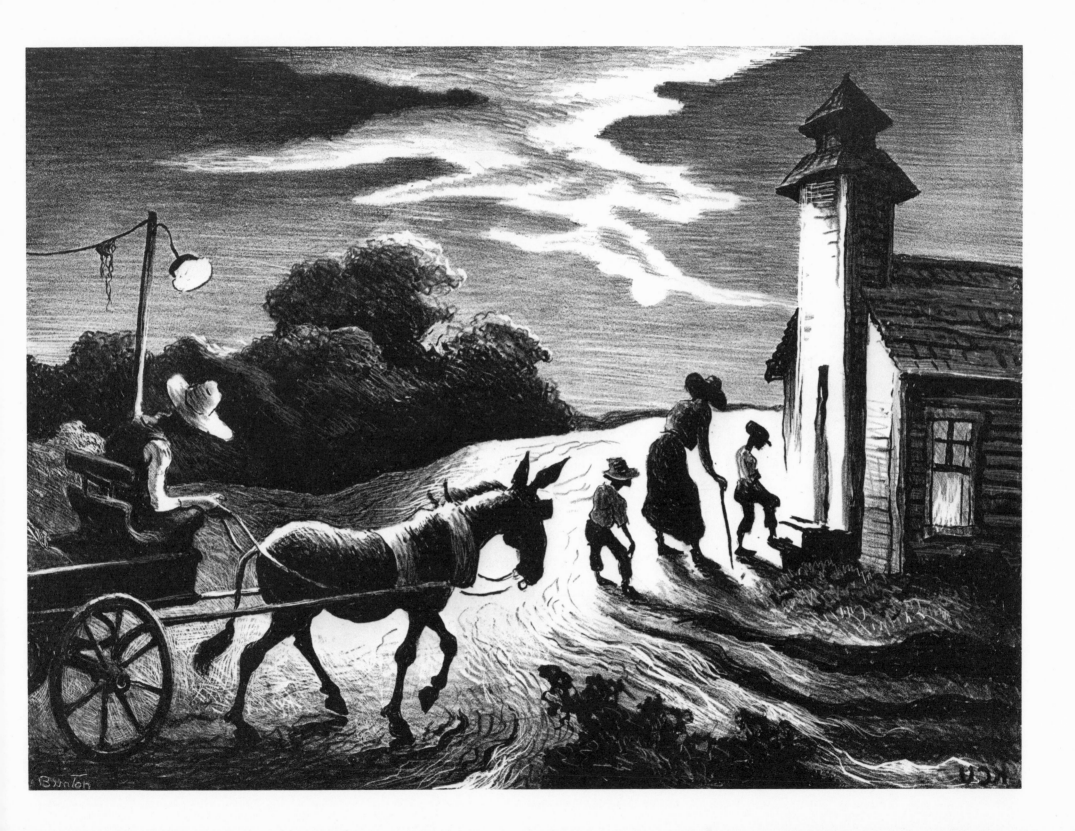

THE HYMN SINGER

also titled *The Minstrel*

12⅜ x 16
1950
Edition of 500
Circulated by Twayne Publishers, New York City.

This is a characterization of Burl Ives.

Burl visited me in Kansas City in 1950, returning from Hollywood, with a beard which had been grown for a part in some southern movie story. He sang some old southern hymns which produced the idea for this print and a life size portrait. The latter still in my possession.

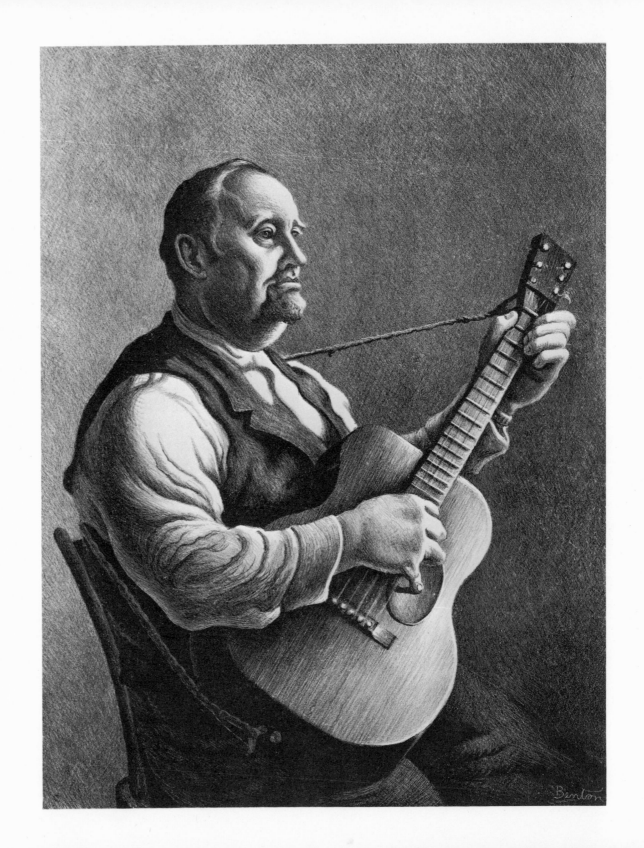

PHOTOGRAPHING THE BULL

16 x 11¹⁵⁄₁₆
1950
Edition of 500
Circulated by Twayne Publishers, New York City.

A painting of this subject, *Photographing the Bull,* is in the collection of Ralph Ritter, Kansas City, Missouri.

Study made while preparing the mural "Achelous and Hercules" for the Harzfeld Store in K. C. This shows an attempt to get a young bull to stand on a straw carpet for his photograph.

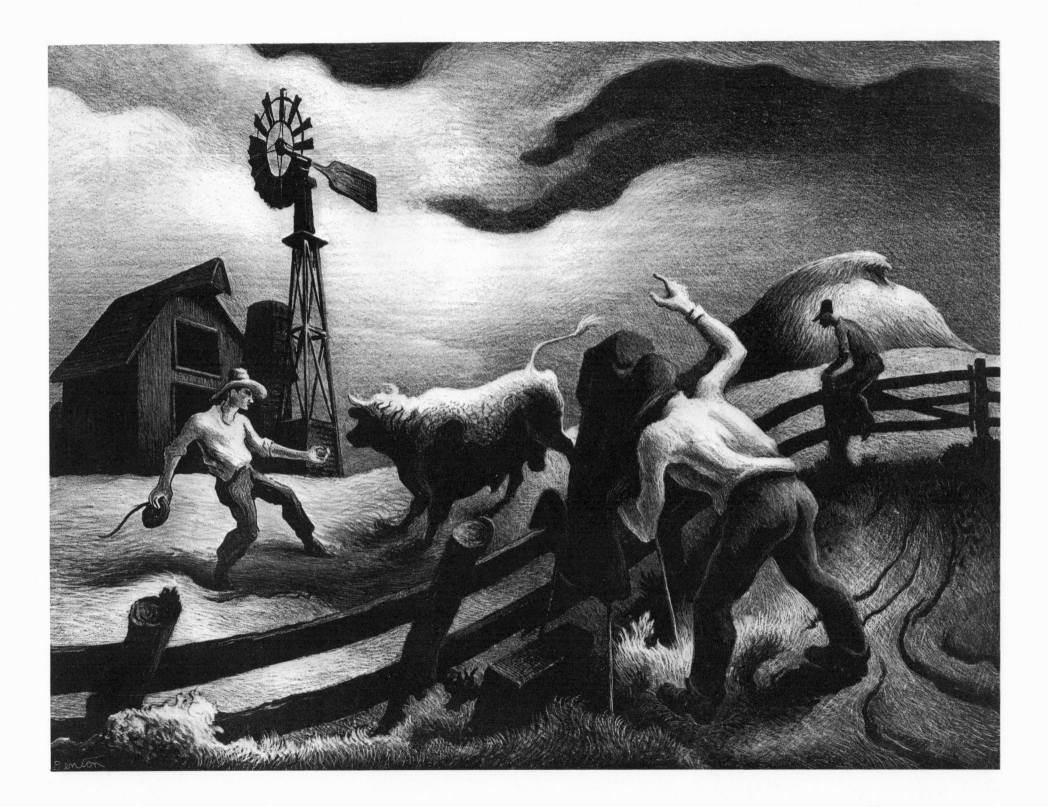

NEW ENGLAND FARM

13¹⁵⁄₁₆ x 9
1951
Edition of 300
Commissioned and circulated by The Friends of Art of Kansas State University, Manhattan, Kansas.

A painting *New England Farm,* tempera on paper, preceded the lithograph. The painting is in the collection of Morris Primoff, New York City.

This is a haying scene on the Marthas Vinyard farm of Denys Wortman, famous N.Y. newspaper cartoonist.

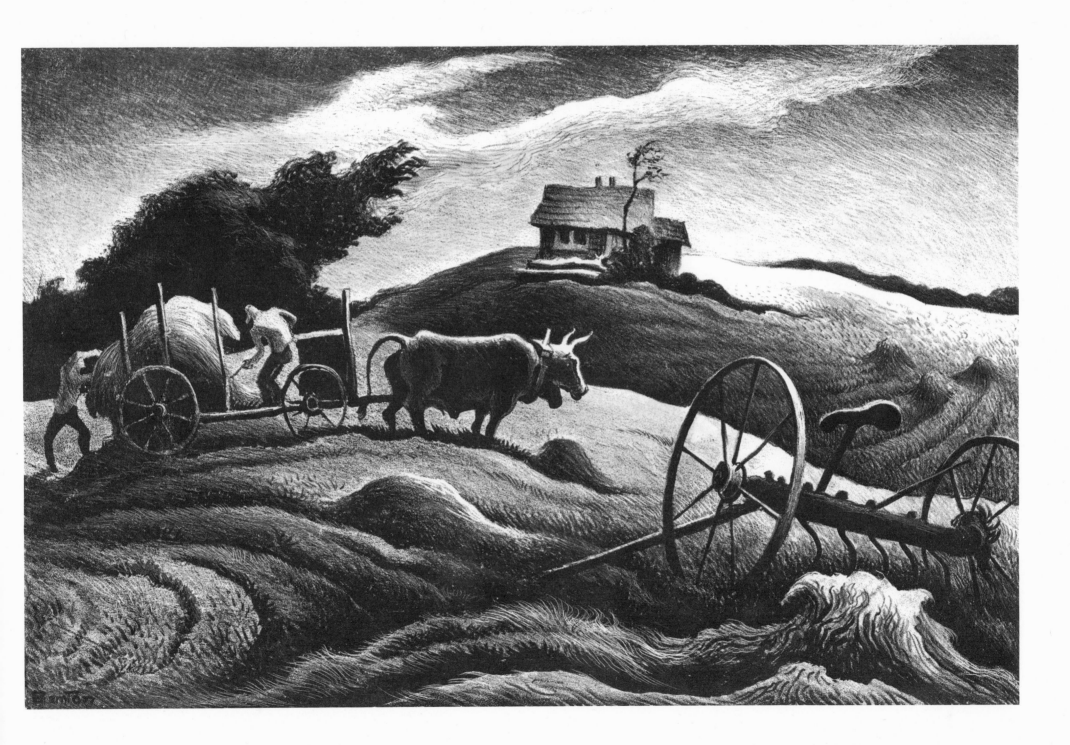

WEST TEXAS

10¹⁵⁄₁₆ x 13⅞
1952
Edition of 300
Commissioned and circulated by the Southern Methodist University
Press, Dallas, Texas.

Scene in the Texas panhandle — a little
west where the mesa-like formations show up.
Drawing made about 1944.

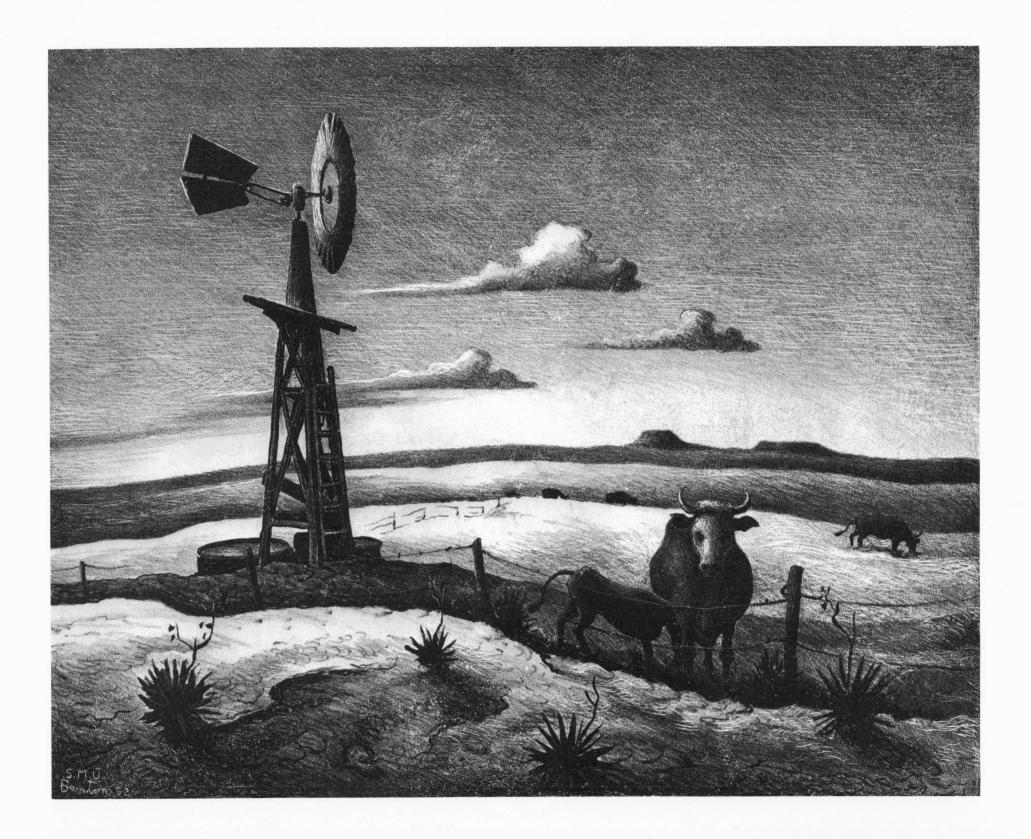

RUNNING HORSES

16⅜ x 12½
1955
Edition of 100
Seventy-five prints of this lithograph were turned over to Associated
American Artists, New York City, for circulation in 1964.

Again, horses running with a steam train

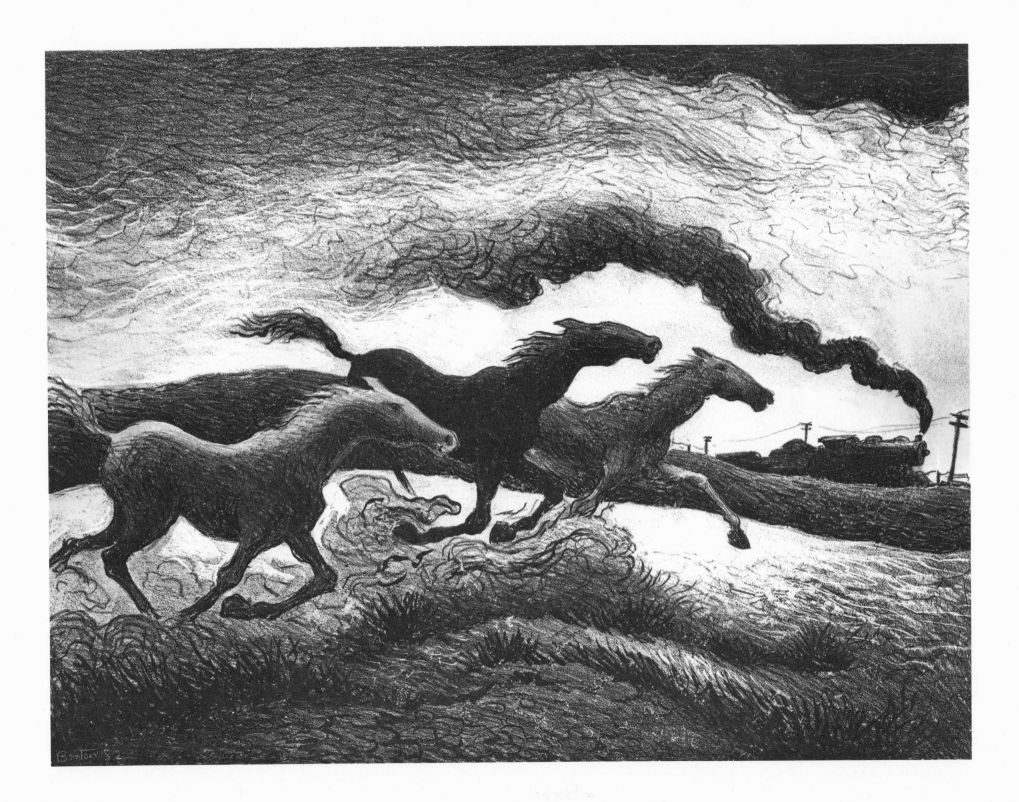

TEN POUND HAMMER

9¹³⁄₁₆ x 13¹³⁄₁₆
1967
Edition of 300

Old story of my youth – before
the steam hammer beat out
John Henry.

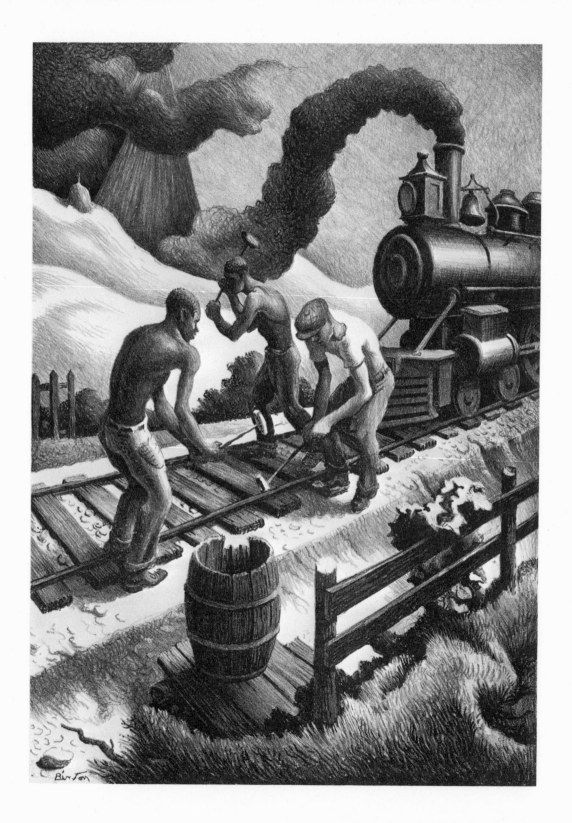

THE LITTLE FISHERMAN

10 x 14⅛
1967
Edition of 300

Not much story. Britt Adler a
boy of our neighborhood posed for it
some fifteen years ago. Based on
a common incident in Missouri
country — a boy, on the lake or
river bank, baiting his hook. No
doubt the same occurs in Texas
wherever, and whenever, there's water
and fish.

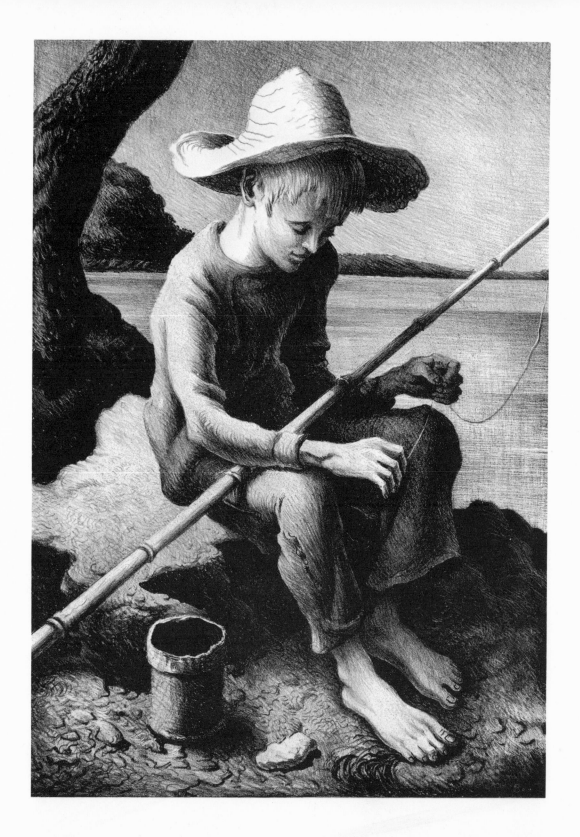

Chronology and Bibliography

(The chronology is adapted from "A Chronology of My Life," by Thomas Hart Benton, in the catalogue of the retrospective exhibition of Benton's work presented under the patronage of The Honorable Harry S. Truman and Mrs. Truman of Independence, Missouri, at The University of Kansas Museum of Art, Lawrence, Kansas, April 12 to May 18, 1958. Additional material and partial bibliography have been added as background for the lithographs. The paragraphs in quotation marks were written by Mr. Benton.)

1889 Born April 15, Neosho, Newton County, Missouri; son of "Colonel" Maecenus Eason Benton and Elizabeth Wise Benton. Colonel Benton was born in Obion County, Tennessee, attended two western Tennessee academies and the University of St. Louis, Missouri, was graduated from the law department of Cumberland University, Lebanon, Tennessee, in 1870, and soon thereafter commenced the practice of law in Neosho, Missouri. He was appointed United States Attorney for the Western District of Missouri by President Grover Cleveland, serving from March 1885 to July 1889. Colonel Benton sided with Senator George Vest of Missouri in an altercation with Cleveland about the President's preferences for Eastern Capitalists. Vest had said that under Cleveland's policies "the Missouri Cow had its head in Missouri, where it was fed, but that Cleveland kept its 'tits' in Wall Street, where it was milked." Benton so vociferously supported Vest that Cleveland suspended him from office for "offensive partisanship." However, political outcry over Missouri was so great that Cleveland promptly backed off and reinstated Benton. This was the first and only time "offensive partisanship" was used as an excuse for political pressure. Thomas Hart Benton was named for his father's grand uncle, for thirty years the United States Senator from Missouri, friend of Andrew Jackson, eloquent statesman out of America's great past, one of the ruling voices of America in the age that included Webster, Clay, and Calhoun.

1894 "Began drawing Indians and railroad trains. Executed first mural with crayons on newly papered staircase wall in Benton home in Neosho. Work unappreciated."

1896 Colonel M. E. Benton elected to Congress. He served in the Fifty-fifth, Fifty-sixth, Fifty-seventh, and Fifty-eighth congresses, 1897–1905. During the sessions the Bentons lived in Washington, D.C.

1897–1899 "Grade schools in Washington, D.C. First introduced to formal art in the Library of Congress and the Corcoran Gallery in Washington."

1900–1904 "Finished grade school. Met Buffalo Bill and saw his Wild West Show. Had first training in art at Western High School in Georgetown, Washington, D.C. Visited St. Louis World Fair. Saw first Remington pictures and shook hands with the last fighting Indian chief, Geronimo. Returned, with father's political defeat, to all year residence in Neosho."

1905–1906 "High School in Neosho. Began acquiring steady reading habits in father's library and with dime novels in the hayloft. Continued drawing work in summer of 1906 as surveyor's assistant (rodman), around Joplin, Missouri, mining field. Found position as cartoonist on Joplin American—first professional work as artist."

1906–1907 "Attended Western Military Academy at Alton, Illinois, until

February, when serious study of art was begun at Chicago Art Institute. Abandoned plans of doing newspaper work and took up painting."

1908–1911 "Went to France. Enrolled at Académie Julien, Paris. Made first approach to classic composition and to anatomy and perspective. Learned French. Attended lectures and musical events. Developed life-long attachment to chamber music at concerts at the Salle Pleyel and the Salle Wagram. Painted in various opposed manners from "academic" chiaroscuro of Académie Julien to "pointillist" landscape. Met and associated with many personalities later to become famous in the art world, such as Leo Stein, brother of the famous Gertrude, John Marin, Jacob Epstein, Jo Davison, André Lhote, Diego Rivera, Morgan Russell, and Stanton MacDonald Wright. Was an habitué of cafes and studios where problems of new art were vociferously discussed. Stimulated by work in galleries of the Louvre, began study of art history. Read extensively in French literature, aesthetics and philosophy, along with classics. Became acquainted with work of Balzac, Baudelaire, Verlaine, Gautier, de Musset and other writers who were in vogue at the time. Read Hippolyte Taine's *Philosophie de L'Art,* whose environmentalist aesthetic was to have its full effect later when American 'Regionalism' became an issue in the art world. Influenced by Zuloaga, well-known Spanish painter, and became interested in Spanish school, chiefly in the works of El Greco."

1912 "Returned to America, and made an abortive effort to settle in Kansas City, then moved on to New York."

1913–1916 "Struggle to make a living and find a 'way of painting.' Occasional commercial art jobs, decorative work in overglaze ceramic, set designing, historical reference and portrait work for the moving picture industry, then mostly located at Fort Lee, New Jersey, across the Hudson from New York. Worked with directors, Rex Ingram and Gordan Edwards, and with such stars of the day as Theda Bara, Clara Kimball Young, Stuart Holmes, etc. Set up a studio in an old house at Fort Lee, and met Walt Kuhn, "Pop" Hart, Arthur B. Davies and other artists who frequented the west side of the Hudson River. Tried acting, unsuccessfully. Met Alfred Stieglitz and frequented his gallery at 291 Fifth Avenue. Intimates of the period were Rex Ingram, the movie director, Thomas Craven, then a poet and teacher, Willard Huntington Wright, art critic and editor of *Smart Set,* known later as S. S. Van Dine of detective story fame, Ralph Barton, famous caricaturist, and Stanton MacDonald Wright, earlier friend who had returned from Paris, now war-ridden. In Spring of 1916, had first public exhibition with a series of paintings in the Forum Exhibition of Modern American Painting held at Anderson Galleries in New York. These paintings, though mostly 'figurative,' were variants of the synchromist 'form through color' practices of Morgan Russell and S. MacDonald Wright. They were highly generalized, purely compositional and contained no hint of the environmentalist work of later years. Began to sell an occasional picture. Joined 'People's Art Guild,' founded by Dr. John Weischel, a mathematician, social theorist and critic well known in 'radical' circles of New York. The 'People's Art Guild' dominated by socialist theory, was designed to bring art to the workers and to enlist the interest of the unions. At the Friday night discussions of the Guild was introduced to the thinking of Owen, Prud'hon and Marx. Ideas about the social meanings and values of art were germinated in these discussions. These were to have fruit later. Met Bob Minor, Max Eastman, John Sloan, Mike Gold, and the other 'radical' artists of the old *Masses* magazine. Entered into first controversies at Stieglitz 291 gallery on future values of 'representational' versus 'abstract' art. This was the beginning of a series of controversies on the purpose and meaning of art which was to last for more than thirty years. Met an extraordinary income producing patron, Dr. Alfred Raabe, who picked up studio experiments, framed them and sold them to his patients in the Bronx."

Europe After 8:15 by H. L. Mencken, George Jean Nathan, and Willard Huntington Wright, with decorations by Thomas H. Benton, published by The John Lane Company, New York, 1914.

1917 "Through 'People's Art Guild' obtained position as gallery director and art teacher for 'Chelsea Neighborhood Association' on the lower West Side, which was supported by well-to-do-conservatives, but followed the social directions of the 'People's Art Guild.' It had little success but provided a skimpy living in the difficult period of America's entrance into First World War."

1918 "Enlisted in U.S. Navy. Shovelled coal for a month, engaged in Saturday night athletic exhibitions, boxing and wrestling, and ended up finally as draughtsman at Norfolk Naval Base. Sketched constantly during 'off-duty' periods. Spent evenings reading an old fashioned American history: "History of the United States" in four volumes by J. A. Spencer, published in New York in 1866, the engravings of which generated the first thoughts of making a pictorial history of the United States."

1919 "Returned to New York with Navy discharge and collection of drawings and watercolors of naval base activities. Though at times semi-abstract, this was first work based wholly on environmental obervations—on the American scene. It was shown at the Daniel Galleries and received considerable public attention. Continued reading American history and conceived idea of a series of large paintings to illustrate its progressions. This constituted a return to mid-19th century subject painting and involved a definite break with modern theory which was moving away from representational concern towards pure abstraction. Started tentative designs for this historical project and to increase their objectivity began modelling the designs in clay. This was a frank return to Renaissance method, whose emphasis, involved with chiaroscuro and realistic form rather than color patterns, caused another step away from accepted modern theories."

1920–1924 "Continued moving towards 'realistic' subject painting, and present style of painting developed, largely determined by practice of modelling compositions. Pictures began attracting considerable attention and argument. Participated in 1922 Philadelphia Exhibition of Modern Americans and sold a large work to the famous Philadelphia collector, Albert C. Barnes. Married Rita Piacenza. Began diagrammatic analyses of the compositional history of occidental painting. This project was undertaken for Albert Barnes, but because it failed to jibe with his growing 'color-form' theories, it led to disagreement and was never finished. Sections of it were later published in the *Arts Magazine* (1926–27). Began showing series of paintings on American historical themes at the Architectural League in New York. These were mural-sized works. They were controversial because, with their sculptural and three-dimensional character, they were in opposition to prevalent beliefs of architects and critics that mural paintings should not break wall surfaces but remain flat and linear in the manner of the French muralist, Puvis de Chavannes. Published first theoretical paper 'Form and the Subject' in *Arts Magazine*, June, 1924. During the period began exploring the 'back-country' of America by foot, bus, and train, searching out American subject matter."

In November 1924 there was an exhibition of Benton's paintings at the Daniel Gallery, New York City.

1925 "Thomas Hart Benton, American Painter," by Thomas Craven, *The Nation* (January 7, 1925).

1926 In January, 1926, there was an exhibition of "Portraits of New England Characters" by Thomas Hart Benton at the Artists Gallery, New York City.

"Thomas Hart Benton, American Modern," *Survey* (October 1, 1926).

1927 In February 1927 there was an exhibition of mural painting by Benton at The New Gallery, New York City, during the period of the Architectural League Exhibition.

"American Epic In Paint," by Lewis Mumford, *New Republic* (April 6, 1927).

1925–1927 "Gave series of lectures on art at Dartmouth College and at Bryn Mawr College. Thomas P. Benton, first child, born in New York City in 1926. Through influence of the famous draughtsman, Boardman Robinson, obtained permanent teaching position at the Art Students League in New York which supplied a much needed basic income. Debated with Frank Lloyd Wright on architecture and mural painting at Brown University, Providence, Rhode Island. Debate punctuated by complete disagreements on relation of architecture and painting. Purchased permanent summer home on island of Martha's Vineyard."

1928–1929 "Joined with José Clemente Orozco, famous Mexican painter then living in New York, in exhibitions at the Delphic Studios. Showed drawing and paintings of the current American scene, the outcome of the exploratory travels mentioned earlier. Among paintings were 'Boomtown' now at Rochester Museum, 'Cotton Pickers' now at Metropolitan Museum in New York, also 'Rice Threshing,'

now at Brooklyn Museum. Received commission with Orozco to do murals for the New School for Social Research. These murals were executed for little more than expenses, but offered opportunity for a public trial of the new mural styles." The Benton show at the Delphic Studios in October 1929 included the oil painting *Slow Train Through Arkansas* which was purchased by Thomas Beer. The drawings exhibited were divided into four groups: 'King Cotton,' 'The Lumber Camp,' 'Holy Roller Camp Meeting,' and 'Coal Mines.'

1930–1931 "Drawing upon mass of factual material gathered in travels, the New School mural, 'Modern America,' was painted. This was the first large scale American work executed with egg tempera. It was both widely praised and heavily criticized. Reproductions were published in magazines and newspapers all over the world. Through Thomas Craven met John Steuart Curry. Because of similar beliefs and interests, an enduring tie was made with Curry. It lasted until his death."

1932 "Received commission from Mrs. Juliana Force to do murals for library of Whitney Museum of American Art. Finished and unveiled in December. These murals again drew sharp criticisms. Fellow instructors at the Art Students League drew up a roundrobin letter of condemnation. The *New Republic* published a special article on the mural's inadequacies. Representing facets of ordinary American life and folk lore, the Marxist group of New York attacked the work as a form of chauvinism, as politically reactionary and 'isolationist.' A 'question-answer' appearance on the meaning of the murals at the John Reed Club, the center of artistic and literary radicalism in New York, wound up in a chair-throwing brawl and resulted in the loss of many old radical-minded friends. From this time on 'American Regionalist' works would never be free of the political charges—'reactionary' or 'isolationist.' "

In 1932 Benton also illustrated *We, The People,* by Leo Huberman, published by Harper & Brothers.

For the catalogue of the show for the opening of the Whitney mural Benton wrote a thirteen-page essay "The Arts of Life in America."

1933 "Given gold medal of Architectural League for mural work. Received commission and executed mural for the State of Indiana. This mural, 200 feet long by 12 feet high, was researched, planned and executed in six months of intensive labor. Covering the theme of social evolution of Indiana, it was shown as Indiana's exhibit at the 1933 Chicago World's Fair. It is now installed in the University of Indiana Auditorium at Bloomington. The work was well received. Criticism was chiefly leveled at the propriety of the subject matter; the inclusion of Indiana's Ku Klux Klan episode drew most of the objection."

1934 "Received commission from Treasury Department for a mural in new Federal Post Office in Washington. Abandoned work during planning stage because of difficulties in accommodating artistic ideas to those of Treasury's Art Commission. Took on a country-wide lecture tour on American Art. Speaking at Iowa University, met Grant Wood and, as with Curry, established an intimate and enduring friendship. After a lecture at Kansas City Art Institute, went with brother, Nat Benton, and State Senator Ed Barbour to Jefferson City where preliminary discussions about a mural for State Capitol were begun. Returning to New York had exhibit of paintings at Ferargil Galleries along with Grant Wood and John Steuart Curry, and thus became permanently associated with 'Regionalism' or the 'Regionalist School.' There was no such 'school' but the designation 'regionalist' stuck. *Time* magazine catapulted the 'school' into national attention with a Benton self portrait in color on its cover and a well documented article on the 'new American art.' Gave lecture to a large audience at the Art Student's League auditorium on 'American Art and Social Realism.' Bitter debate from the floor. This was followed by attacks in art magazines and pamphlets on 'provincialism' of regionalist aesthetics."

In July 1934 Benton began his association with Reeves Lewenthal and Associated American Artists, New York City. During the next fifteen years the series of lithographs by Benton on "The American Scene" circulated by Associated American Artists totaled some fifty stones.

1935 "Received commission for mural in Missouri State Capitol along with a request to head painting department at Kansas City Art Institute. Seeing in the latter a chance to escape continuing New York controversy promptly accepted. Moved to Kansas City. Spent the year teaching and planning Capitol mural."

"America and/or Alfred Stieglitz," by Thomas Hart Benton, *Common Sense* (January, 1935).

Interview with Thomas Hart Benton, New York *Times* (February 8, 1935), page 23.

"Answers to Ten Questions," by Thomas Hart Benton, *Art Digest* (March 15, 1935).

"What Future for the Negro?" by Lester B. Granger, illustrated by Thomas Hart Benton, *Common Sense* (April, 1935).

In the New York *Times* (December 22, 1935), Sec. IX, page 13, Benton debated in print with Diego Rivera. The *Times* article was adapted from the winter issue of *University Review* and titled "Art and the Social Struggle."

1936 "Executed Missouri mural. Here again a storm of criticism arose mostly, as in Indiana, about subject matter. Mural was given wide attention in the press. It eventually came to please, or at least interest, most Missourians and remains on the Capitol wall."

"In Darkest Cleveland," by Thomas R. Amlie, illustrated by Thomas Hart Benton, *Common Sense* (July, 1936).

"How Radical Is the New Deal," by Thomas R. Amlie, illustrated by Thomas Hart Benton, *Common Sense* (August, 1936).

1937–1938 "Wrote *Artist in America* for McBride publishing house in New York. Book autobiographical—chiefly a report on American travel. Very successful. Reported on 'sit-down' strikes in Detroit for *Life* magazine (July 26, 1937) with a series of on-the-spot sketches. Made for same magazine, a painting and a forty drawing commentary on Hollywood and the movie industry, latter not published. Made series of drawings on 1937 floods in Southeast Missouri for St. Louis *Post Dispatch* and Kansas City *Star*. Wrote and illustrated (1938) an article for *Scribner's* Magazine on Disney, Oklahoma, then on the boom. Painted 'Susannah and the Elders.' This once controversial nude now in Museum of the Palace of the Legion of Honor at San Francisco. Sold 'Cradling Wheat' to St. Louis Museum."

"Artist's Point of View," by R. M. Pearson, *Forum* (June, 1937).

"Confessions of An American," by Thomas Hart Benton, *Common Sense* (July, August, September, 1937), in three parts.

In December 1937 The Limited Editions Club announced awards to four artists selected to illustrate American literary classics of their own choosing. The artists were Thomas Hart Benton, John Steuart Curry, Reginald Marsh, and Henry Varnum Poor. In January 1938 The Limited Editions Club announced that Benton had selected Mark Twain's *Adventures of Tom Sawyer* to illustrate.

A letter by Thomas Hart Benton on "The Liberal and Anti-Fascism," *Common Sense* (November, 1938).

"The New American Art," by Thomas Hart Benton, St. Louis *Post Dispatch* (December 11, 1938).

1939 "Became interested in texture, an aspect of painting neglected during years predominately devoted to murals. Painted "Persephone," another highly publicized nude. Purchased present Kansas City home. Jessie P. Benton born. Had retrospective exhibition at William Rockhill Nelson Gallery in Kansas City, which went afterward to Associated American Artists' new galleries in New York. From this exhibition, Metropolitan purchased its second Benton 'Roasting Ears.' All except the very large works in this exhibition were sold. This was first substantial success with a New York exhibition."

"A Descriptive Catalogue of the Works of Thomas Hart Benton," by Thomas Craven, was published by the Associated American Artists (April 12, 1939).

Benton was commissioned by Twentieth-Century Fox Film Corporation to do a series of drawings portraying the characters of John Steinbeck's *The Grapes of Wrath*.

The Limited Editions Club *Adventures of Tom Sawyer,* illustrated by Thomas Hart Benton (December, 1939).

1940–1942 "Illustrated John Steinbeck's 'The Grapes of Wrath' for The Limited Editions Club. Lecture tour, teaching, experiments with texture painting and increased coloration occupied my attention at this time. New interest in Flemish Renaissance painting stimulated partly by Grant Wood and partly by exhibitions of such paintings held at

Nelson Gallery in Kansas City. Fired from position at Kansas City Art Institute after various disagreements with trustees. Illustrated *Huckleberry Finn* for The Limited Editions Club. Made an album of flute, harmonica and voice recordings with son, Thomas P., an accomplished flutist, and Frank Luther's singers for Decca records. Music based on American folk songs, especially composed for album ["Saturday Night at Tom Benton's," Decca Album No. 3-311, 18 M Series]. Was lecturing in Cincinnati, Ohio, when news of Pearl Harbor was released. Returned to Kansas City and commenced series of war paintings designed to help awaken American public to dangers of the moment. This series was purchased by Abbott Laboratories of Chicago. Reproduced in full color, it was presented in book and poster form to the U.S. Government for propaganda use. Distribution of reproductions ran to 18,000,000 copies. Exhibition of original paintings at Associated American Artists in New York attracted 75,000 people. Paintings were later presented by Abbott Laboratories to Missouri Historical Society at Columbia, where they are now on exhibition. Painted "Negro Soldier" also now at Missouri Historical Society, and "Prelude to Death" embarkation scene.

"A Tour of Hollywood—six drawings by Thomas Hart Benton," *Coronet* (February, 1940).

"Benton Sounds Off," *Art Digest* (April 15, 1941).

"Art vs. The Mellon Gallery," by Thomas Hart Benton, *Common Sense* (June, 1941).

"The Year of Peril Paintings," by Thomas Hart Benton, *The University Review*, The University of Kansas City, Kansas City, Missouri (Spring, 1942).

The Artist in America, by Carl Zigrosser, published by Alfred A. Knopf (1942), has a chapter on Thomas Hart Benton.

1943–1944 "Continued paintings and drawings of the war for Abbott Laboratories and U.S. Government. Visited industrial plants, training camps, oil fields. Went to sea on submarine, and down Ohio and Mississippi and into Gulf of Mexico on L.S.T. boat. Illustrated Mark Twain's *Life on the Mississippi* for The Limited Editions Club. By end

of 1944, returned to normal painting activity. Wrote article on Grant Wood (now deceased) for University of Kansas City Review."

Taps for Private Tussie, by Jesse Stuart, illustrated by Thomas Hart Benton (E. P. Dutton & Co., Inc., 1943).

The Autobiography of Benjamin Franklin, illustrated by Thomas Hart Benton (Illustrated Modern Library, 1944).

1945 "Made honorary member of Argentine *Academia Nacional de Bellas Artes.* Productive year, among paintings 'July Hay,' third work to go to Metropolitan Museum, 'Flood Time,' now in collection of Harpo Marx, and 'Custer's Last Stand,' now in the Richard Russell Collection, Scarsdale, New York."

"Thomas Hart Benton," American Artists Group Monograph No. 3, published in New York with fifty reproductions.

"*The Oregon Trail,*" by Francis Parkman, illustrated by Thomas Hart Benton (Doubleday-Doran & Co., Inc., New York, Limited Editions series, 1945).

1946 "Exhibition of paintings at Chicago galleries of Associated American Artists. Chicago press generally receptive though an echo of the old New York charge of 'provincial' was heard. Received commission for mural at Harzfeld department store in Kansas City. Went to Hollywood and worked with Walt Disney on plans for an American operetta on the theme of 'Davy Crockett.' Could not accommodate to Disney needs and abandoned project."

1947 "Executed Harzfeld mural 'Achelous and Hercules.' Encyclopaedia Britannica made film of mural's technical progressions which had international distribution."

1948 "Wrote article on John Steuart Curry, after his death, for *University of Kansas City Review.* Began intense study of west—New Mexico, Utah, and Wyoming. These areas began taking place of middle west and south which had hitherto furnished bulk of 'regionalist' subjects.

Received honorary degree of Doctor of Arts from Missouri University. Made honorary Phi Beta Kappa."

1949 "Returned to Europe. In Italy, made honorary member of *L'Accademia*

Fiorentina delle Arti del Disegno at Florence, and of *Accademia Senese degli Intronati* at Sienna. Revisited Paris. Had a hard time reviving French, which now had Missouri accent."

1951 "Retrospective exhibition at Joslyn Museum, Omaha, Nebraska. Added chapter to a new edition of *Artist in America* which reawakened old New York controversies about 'regionalism' in the *Saturday Review of Literature*."

"Disaster on the Kaw," by Thomas Hart Benton, *New Republic* (November 19, 1951).

"Tom Benton In Omaha," *Newsweek* (December 3, 1951).

"What's Holding Back American Art," by Thomas Hart Benton, *Saturday Review of Literature* (December 15, 1951).

1952–1953 "Revisited France and Italy. Returned to America with Admiral James Flatley on U.S.S. 'Block Island.' Made lithograph illustrations for The Limited Editions Book Club edition of Lynn Riggs's *Green Grow the Lilacs,* printed by the Oklahoma University Press. The book was published in 1954. Painted Lincoln mural for Lincoln University at Jefferson City, Missouri."

1954 "New York's Whitney Museum, moving to new quarters, gives its Benton murals to Museum of New Britain Institute at New Britain, Connecticut. Along with exhibition of murals, the Institute stages a retrospective showing of Benton paintings. Institute also purchases Benton portrait of Dennys Wortman and portrait of Benton by Dennys Wortman."

In 1954 Benton was commissioned by United Artists Corporation to depict a motion picture in a painting, *The Kentuckian.*

1955 "Made study trip to Spain. Received commission for, and began planning mural 'Old Kansas City' for Kansas City River Club."

1956 "Finished River Club mural and received commission from Power Authority of the State of New York for a mural representing discovery of the St. Lawrence River by Jacques Cartier. Began research and planning for work."

1957 "Executed St. Lawrence mural, now installed in New York Power Authority Administration Building at Massena, New York. Received honorary degree of Doctor of Letters from Lincoln University, Jefferson City, Missouri."

1958 "Painted the 'Sheepherder,' an interpretation of the Grand Teton Mountains in Wyoming. Now divide time between home in Kansas City and summer home on Martha's Vineyard. Occasionally lectures and teaches at University of Kansas City, and elsewhere. Signed a contract with the Truman Memorial Library, Independence, Missouri, for an historical mural on the theme, 'Independence and the Opening of the West,' and another with the Power Authority of the State of New York for a mural on 'The Discovery of Niagara Falls by Father Hennepin.' "

Retrospective exhibition of the works of Thomas Hart Benton, The University of Kansas Museum of Art, Lawrence, Kansas, April 12 to May 18, 1958.

1959 "Worked on plans for above murals. Research in the field and at Museums and Historical Societies. Found models for Pawnees and Cheyenne Indians through help of Charles B. Wilson, Oklahoma artist, and Brummit Echo Hawk, Pawnee artist. With Wilson went along as much of Old Santa Fe trail as could be found to the site of Bent's Fort and beyond to Spanish Peaks in South Colorado Rockies. For Oregon Trail section and Truman mural was driven by Aaron Pyle, west Nebraska artist, to Chimney and Courthouse Rocks, landmarks of Oregon Trail. Books of drawings made on research trips."

1960–1961 "Finished mural designs. Nov. 17, 1960 started execution of Truman mural. Installed canvas in studio 7' x 20' for Niagara mural. Planned to work on this when weather was too bad to get over to the Truman Library at Independence. Finished both murals in the spring of 1961. Developed bad bursitis condition while working on Truman mural which went over whole body. Finished both murals under cortisone. Dedication of Truman mural was presided over by President Truman and Chief Justice Warren. It was a memorable occasion."

The American Institute of Architects conferred their Fine Arts Medal on Thomas Hart Benton in April 1960.

"Painting and Propaganda Don't Mix," by Thomas Hart Benton, *Saturday Review of Literature* (December 24, 1960).

"Thomas Hart Benton's Jealous Lover and Its Musical Background" by Ray M. Lawless, The Register of the Museum of Art, The University of Kansas, Lawrence, Kansas (June, 1961).

The Truman mural was dedicated on the artist's seventy-second birthday, April 15, 1961.

1962 "Overcame bursitis condition and effects of cortisone. Decided, however, that I was getting too old for mural work and began thinking again in terms of easel pictures. In May, 1962, my home town of Neosho gave me a 'homecoming celebration.' This was a delightful honor. President and Mrs. Truman went with a whole special train load of friends from Kansas City to the celebration. Only a small handful of the friends of my youth left in Neosho."

The homecoming tribute to Thomas Hart Benton was held on May 13, 1962, at Neosho, Missouri.

Interview with Thomas Hart Benton, the New York Times (May 14, 1962).

Thomas Hart Benton elected to the American Academy of Arts and Letters, May 22, 1962.

John Ciardi interviewed Thomas Hart Benton on his television program Accent, reviewed by Jack Gould in the New York Times (June 8, 1962).

"Thomas Hart Benton: A Discussion of His Lithographs," by George Michael Cohen, American Artist (September, 1962).

"Random Thoughts on Art," by Thomas Hart Benton, the New York Times magazine section (October 28, 1962).

1963 "Revisited Wyoming in Summer sketching trip. Painted a complicated composition of 'The Twist' dance scene."

1964 "In good physical shape again. Made interesting trip into Canadian Rockies. Rode horseback from Banff to Assineboine. 9½ hours of riding divided into two days. First horse ride in many years. Certainly more than 30 years. Made a series of drawings of Mt. Assineboine, and in the autumn started a large painting from these."

On April 15, 1964, Thomas Hart Benton was honored on the occasion of his seventy-fifth birthday with a dinner in Kansas City, Missouri. Benton received many congratulatory messages including one from the President of the United States, Lyndon B. Johnson. President Johnson said: "You have made lasting creative contributions to the legacy of our nation. All your countrymen applaud your unceasing efforts to preserve and enhance our cultural heritage." The New York Times reported that Mr. Benton stood and surveyed the crowd at the dinner in his honor, then remarked, "This is the kind of thing that comes to you when you've outlived your critics."

Some of Benton's famous paintings were exhibited in the Missouri Pavilion at the New York World's Fair.

1965 "Finished painting of Assineboine—called 'Trail Rider.' Resigned from American Academy of Arts & Letters because of an inappropriate and compromising political speech by the organization's President. Went on a long exploratory expedition up the Missouri River from Omaha, Nebraska, to Three Forks, Montana, and from there into the 'Rendezvous' area of the Wind River Mountains in Wyoming. Five weeks' trip. Following routes of Lewis & Clark and the fur traders and trappers. Went, in Autumn, to Italy for two months to try hand [in American Sculptor-Painter Harry Jackson's Italian Studio] at bronze sculpture. Learned modeling in wax, and executed one figure 'The Ten Pound Hammer.' Made Tour, Orvieto to Venice across Apennines—revisited Padova, Bologna, Florence, etc."

"Down the Wide Missouri with an Old S.O.B.," by R. Wernick, Saturday Evening Post (October 23, 1965).

1966 "Mr. Lyle Woodcock, St. Louis Collector, set up exhibition of Benton paintings, drawings and lithographs at Illinois College, Jacksonville, Illinois. Well received. Had 'stroke' followed by heart attack. Remained in hospital five weeks. Recovered but mode of life will have to be changed. Now among the 'old folks.' Reelected to American Academy of Arts and Letters under sponsorship of Alan Nevins, American Historian and new President of Academy."

Thomas Hart Benton Exhibition, Birmingham Arts Festival, Bloomfield Art Association, Birmingham, Michigan, October 1–23, 1966.

1967 "Made two lithographs, *Ten Pound Hammer* and *The Little Fisher-man*. Wrote another, and final, chapter for *An Artist in America*, republished by Missouri University Press in 1968. Selected 135 drawings from various periods and styles for a book called *Benton Drawings* also issued by Missouri University Press in 1968. An exhibition of the original circulated over the State of Missouri by the Missouri Foundation for the Arts in 1968. Experimented with highly realistic still lives in polymer tempera."

1968 "Painted *Casey Jones*, a picture based on the song. Signed contract with Kansas University Press for a survey of technical developments, to go with a book of reproductions of paintings from 1909 to 1968. This covers influences and methods in detail. Given honorary degree by New School for Social Research, June 4, 1968."

INDEX OF TITLES